LIVINGSCULPTURE

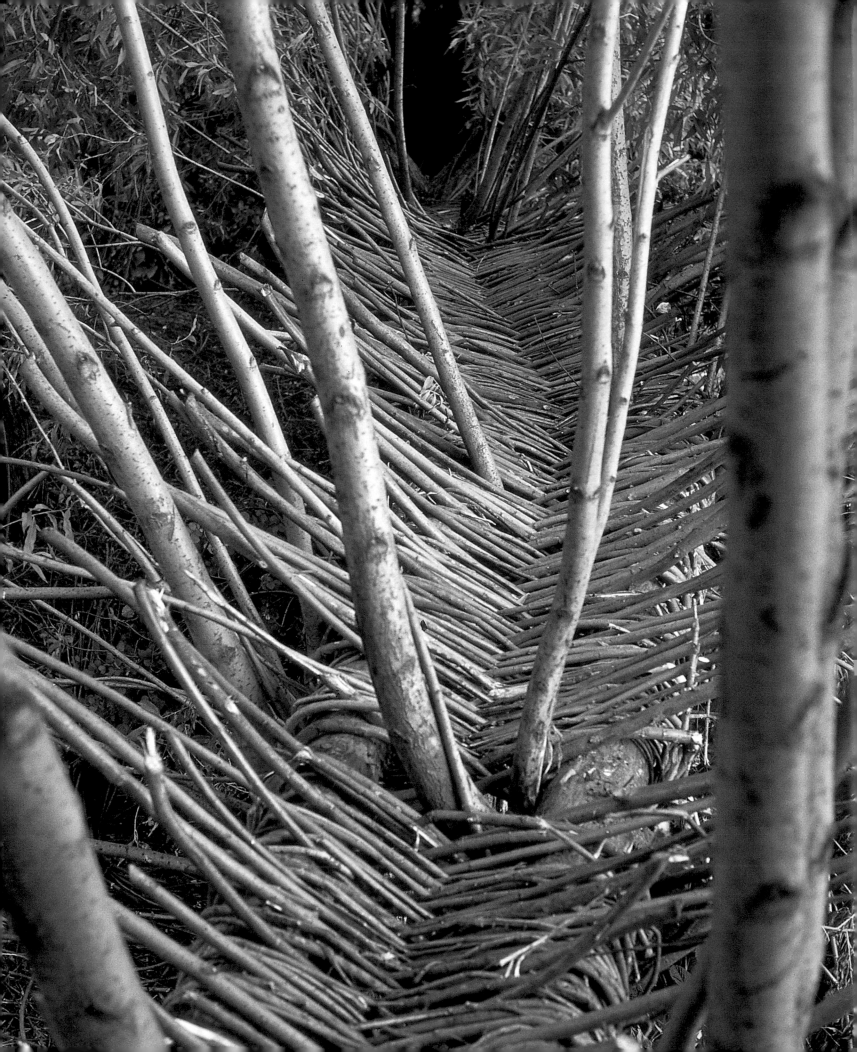

LIVINGSCULPTURE

PAUL COOPER

MITCHELL BEAZLEY

FACING TITLE PAGE: "Willow Walk," by Richard Harris, Ness Botanic Gardens, Cheshire, England, 1991.

CONTENTS PAGE: (TOP) box figure, part of a garden by Elizabeth Banks and Tom Stuart-Smith for the Chelsea Flower Show, 1991; (CENTRE) turf labyrinth by Alex Champion, private garden, California, United States; (BOTTOM) pollarded trees protected with hessian, Fukuoka, Japan.

LIVING SCULPTURE
Paul Cooper

First published in 2001 by Mitchell Beazley, an imprint of Octopus Publishing Group Ltd, 2–4 Heron Quays, London E14 4JP

ISBN 1 84000370 7

A CIP catalogue copy of this book is available from the British Library

Executive Editor **Mark Fletcher**
Art Director **Geoff Borin**
Deputy Art Director **Vivienne Brar**
Project Editor **Michèle Byam**
Design **John Grain**
Contributing Editor **Richard Dawes**
Production Controller **Nancy Roberts**
Picture Researcher **Rosie Garai**
Indexer **Laura Hicks**

Set in Frutiger and Trajan

Printed and bound in China by Toppan Printing Company Limited

CONTENTS

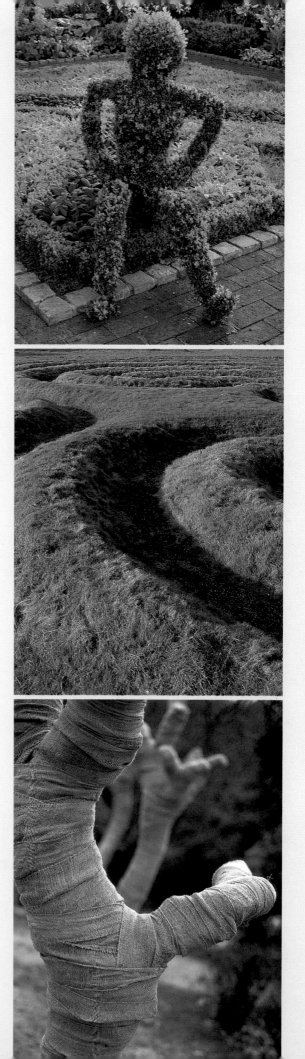

INTRODUCTION

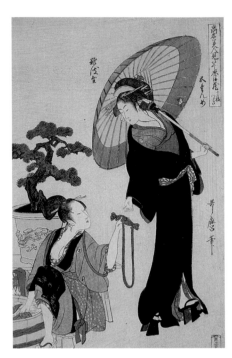

ABOVE Miniature trees created by the Japanese art of bonsai can be hundreds of years old. These living sculptures are the subject of pictorial art, as here, and, as art objects themselves, command high prices.

It is probably accurate to say that for the majority of people the art of sculpture can be defined as the making of artifacts with materials such as stone, wood, plaster, clay, or cast bronze. The popular appeal of this definition is reinforced by the fact that, throughout the centuries, the most widely celebrated sculptors, from Michelangelo, through Rodin, to Henry Moore, have all given expression to their ideas by using one or more of these inert mediums.

More recently steel, plastics, and other modern and unconventional materials have been added to this repertoire as artists have explored new ways of making sculpture. Some of the more radical creations have attracted extensive media attention. In the 1960s it was the crushed cars of César; in the 1970s it was the pile of bricks by Carl Andre. Damien Hirst's dead cow in a glass tank full of formaldehyde is the latest manifestation of the headline-hitting sensationalism of much contemporary art.

Away from the museums and the art galleries, a quieter revolution has been taking place over the past few decades. In remote landscapes, throughout the cultivated countryside, and in gardens, an increasing number of artists and craftspersons have turned to the natural world for both their sculptural material and their inspiration. For many centuries plant forms such as the acanthus leaf were an important source of inspiration for sculptural ornamentation, carved into the work as architectural detail, but now plants themselves have become the sculptor's medium.

Living sculpture is about art that is created with live and growing plants. A distinction must be drawn here between this type of art and the work made by sculptors such as Andy Goldsworthy, who, although he works closely with nature and natural processes, rarely uses living plant material. Goldsworthy finds inspiration in the autumnal colours of fallen leaves, forest and woodland debris, and even snow and ice. Living sculpture is

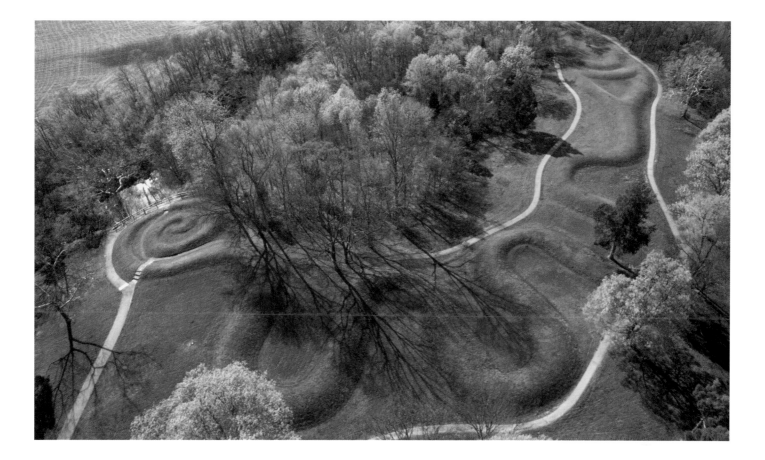

concerned with the work of artists and craftspersons who make creative use of living plants. It is work created by those who regard growing trees, grass, or crops as their sculptural medium. And even when other, non-living ingredients are incorporated in these works, the living element remains of primary importance to both the form and the meaning of the work.

Shaping and sculpting plants is not new. One of the oldest forms of living sculpture is bonsai, the ancient Japanese art of cultivating plants in containers. The term means a "plant in a pot", and it originally referred to the practice of taking specimens of any plant from the wild and maintaining them in the home or garden. The essence of the cultivation and manipulation of the tree was to preserve or recreate a sense of "wildness." While containerization was the basic means of controlling small trees and shrubs, further

ABOVE This earthwork in the form of a giant serpent, at Chillicothe, Ohio, in the United States, might be the work of a modern land artist. In fact it was made between 1000 BC and AD 700 by Hopewell Indians.

techniques were developed to stunt their growth and to retain their similarity to their full-sized natural counterparts. The methods introduced included potting, root and shoot pruning, pinching out, and the use of wire to shape plants. Original versions were naturally stunted plants taken from the wild; it was not until the early nineteenth century that bonsai became the art of growing scaled-down wild trees. The aim of the modern bonsai artist is to create a picture of what one sees in nature but on a miniature scale, using a living plant as the means of expression. In this sense it is a visual art, like painting or sculpture. As a painter might aim to capture on a canvas the essence of a natural scene, so a bonsai artist creates the "image" of a tree as a miniature living sculpture.

Topiary is also a decorative art that shapes living garden plants, but it works more with a plant's surface foliage than with its

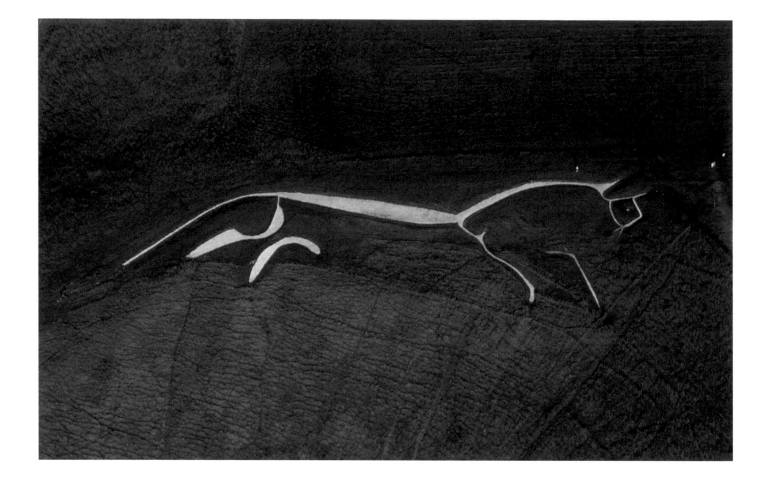

8

overall structure, as in bonsai. Since the emergence of topiary, in Roman times, its popularity and style have been determined by contemporary taste and fashion. Its early use was an expression of power. To conquer nature was the aim of the kings who commissioned the seventeenth-century French formal gardens. Designers such as Le Nôtre imposed on land and plants the "grand orders" of the favoured architectural style, which usually meant forms belonging to the classical past. A tree was nothing more than building material, albeit one that needed keeping in order. Topiary later went in and out of fashion as attitudes to garden design changed, but it remains the most popular way in which plants and trees are turned into sculptural, architectural, and decorative forms. Today it is mainly found as frivolous and fun shapes in well-tended suburban gardens.

ABOVE The ancient representation of a horse drawn on a chalk hillside at Uffington, in Oxfordshire, England, was never intended as art in the modern sense of the term. Yet, looking at it today, it is difficult not to admire the abstract quality of the work.

Long before gardeners began shaping the natural scenery, ancient civilizations had already left their mark on the living landscape. They had exploited its physical properties and its vegetation to make vast drawings or sculptured mounds, many of which were representations of animals. The art historian E.H. Gombrich once remarked that there is no such thing as art; there are only artists. Although we might interpret these ancient monuments scattered across the rural landscape as the work of artists, their existence has nothing to do with making "art for art's sake." This conception of art is relatively new, arguably no older than the nineteenth century. By contrast, the works of our distant forebears were purely functional. As powerful tools in working magic, they were used for ceremonial and religious purposes, such as marking burials or making offerings to the gods.

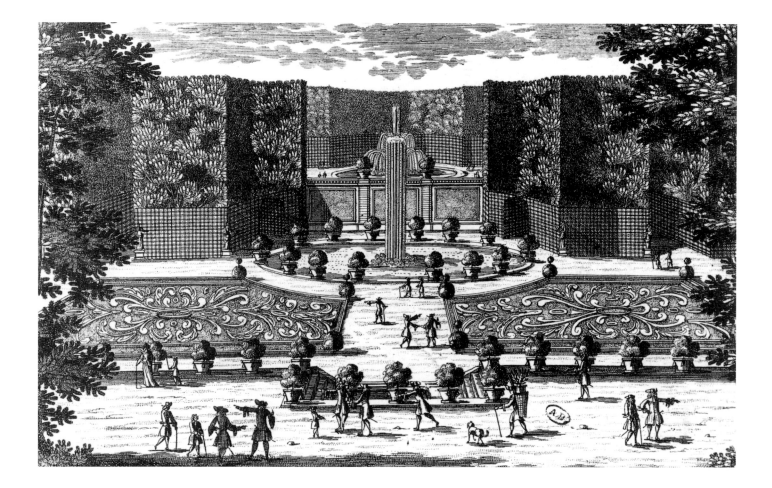

In the 1960s sculptors were inspired by these ancient "artworks" to work with the natural landscape on a similar vast scale. Although there was a wish to revive the spirit of the past, the primary motivation for these modern-day "land" artists was the emancipation of art. Over the past century works of art have become precious objects to be owned by the few or appreciated in the exclusive world of museums and galleries. The artists saw working with the natural environment as a means by which art might be freed from its function as a commodity and could instead serve the community.

A search for a new, less insular form of art led other artists and craftspersons to reject the usual sculptural practice of carving wood in favour of using living trees. Some turned to traditional

ABOVE This engraving shows a garden in the French style of the seventeenth century. The subjugation of nature by art was the aim of this highly formal approach to landscape design. Topiary was particularly popular, and trees and shrubs were clipped into architectural forms.

techniques, such as those used in horticulture and agriculture, adopting the methods by which living vegetation is managed to supply the needs of society. These techniques include pleaching, coppicing, and pollarding, all of which are used in the making of hedges and in woodland maintenance. Artists such as David Nash and Mick Petts have consciously sought out these low-tech, traditional skills as the most appropriate way to persuade shrubs and trees to grow into the living sculptures they create. In its interest in the use and preservation of rural skills, this is art with a social conscience. The desire of its creators to convert plants into aesthetic forms may recall the formalist landscape gardeners of the seventeenth-century, but the guiding principle of these modern artists is not to have power over nature but to make art with it.

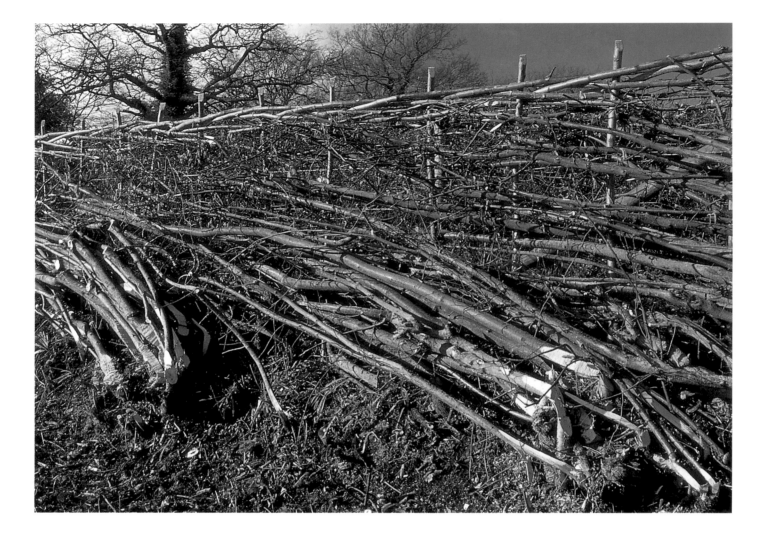

10

As "green" issues have become a part of mainstream politics, so living sculpture has become a vehicle for expressing concern about what is happening to the natural environment. The planted sculptures by artists such as Samm Kunce and Meg Webster are artworks with a message. They are designed to raise awareness of ecological issues and to highlight the dangers associated with developments in the biological sciences.

As an art form living sculpture is transitory, and works made from a growing crop by artists such as Pierre Vivant and Stan Herd are particularly so. Living sculpture is a way of making art that goes against the centuries-old values of Western art and architecture.

ABOVE "Laid" hedges, such as this one in Surrey, are a familiar sight in the British countryside. In this technique, also used to make living sculpture, the trunks and branches of the trees are partially severed, bent over, and woven through vertical wooden stakes.

Since ancient times the materials, such as minerals and metals, from which artifacts have been made suggested longevity or permanence. In political terms they symbolized the status quo. These values were still dominant in the early part of the twentieth century and continue to prevail in much contemporary art. Living sculpture is the antithesis to this concept of art. Its works will not last for ever. Throughout their existence they have to be nurtured and maintained to retain their forms, and they also require certain environmental conditions if they are to survive.

Not all those who are making living sculpture were formally trained as artists. Some are self-taught, and their work could be

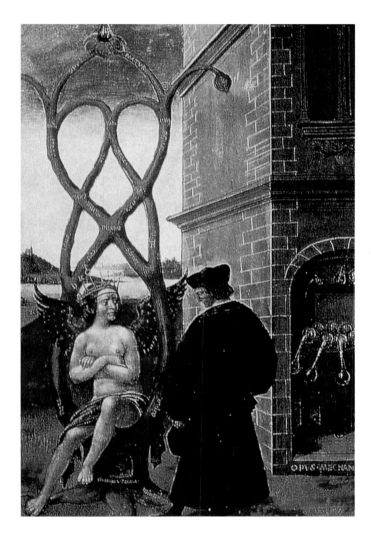

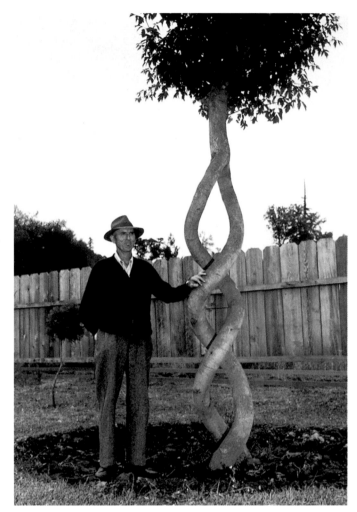

described as idiosyncratic. By Gombrich's definition they are artists, but they have been attracted by the craft and the science rather than the "art" of shaping living plants. The tree sculptor Axel Erlandson did not set out to create art, but simply to experiment with plants. The work of these "outsider" artists is often intuitive and not influenced by either traditional or contemporary art styles.

ABOVE LEFT A work by the sixteenth-century French painter Jean Perréal depicts the mythical "Forge," a symbolic tree that grows from the three roots Mineralia, Vegetativa, and Sensitiva. Its interwoven form bears an uncanny resemblance to the work of the twentieth-century tree sculptor Axel Erlandson.

ABOVE RIGHT Axel Erlandson in 1947 with one of his remarkable tree sculptures in California.

Over the centuries plants have often been used in the garden to provide a background for sculpture and architecture. Even topiary frequently had a subordinate role in the design of gardens, trees and shrubs being grown and clipped to create a context for other forms of ornamentation, such as statuary and fountains. But now a new generation of artists, designers, and gardeners has rediscovered the age-old

Their motivation is akin to that of the obsessive gardener who repeatedly attempts to breed a rose of a new colour or a monstrous vegetable. Like him, they wish only for their horticultural skills to be admired: skills that they often prefer to keep secret.

truth that plants themselves, from grass to trees, can become sculpture. Inspired by traditional rural crafts, historic horticultural art, and ancient earthworks, they are making a "living art" that changes with the seasons.

SCULPTURE IN LEAF

The oldest and most familiar form of "living sculpture" is topiary.
Throughout the centuries the art has gone in and out of fashion as
the approach to garden design has changed, but it is at present
enjoying a revival in the hands of a diverse group of artists,
enthusiastic gardeners, and landscape designers. Some of these
have been drawn to topiary by an interest in reviving the styles
of the past. For others it provides an opportunity for personal
expression and has become a lifelong obsession. Topiary depends
almost completely on the presence of a dense surface of leaves,
and it is with these that the form of the subject is defined.
Evergreen trees and small-leafed shrubs are the ideal choice for the
creation of this "sculpture in leaf."

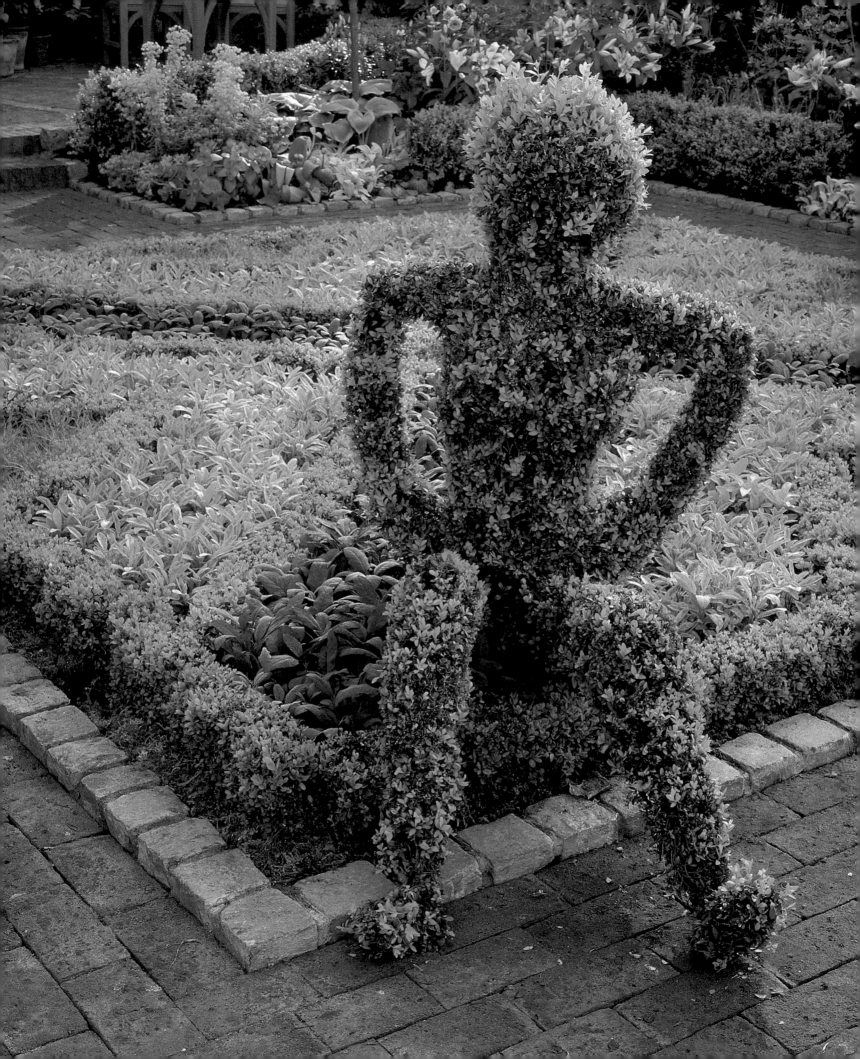

The word "topiary" is derived from the Latin *opus topiarum*, which means "ornamental gardening." Topiary has always been associated with the art of the garden rather than any horticultural necessity. It is totally unlike pollarding, in which trees are cut back as a part of horticultural husbandry or to stimulate new growth. Topiary can be defined as the clipping and coaxing of a tree or shrub into a chosen shape, and it has always fulfilled an aesthetic rather than a practical function. It has been closely associated with the history of garden design, and its popularity through the centuries has varied according to changes in this practice. Up until the twentieth century the inclusion of topiary in gardens was generally linked to the formal tradition, for it was seen as befitting gardens in which designers sought to control and order nature.

The first reliable descriptions of the practice of topiary date back to the first century AD. In the writings of the ancient Roman encyclopedist Pliny the Elder there are passages on Roman gardening and gardens, and he refers to "carvings of trees into scenes of hunting, ships and all variety of images in Cyprus." It is known that clipped box was also used at the time and that master topiarists were even able to "sign" their names in leaf. After the Roman Empire collapsed villas and their gardens fell into ruins. The subsequent centuries-long instability in the Western world provided little opportunity for the creation of ornamental or pleasure gardens.

Although there is evidence that a simple form of topiary was incorporated in a few gardens during the medieval period, with plants trained and clipped into simple, geometric shapes, there was little call for the more extravagant forms of the art. It was not until the Renaissance, in fifteenth-century Italy, that there was a revival of topiary. Some of the first examples of the rediscovered art were created in the gardens of the Palazzo Rucellai in Florence during the second half of that century. Here there were trees shaped into spheres, porticoes, and temples, as well as more representational forms, such as giants, warriors, and animals. These were all grown from evergreens over withy frames, a withy being a strong, flexible twig, usually of willow. These frames acted like templates to train the new growth into the desired shapes, which could then be maintained and improved by subsequent clipping.

By the sixteenth century topiary had become widespread in Italian gardens, and interest in the craft had reached other European countries. Such was the enthusiasm for this revived art form that the repertoire of topiary plants became extensive, often regardless of their suitability. Rosemary, juniper, phillyrea, myrtle, and privet were among the most popular.

PREVIOUS PAGE Sitting among the purple sage with her legs straddling a hedge, this simple representation in box of a female figure has a strange presence. Partly in the garden and partly out of it, the sculpture seems to belong to both the plant and the human world and is representative of recent informal and whimsical trends in topiary. The figure was included in "A Gothic Retreat," a garden created by the British designers Elizabeth Banks and Tom Stuart-Smith at the Chelsea Flower Show, London, in 1991.

However, in the ensuing debate on the merits of topiary it was not the choice of plant that was to be the principal issue. It was the choice of subject matter.

In *New Orchard and Garden* of 1618 the Englishman William Lawson suggested that "your gardener can frame your lesser wood to the shape of men armed in the field … hounds to chase the deer." This view reflected the popularity of human and animal motifs, and whimsical subjects such as these continued throughout the seventeenth and eighteenth centuries, mainly at the behest of the nouveau riche. Other commentators were eager to confine the use of topiary to the imitation of architectural forms. One who advocated this more restrictive approach was Sir Francis Bacon, who, in his essay "Of

BELOW Evergreen topiary chairs provide winter interest in this snow-covered garden at Hillbarn House, in Wiltshire, England. The angular, box-like forms, which are in the tradition of architectural-style topiary, are similar to one another but not quite the same. The differences are perhaps intended to suggest male and female characteristics.

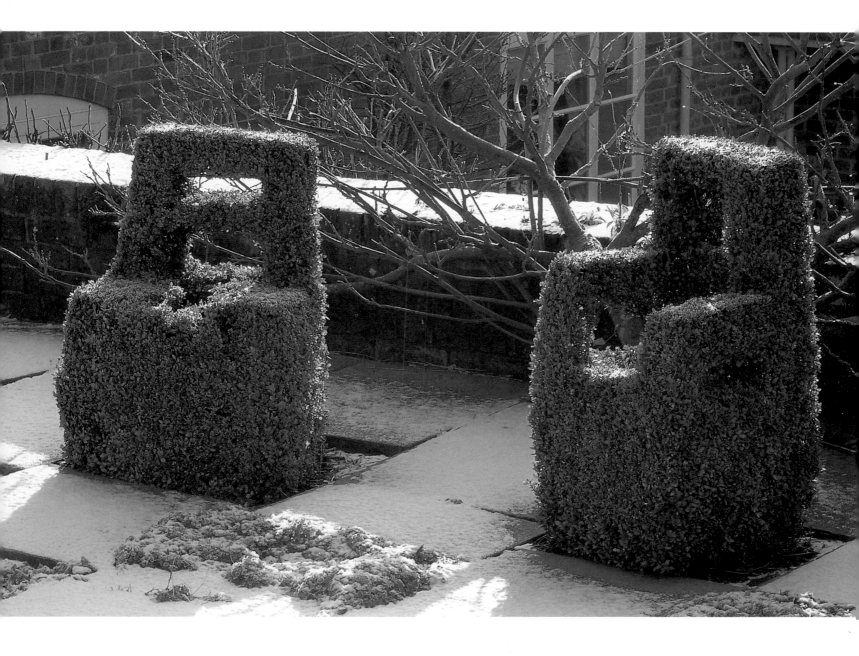

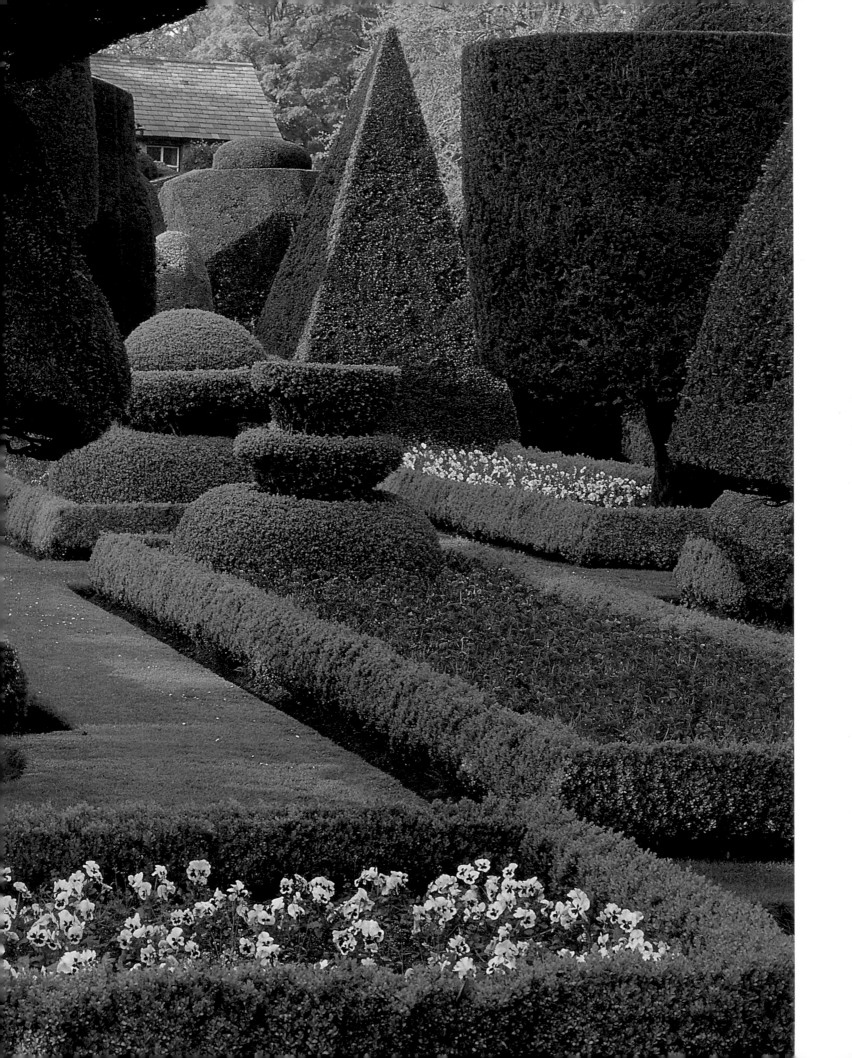

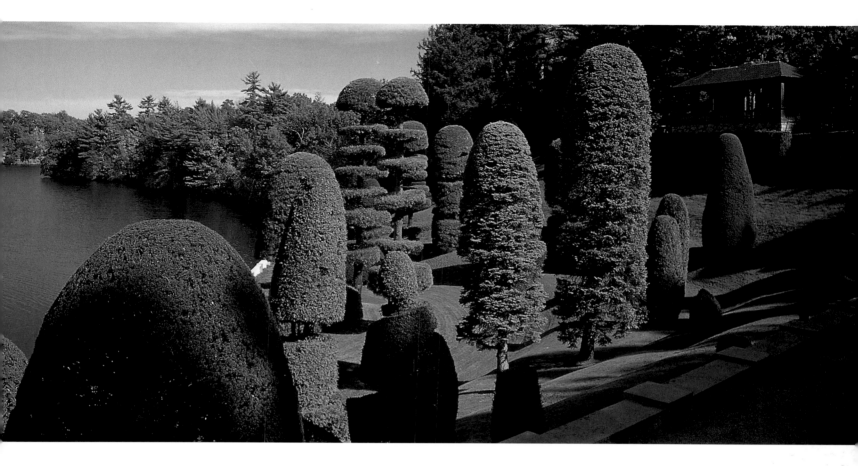

Gardens" of 1625, conveyed a dislike for "images cut out in Juniper or other garden stuff … they be for children." He preferred subjects that were less frivolous, such as pyramids and columns. This more architectural topiary became increasingly evident in the formal gardens of the seventeenth and eighteenth centuries and was particularly prevalent in France, where it suited the French style of garden design. It existed either as a simple, geometric shape, used to provide a vertical element in a parterre, or as a complete architectural feature, and in either case was usually created out of yew, box, laurel, or holly.

In the early eighteenth century there was a reaction against the formal garden, and consequently topiary fell out of fashion. Instead there was an emphasis on nature and the natural in the garden. This idea originated in England, where a growing discontent with formal design was expressed by writers such as the satirist Alexander Pope, who commented on the trend: "Our trees rise in cones, globes and pyramids. We see the marks of the scissors upon every plant and bush." The English Landscape movement and its principal practitioners, William Kent (1685–1748) and Lancelot "Capability" Brown (1715–83), replaced the excessively formal layouts prevalent during the reigns of William and Mary and Queen Anne with a style of garden that was, according to Robert Walpole,

ABOVE The Topiary Garden of the Hunnewell Estate, at Wellesley, Massachusetts, stimulated an enthusiasm for topiary in the United States when it was created in the 1850s. The conical and cylindrical topiary owes a debt to the formal tradition that was a feature of the nineteenth-century garden at Elvaston Castle, in Derbyshire, England. But while the topiary at Elvaston was part of an overall design, at Wellesley it is essentially a collection of individual specimens.

OPPOSITE The garden at Levens Hall, in Cumbria, has one of the oldest and most spectacular topiary collections in Britain. The extensive repertoire of shapes is made even more impressive by the variety of colour. Shades of emerald green, lemon yellow, and watery blue are achieved by the use of different species of box and yew.

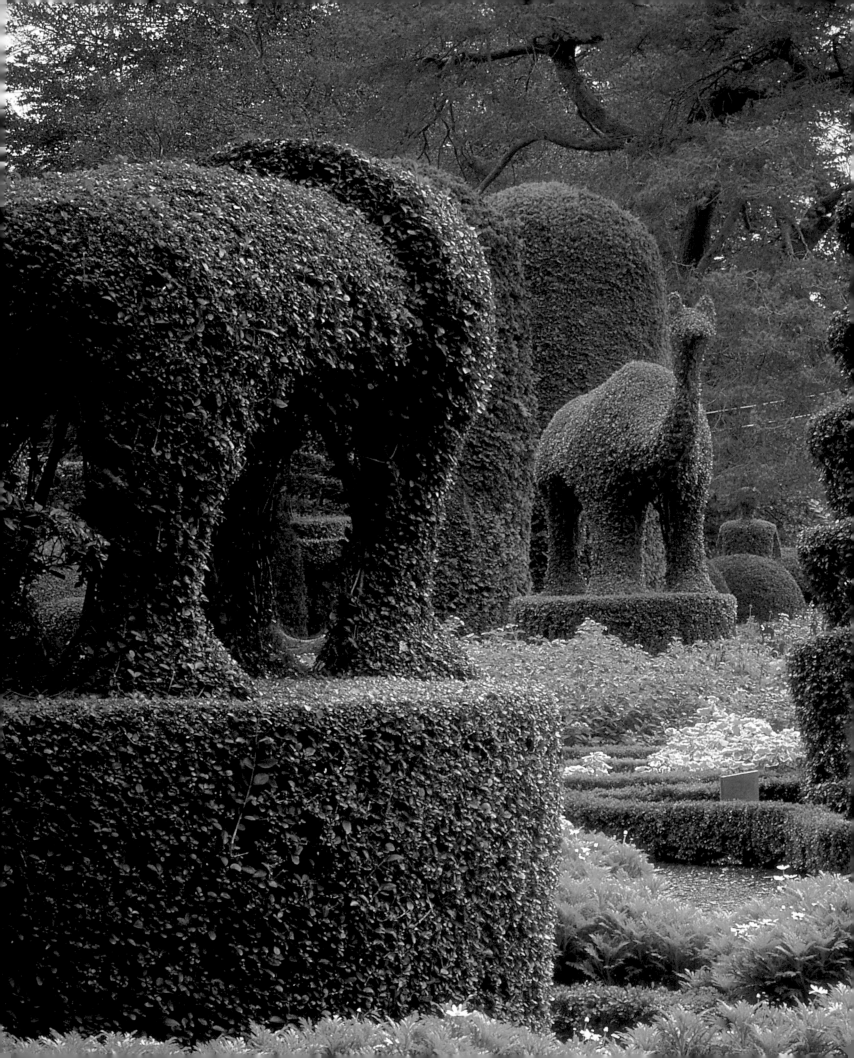

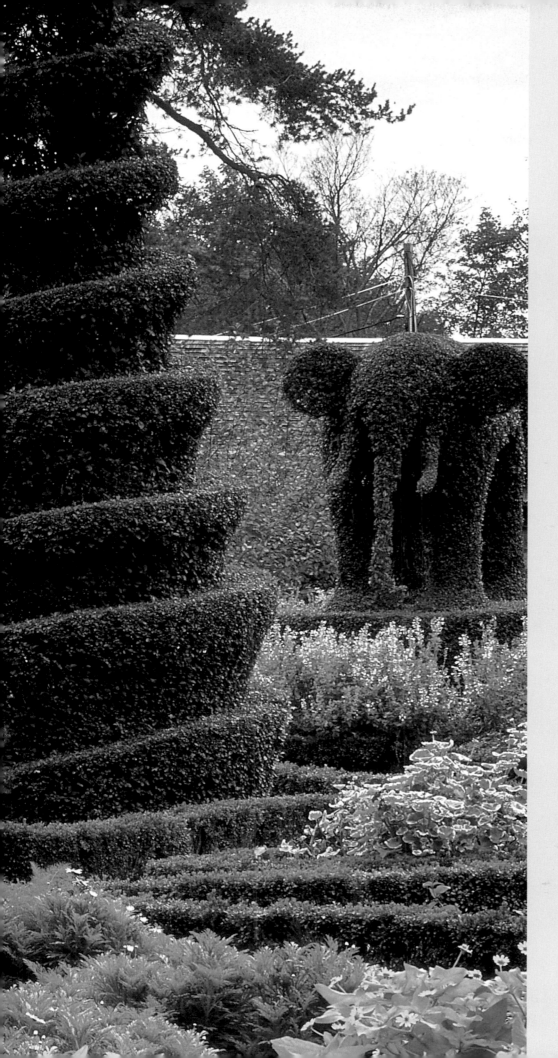

LEFT This topiary "zoo" was begun at the end of the
nineteenth century by Thomas Brayton in his garden
at Portsmouth, Rhode Island, in the United States.
The collection has more than eighty topiary animals,
including elephants and camels, all of them
exquisitely formed and easily recognizable.
Each animal stands on a pedestal, like
conventional sculpture.

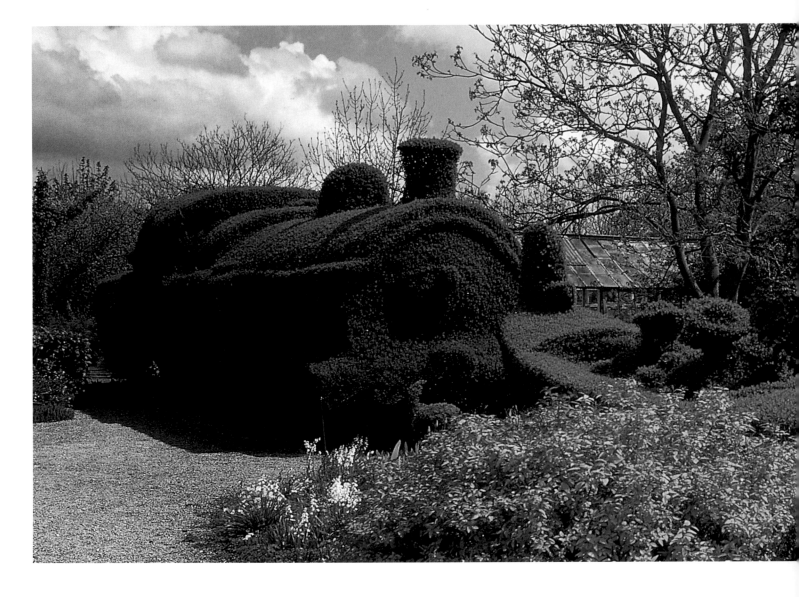

"to be set free from prim regularity that it might assort with the wilder country without." Many great formal gardens and their topiary were destroyed in the process. By the 1830s, however, a further change of taste saw the decline of the English Landscape style of garden design. Writers and commentators lamented the destruction of the old formal gardens and inspired in many a desire to restore those that had survived.

It is thought that the garden at Levens Hall, in Cumbria, was one of the few to escape destruction. In 1804 the head gardener, Alexander Forbes, cut the overgrown shrubs and trees into their present shapes, although it is not known whether the originals on which he worked had been topiary or were simply overgrown parterre bushes. Today visitors to Levens Hall, which is open to the public, cannot fail to be impressed by both the extraordinary variety of shapes and the size of the topiary.

LEFT A shunting locomotive seems to have been stopped in its tracks by a Venetian gondola. This unlikely scenario was staged in topiary by Adrian Powell in his garden near Bristol, England. In traditional topiary plants were grown for the intended purpose, and were at first "trained" into the shape required, usually with the aid of a frame made of wood or wire. Here Powell used a more modern technique, simply working with an established privet hedge, which he has carefully clipped over many years to achieve his unusual shapes.

Between 1830 and 1850, at Elvaston Castle in Derbyshire, William Barron created a completely new garden for the 4th Earl of Harrington in a manner which combined historical revivalism and exotic planting with the use of both topiary and grafting for ornamental effect. It included a series of hedge-enclosed gardens in which architectural features such as walls, buttresses, columns, plinths, and finials were imitated in topiary.

The topiary at Elvaston Castle is thought to have inspired the American horticulturalist W.W. Hunnewell to create one of the first topiary gardens in the United States. Dating from the 1850s, the Hunnewell Estate, at Wellesley, Massachusetts, was the forerunner of the many ambitious topiary gardens that were developed in America during the second half of the nineteenth century and in the twentieth. Few are more spectacular than the eighty or so green animals created in Thomas Brayton's garden at Portsmouth, Rhode Island.

Until the 1880s most topiary in Britain remained architectural in style. It had made a comeback in the nineteenth century, helped by the romanticism of the Pre-Raphaelite painters and the Arts and Crafts movement. The latter, led by William Morris, was sympathetic to topiary because it idealized the old rural skills of England. Morris encouraged the architectural use of trained trees and shrubs and admired topiary. Architectural topiary suited the large garden of the manor house, castle, or hall, but sculptural topiary also found support. The Arts and Crafts architect John Sedding, in *Garden Craft Old and New*, wrote: "My Yews should take the shape of pyramids or peacocks or cocked hats or

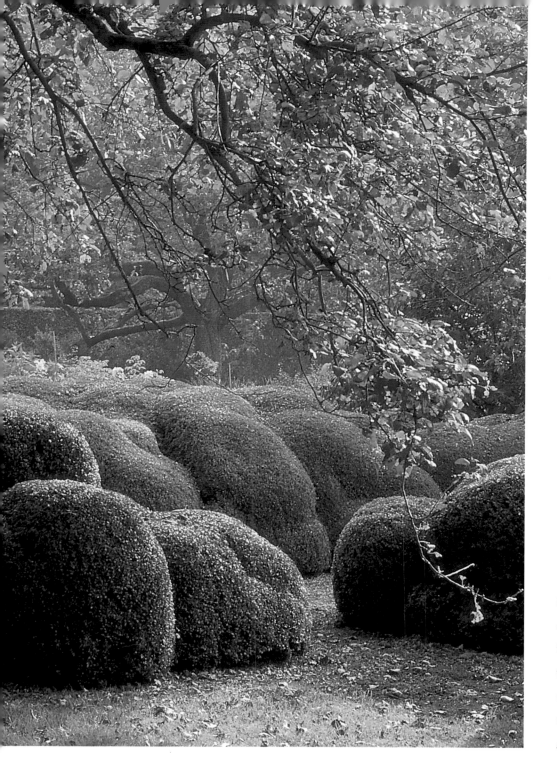

LEFT For the topiary in his garden in Botermelk, near Antwerp, the Belgian garden designer Jacques Wirtz favours organic, curvilinear forms. Very much of the twentieth century, they are neither architectural nor representational, and owe more to the abstract, Surrealist-inspired sculpture of artists such as Jean Arp and Henry Moore than to traditional topiary.

ramping lions in Lincoln green." The popularity of this "vegetable sculpture" reached its peak in Britain in the Edwardian era, but went into decline during World War I.

Social changes during the second half of the twentieth century affected the size, layout, and function of the garden, and consequently the role and status of topiary. From the 1950s an increase in both new housing and home ownership rather than renting led to more, but smaller, private gardens. Few of these warranted a full-time professional gardener, and it was left to a new breed of amateur gardener to keep the art of topiary

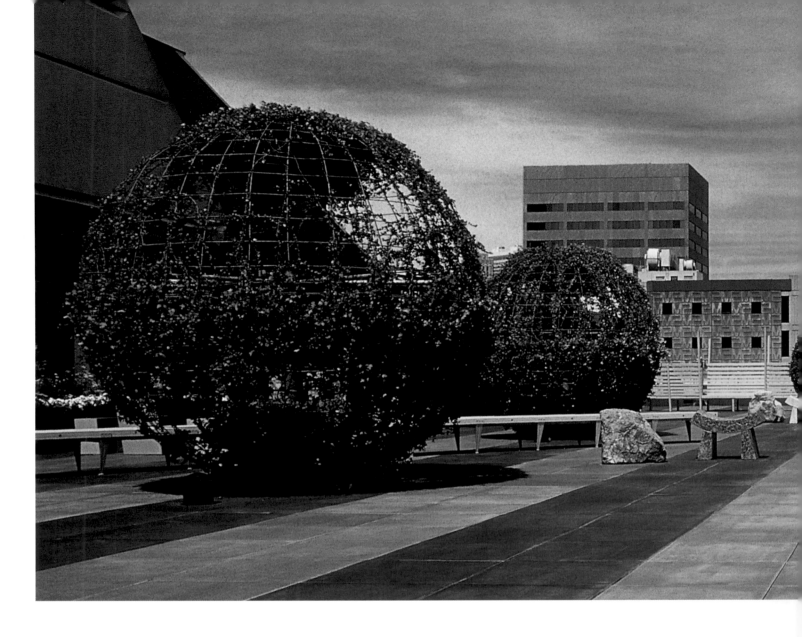

ABOVE Huge topiary balls, created by the American landscape designer Topher Delaney, provide both greenery and an element of fun for the roof terrace of the Bank of America in San Francisco. The balls are made of fast-growing, large-leafed, hardy ivies trained over armatures of metal mesh.

alive. In Britain it first found favour in the neatly trimmed hedges of suburban front gardens, but this was soon followed by more ambitious free-standing sculptural topiary. The new custodians of topiary began by borrowing their shapes from a traditional repertoire that included peacocks, teapots, cake stands, spirals, and crowns. The origins of these motifs are obscure. The teapot became a favourite in The Netherlands at a time when tea drinking and topiary were simultaneously novel and fashionable. The origin of the peacock is even older, harking back to the days when the display of rare birds was regarded as a sign of wealth and status. The reason for its re-emergence is more mundane, however. The creation of the peacock's shape provides the beginner with a useful exercise in one of the principal techniques of topiary. This involves the separation of growing shoots into groups, and in the peacock this method helps to distinguish the head from the tail.

A new generation of more confident topiarists has extended the traditional repertoire by adding steam engines, teddy bears, monsters, and ocean liners. In this typically British

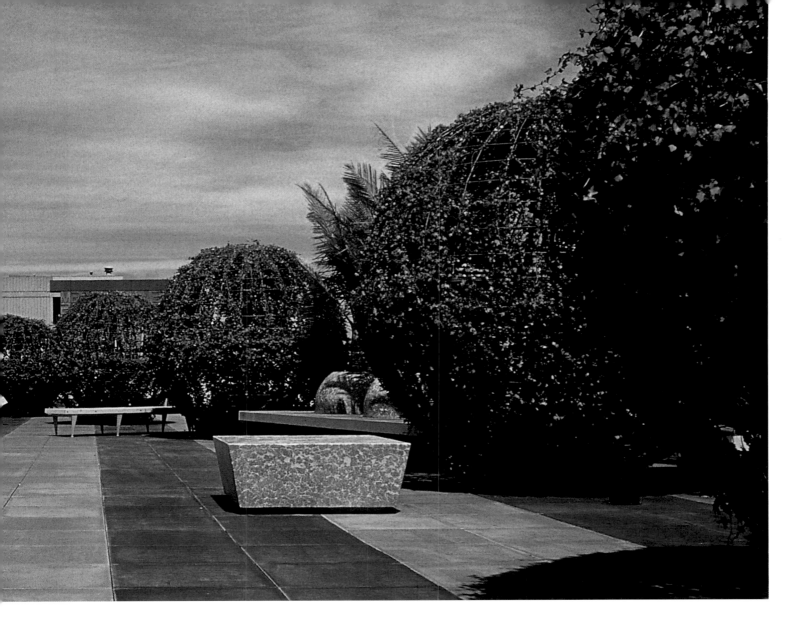

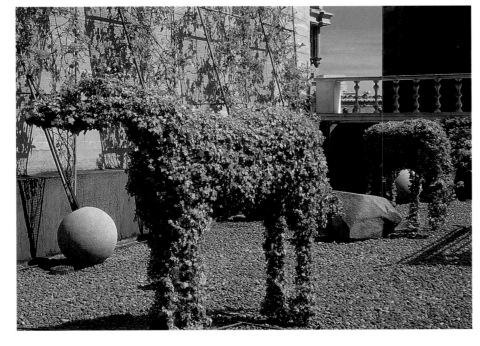

LEFT Topher Delaney's topiary is part of her design for the Coblenz, Kahen, McCabe, Bryer Roof Garden, in San Francisco. The formal design of the garden contrasts with the witty and idiosyncratic topiary animals grazing on gravel.

genre, eccentricity is customarily married to restraint. Adrian Powell has filled his garden at Rangeworthy, near Bristol, with this representational style of topiary. His extensive collection is a lifetime's work and includes a 14m (45ft) long shunting engine and a Venetian gondola. Both are worked from a privet hedge and were started more than thirty years ago. They are now part of a larger collection in this garden of 1.1 hectares (2.75 acres) that currently contains a baby dinosaur, a horse-drawn sleigh, and two armchairs that "belong," presumably, to the topiary lady and gentleman nearby.

The evolution of garden and landscape design in the second half of the twentieth century embraced a more liberal and diverse approach. While some were keen to revive old styles, there were others who attempted to develop a style that was more in keeping with contemporary design, art, and architecture. Many contemporary garden designers, including the Belgian designer Jacques Wirtz and the American designer Topher Delaney, have chosen to include topiary forms, but in a manner that reflects their innovative style.

Many of today's best garden designers respond to the spirit of the place and attempt to use it to bring out the best in a site. The gardens of Jacques Wirtz do just this. Having assessed the lie of the land, Wirtz sets out to "animate the site" by linking house and garden together, using devices such as hedges and topiary. Wirtz is not keen on the flippant or whimsical representational topiary that has found favour in Britain. He prefers simple, soft, geometric and organic forms, which he often uses in groups to create a contrast with the angularity of a house.

Elsewhere contemporary garden and landscape designers have approached the garden from a less conventional viewpoint, although many have still found a use for topiary. This is particularly true in the United States, where the latter half of the twentieth century saw some ground-breaking landscape design solutions. One of the most innovative practitioners is Topher Delaney. Based in San Francisco, she specializes in gardens that are customized to the personality of her clients, taking care to understand their individuality and character. Delaney often includes structures and imaginative sculptural forms, and uses topiary in this context. Unlike Wirtz's, her topiary is not simply a formal device but provides the wit and humour that are essential ingredients of her work.

For the roof terrace of a multinational bank Delaney introduced multicoloured windsocks and giant topiary balls, created by growing ivy over a steel mesh frame. This is a much quicker form of topiary and is particularly popular in the United States. Traditional topiary

OPPOSITE Pearl Fryar's topiary has been described as "botanical sculpture", and his abstract creations certainly bear little resemblance to mainstream work. Sweeping curves, arches, and spirals lend them a dynamism rarely seen in conventional topiary.

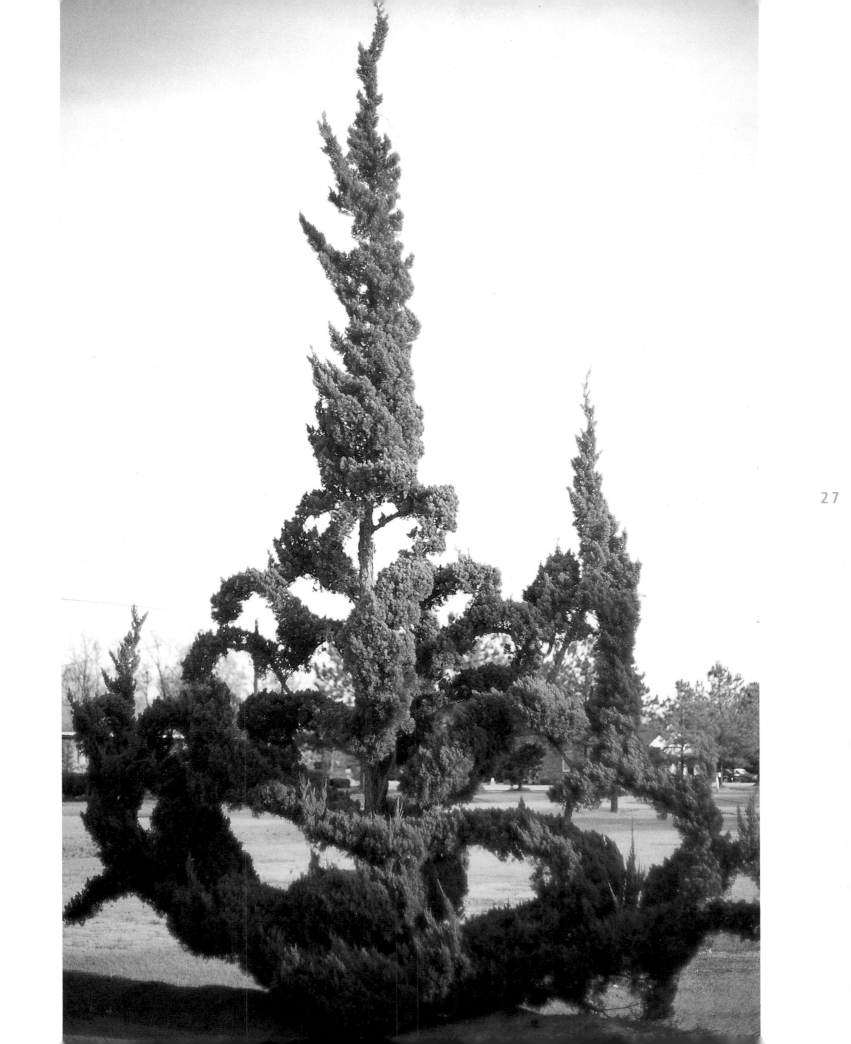

28

RIGHT A fox hunt is the subject of this inventive yew
topiary at Ladlew, Maryland, in the United States.
The work has a wonderful sense of animation.
Coupled with this well-observed representation
of movement in each of the animals, the informal
arrangement of the hounds in pursuit of their prey
gives the impression that the whole topiary is free
of the ground. Even the texture of the yew adds to
the lifelike quality of the scene, particularly in the
depiction of the fox's erect, bushy tail.

can take up to ten years to establish, yet the pace of modern life has led to a decline in the long-term view of the garden. Alternatives to slow-growing yew and box have been explored, and climbing plants trained over pre-shaped frames have become a popular alternative. The main drawback of this method is its reliance on an elaborate frame that clearly reveals the final shape of the topiary before the plant has grown to clothe it.

BELOW At the Deaf School Topiary Park in Columbus, Ohio, in the United States, the sculptor James T. Mason designed a scheme in which art imitates art. By recreating Georges Seurat's painting *Sunday Afternoon on the Island of La Grande Jatte* as topiary, he has made a landscape from a painting of a landscape. The figures, represented by countless dots in Seurat's scene, were perfectly reproduced by using the small-leafed yew.

The creators of today's gardens are by no means all professionals, nor do they follow mainstream trends. Some of the most unusual and adventurous gardens have been made by those who have known little about the tradition or conventions of garden design. They have relied on their instincts rather than following fashions.

For some of these enthusiastic amateurs topiary has become an obsession. In his own garden at Bishopville, South Carolina, the American Pearl Fryar has created 1.2 hectares (3 acres) of topiary trees and bushes. Although he had no previous knowledge of topiary, it was the idea of sculpting real plants that attracted him to create some extraordinary

30

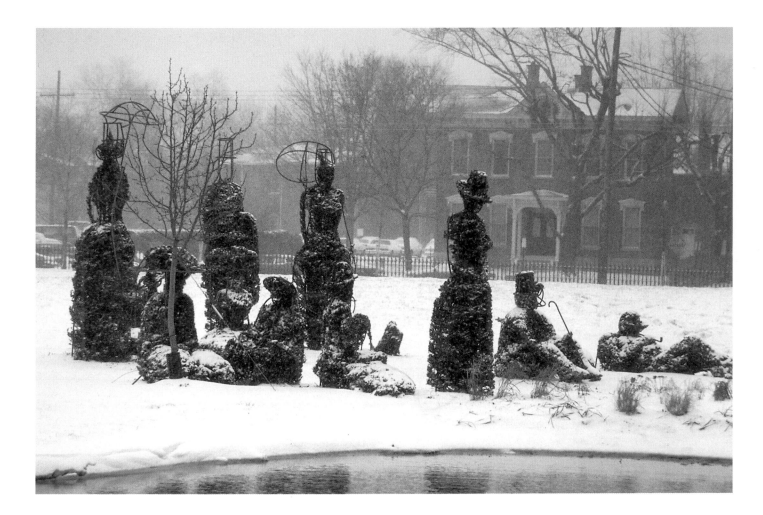

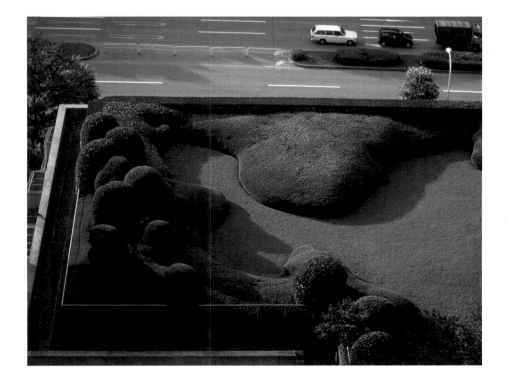

LEFT This rooftop topiary garden in Tokyo is not for conventional use, but is intended to be admired from above. The curvilinear topiary forms merge into one another and create an organic, abstract landscape that provides a pleasant contrast with the angularity of the architecture by which it is contained.

BELOW The designer of this courtyard garden in Japan used topiary in a modernist style as the principal element in a minimalist garden. In an abstract composition precise angular and geometric forms were imposed on the growing medium. The result is an impenetrable space in the form of a horizontal relief sculpture. It is a sculpture that demands a great deal of maintenance.

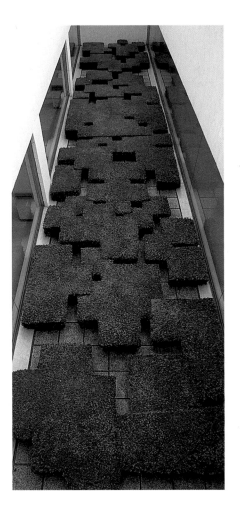

and original topiary forms. He began by making abstract forms and shapes, teaching himself how to prune and shape the plants to the images he had in mind. At first Fryar did not realize that sculpting plants was called topiary and that people had been doing this for centuries. A visitor to his garden sent him a book on topiary from England, and for a time he tried to emulate these forms. But he soon gave up, preferring his own, more inventive approach. Having tried and failed to copy conventional British designs, he has developed his own expressive abstract style in which he allows the existing shape of the tree or shrub to be the inspiration. The results include great swirling, interwoven arches, some more than 10m (33ft) high. It is these long, thin arches, formed in box, yew, and thuja, that best represent his style. Fryar's topiary has attracted the interest of both the gardening and the art world, and his work is now included in South Carolina's State Museum and in the Philip Simmons Garden in Charleston.

Pearl Fryar may have been unaware of the history of topiary, but in the United States box topiary and hedges have been a feature of the formal gardens of many of the major houses of Virginia and Maryland since around the middle of the seventeenth century. The Ladlew Topiary Garden, in Monkton, Maryland, was created almost single-handedly by Harvey S. Ladlew, who began his creations in 1929. It contains a diverse and eccentric mix of clipped hedges and complex evergreen sculptures. One of the most unusual is a topiary hunting scene. This includes a mounted huntsman leaping a five-bar gate, hounds

in full cry running across a lawn, and a fox escaping to a nearby shrubbery. Brimming with vitality, the animals appear not to be attached to the ground, and the sense of movement is increased by their informal arrangement. Sculptural topiary often resembles conventional sculpture in that it is confined to a plinth and looks like a statue. Pearl Fryar's work and the creations of Harvey Ladlew have broken free of the restrictive pedestal.

Today topiary is a mix of traditional and new skills as a new generation of artists has discovered its possibilities. In Ohio, the American sculptor James T. Mason has recreated in topiary Georges Seurat's oil painting *Sunday Afternoon on the Island of La Grande Jatte*. In 1988 a derelict lot in downtown Columbus was designated as being in need of improvement. The aim was to create a new park, and Mason, who teaches sculpture at the park's cultural and art centre, was given the opportunity to create an unusual variation on the French painter's masterpiece. The project covers nearly 0.2 hectares (0.5 acres) and includes a topiary figure that is over 3.5m (11ft) high. There are 50 people, eight boats, three dogs, a monkey, and a cat. The group of topiaries cleverly matches the painting, and the perspective of the original was imitated by making the figures in the foreground larger than those in the distance. The clipped yews' small leaves suggest perfectly the dots of the original pointillist painting. Mason has created a landscape of a painting

RIGHT This sea horse, made for a flower show, is representative of a style of topiary in which the choice of subject matter is all-important. The credibility of the genre relies on the skill of the topiarist to transform box or yew into the most unlikely subject. Sadly, many of the results come close to being kitsch.

FAR RIGHT Mr Toad, from Kenneth Grahame's classic book *The Wind in the Willows*, was a character in the "Garden for Children" that the British designer Bunny Guinness made for the Chelsea Flower Show of 1994. It looks like topiary but it is in fact an imitation. The colourful sculpture was created with a carpet bedding of small, low-growing plants, trimmed in the manner of topiary, to achieve the required detail.

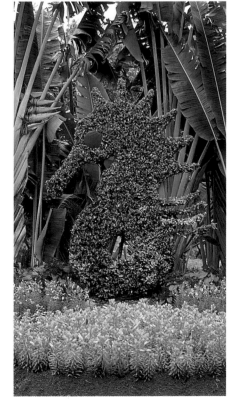

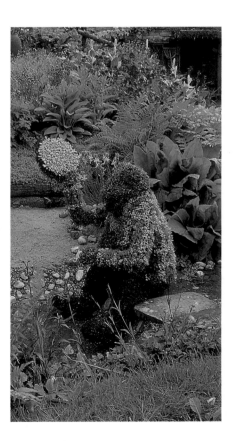

which in turn depicts a landscape. He believes that if "an artist can paint a picture of a landscape … art mimicking nature, then why can't a sculptor create a landscape of a work of art … nature mimicking art?" Most of the people in the work are made from several different varieties of yew, which are grown on steel armatures that are clearly visible. The planting is simply trained and trimmed to fill out and give volume to the linear forms of the frames. The sails of the boat are grown from autumn clematis. Grasses, creeping thyme, and ornamental strawberries are used as ground cover.

The twentieth century saw topiary develop in isolation from the arguments of previous centuries. Its style is now both diverse and international. However, although many professional artists and designers have seen the potential of topiary and extended it as an art form, the most common form of topiary is still that practised by enthusiastic, self-taught amateurs. This is particularly the case in Britain. Although it is perhaps wrong to make value judgments on what are essentially the products of an engrossing hobby, many of the creations are undeniably overblown. These clipped creations of the mythical and the familiar are more concerned with the craft than the art of topiary. Some of the worst examples have appeared at flower shows. The topiary toad created by Bunny Guinness for her "Garden for Children" at the Chelsea Flower Show in 1994 can be

BELOW Complete with wooden window frames and doorway, this imaginative topiary house at Didmarton, in Gloucestershire, must be the ultimate example of "green" architecture. It is a variation on the architectural folly that was an essential feature of many English gardens in the eighteenth century.

33

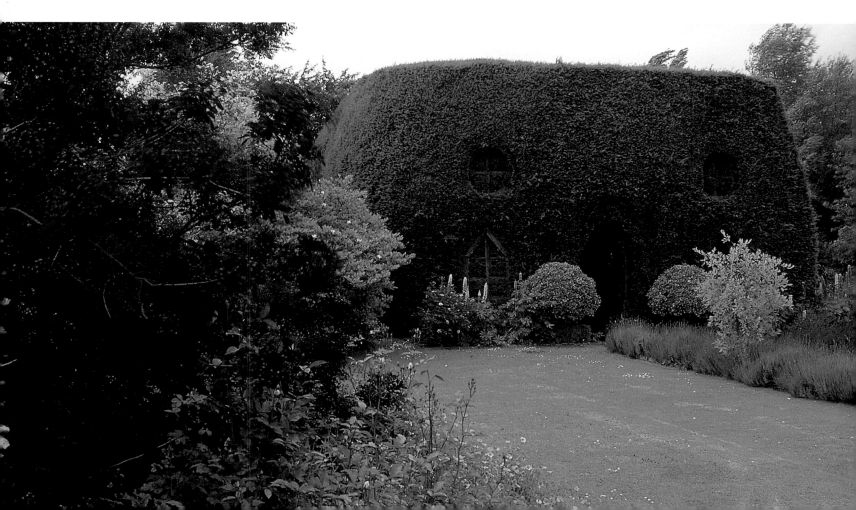

LEFT The simple form of this topiary figure is made
more recognizable by the addition of a red headscarf.
There is something surreal about the sculpture, since
the woman appears to be attending to the pot from
which she is growing. Unusually, the raw material for
this topiary was grown from a tender creeping fig.

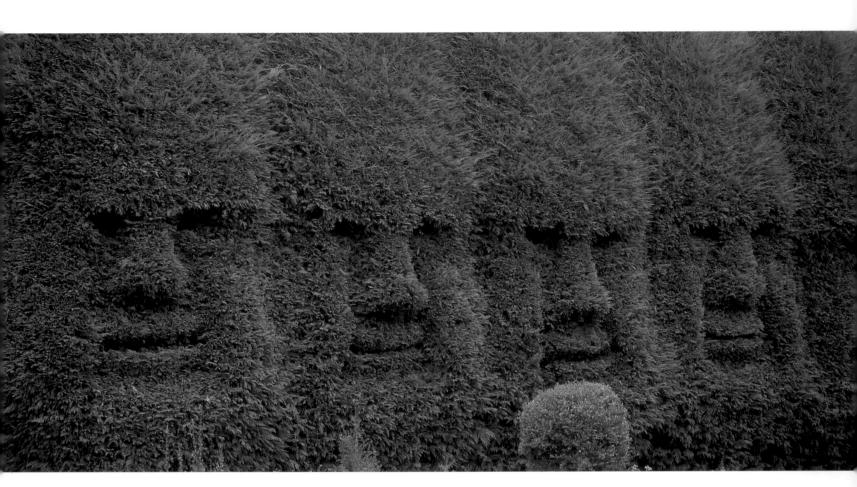

ABOVE A large conifer hedge surrounding a garden in suburban Essex, England, is enlivened by a series of topiary faces. Beautifully sculpted, these are modelled on the ancient heads discovered on Easter Island. Unexpected subject matter such as this is typical of recent British domestic topiary.

RIGHT Quick-growing conifers are not the easiest trees to turn into topiary as the coarse leaf structure makes it difficult to achieve fine detail. Also, depth of clipping is restricted by the fact that the tree will not recover if cut back hard, and so frequent trimming is essential. But none of this has prevented a committed topiary artist from creating this exotic head.

excused because it is not real topiary. The multicoloured effect was created with a carpet bedding of small plants, grown on a cleverly constructed frame and trimmed to shape. The focal point of the garden is Ratty's House, which is set in a bank on a make-believe river, and the imitation-topiary figures of Ratty and Toad complete the scene. There is also, among some topiarists, a tendency to add other ingredients to the living medium. One affectation of these mixed-media creations is to dress figurative topiary with clothing. However, in the case of the topiary woman shown on pages 34–35 attending to her pots, the more restrained addition of a red scarf does make the figure more convincing.

The success of this popular representational type of topiary depends to a great extent on the topiarist's choice of subject matter and sense of humour. The more unusual and seemingly impossible the subject, the greater our delight and surprise when we see it transformed into "vegetable sculpture." This is certainly true of a garden in Essex where the hedge has been fashioned into a homage to the ancient monumental heads of Easter Island. The appropriateness of the subject matter to south-east England is questionable, but the strong, sculptural quality of the topiary deserves recognition.

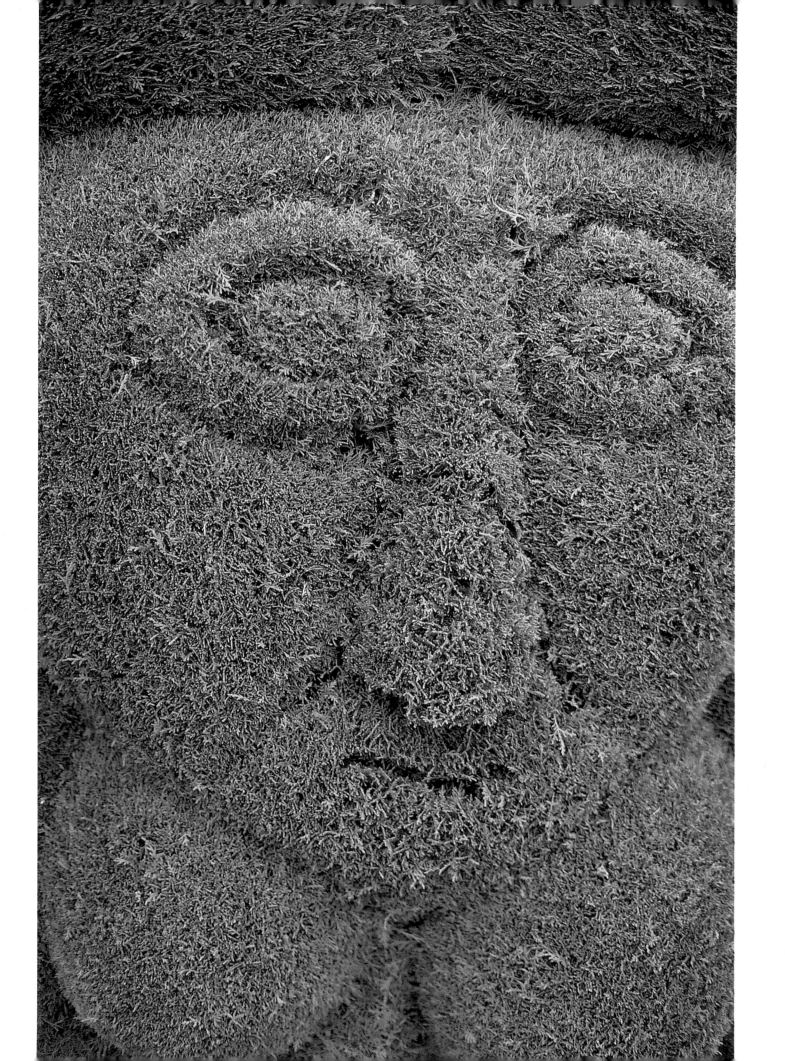

THE WOVEN BRANCH

The art of the woven branch is the making of sculptures or semi-functional features by interlacing the flexible young stems and branches of shrubs and trees. Unlike topiary, it is not concerned with the leaves of the plants, and indeed dead branches are sometimes woven to make supports for living plants. Artists and craftspersons work with living plants, shaping, training, and weaving the stems and branches of growing trees and shrubs into sculpture, furniture, and even architecture. Their principal technique is similar to that used in basket making, but they also employ horticultural and agricultural skills, such as grafting and "laying," or "fletching," a traditional method of hedge construction.

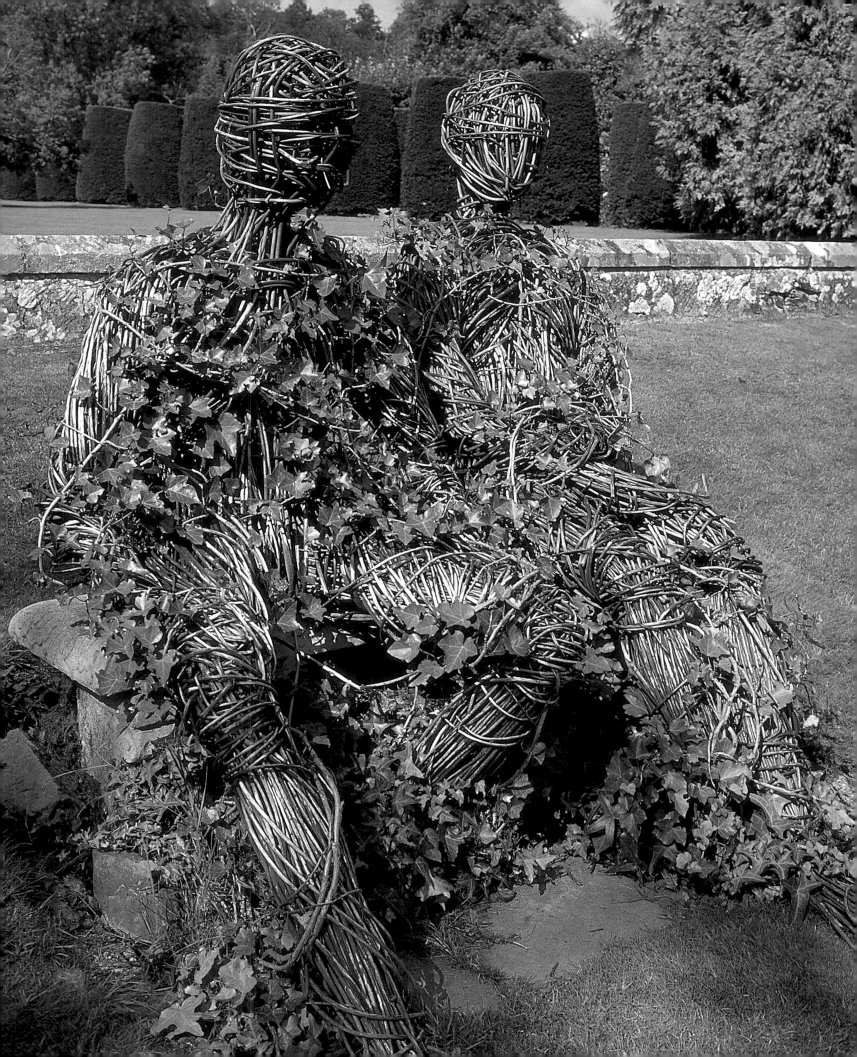

For those who make art by weaving plant material, the essential ingredient is the young growth of trees and shrubs. Some use living saplings and newly planted trees, occasionally starting with just single-stemmed shoots, or "whips." Alternatively, they use the fresh growth from older trees that have been coppiced – that is, cut down and allowed to re-grow as a mass of smaller shoots rather than as a single trunk. Other artists choose to work with material that is harvested after being grown as a crop. In all cases the young trees or new shoots are used collectively, and woven together to make the required form.

PREVIOUS PAGE Ivy is beginning to clothe the two seated people made by Simon Gerhold at Groombridge Place, in Kent, England. The figures were constructed from cut and dried willow, tightly bound and woven to create the desired forms.

OPPOSITE The most striking feature of Lynn Kirkham's sculpture at Chagford of a leaping stag is the antlers, which appear to have sprouted leaves. They are made from a growing willow tree, its trunk concealed within the stag's woven-willow body. The tree also helps to support the sculpture.

40

Many ambitious sculptural forms and architectural structures have been made by exploiting the natural properties of certain trees and shrubs. Particularly important among these qualities is the ability of the slender, new growth, whether used as living or as harvested wood, to be easily bent without breaking. When living plants are used it is important to choose those that are most able to withstand grafting and being bent, cut, folded over, and woven into shapes while still growing, without incurring lasting damage. In Britain the trees and shrubs that artists work with are those that are commonly found growing in, or associated with, hedgerows, since they are amenable to the regular maintenance that hedgerows receive. Most belong to the willow and hazel families.

Hazel (*Corylus avellana*) is a tree that grows successfully at the edge of natural woodland, often alongside ash and field maple. Although it occurs as a free-standing specimen, in Britain it is more usually seen in the hedgerow. Hazel has long been cultivated for harvesting, and has been used in thatching and in wattle work since Neolithic times.

Willow trees are remarkable in that branches or twigs can regenerate from fallen trunks and from the tips of low branches that have become buried in mud. Crack willow (*Salix fragilis*), so called because the trunk grows fast and often splits open under its own weight, can regenerate from the rooting of split and fallen branches. This ability was most famously demonstrated at Middleton Cheney, in Northamptonshire, England, when a farmer who wanted to erect a fence hammered 36 willow stakes into the ground as fence posts. Thirty years later the line of crack willow stakes had grown into new trees to create an unusual landscape feature.

Poles of crack willow, if cut thinly enough, can be woven, and the strips were formerly used in the English Lake District to make rough-and-ready outdoor baskets for cattle food. More elaborate weaving is usually done with the osier willow (*Salix viminalis*). This

shrub occurs naturally in fens, ditches, and other damp places, and it grows at a fast rate, especially when regularly coppiced or cut back. The new growth gives rise to straight shoots, known as withies, which are both tough and flexible.

Osier willow is still grown in osier beds to be harvested for basket making. Nowadays this wood is used by artists and craftspersons, who are expanding the traditional methods of weaving to create new forms. Instead of making baskets, some are now creating sculptures. The medium most often used by the British artists Simon Gerhold and Lynn

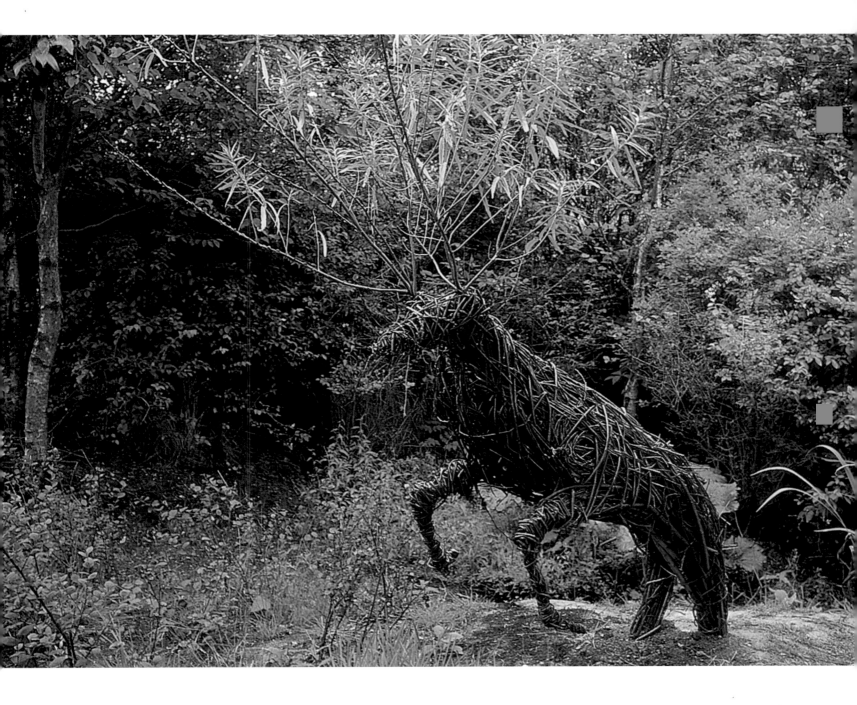

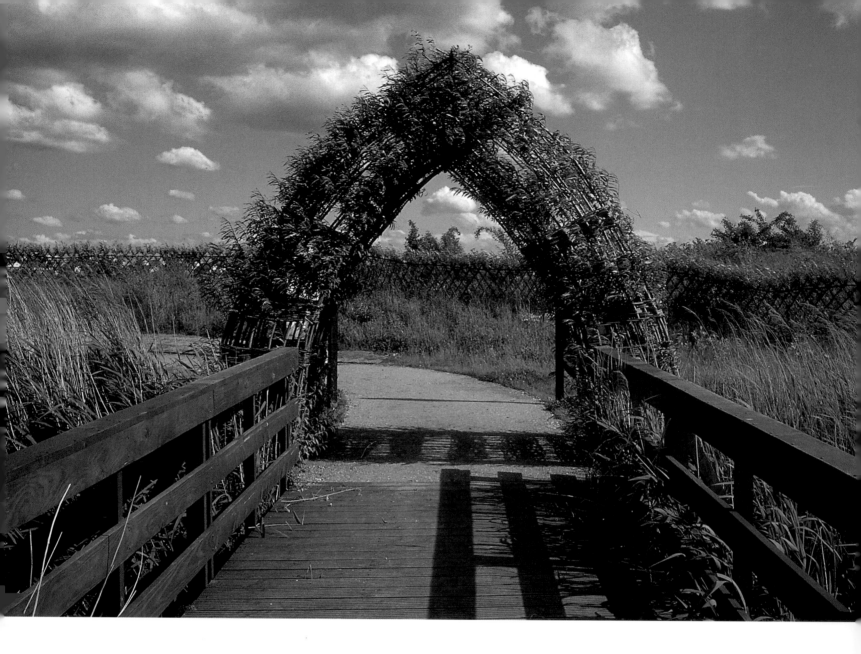

ABOVE The techniques Mick Petts used to build his "Willow Arch" at the Wildfowl and Wetlands Trust Centre in Barnes, south-west London, are normally associated with the making of wickerwork baskets. But whereas basket weavers use only dried willow, Petts wove this material horizontally through vertical lengths of living willow to construct this work.

Kirkham is the cut and dried shoots of young, green willow. Their sculptural way of working with the willow involves not only the elaborate weaving of the branches but also the inclusion of other living plants in the design.

"Willow People," a work made by Simon Gerhold at the country house Groombridge Place, in Kent, uses both living and harvested material. The cut willow branches were woven and bound tightly to form a dense structure in the shape of two seated figures, one male, the other female. Through the mass of twisted branches, the sexes of the cleverly worked figures are distinguishable by subtle differences in size, form, and posture. But the woven willow branches are not simply the main material of the sculpture; they also act as a framework on which an evergreen ivy has been encouraged to grow. While they support the ivy, this climbing and trailing plant provides clothing throughout the seasons for the two figures.

ABOVE A garden seat created by the British designer Ewan McEwan is growing from live willow trees at the Royal Horticultural Society's gardens at Wisley, Surrey. The flexible saplings were bent, woven together, and fixed to a rigid frame. Weaving the young trees can cause them to self-graft, a fusion that strengthens the structure. The willow is pruned at regular intervals to produce the final shape of the seat.

A life-size sculpture of a stag, created by Lynn Kirkham for the annual "Mythic Garden" exhibition at Stone Farm, in Chagford, Devon, was also made of long, dried willow twigs. The flexible twigs were woven and bound together tightly to form the animal's body. But, in contrast with Gerhold's "Willow People," Kirkham's sculpture includes a living tree. The stag's antlers are in leaf and new green shoots are visible. The hind legs emerge from the ground and this provides a clue to the unusual way in which the work was made. Although most of the animal is made of cut willow twigs, the antlers belong to a living willow sapling that is concealed within the woody body. During the sculpture's construction the living tree acted as an internal support for the twigs that gave the stag its shape.

This relatively new idea of incorporating other living material into wickerwork, as stripped and woven willow is called, has been developed further, with the willow being used while still alive. The cut ends of fresh withies are stuck into the ground and woven to form living

ABOVE LEFT The windows of this "living" house are already in place, supported by young red alders that are being trained to form the walls and roof. The trees are just a few of the thousands that the American horticultural artist Richard Reames is growing into sculptures at his outdoor studio in Oregon.

fences or pergolas by some farmers and gardeners. In fact the osier is appearing in all sorts of unusual and novel situations. The living wood has even been used to create sound-absorbing screens alongside motorways. These are made from earth-filled wicker "mattresses" about 3m (10ft) high, into which willows are planted and kept irrigated. Occasionally other plants, such as ivy and honeysuckle, are added to provide a decorative effect throughout the year.

It is not just landscape engineers and gardeners who have discovered the potential of using living willow. Artists also have recognized its possibilities. The sculptor Mick Petts, one of the most prolific and committed artists using living materials in Britain today, is an

expert at weaving with living plants. In 1995 he was commissioned by the Wildfowl and Wetlands Trust to create a "Willow Arch" for its Wetland Centre at Barnes, in London. The pointed, Gothic-style arch he created, 4m (13ft) high and 4.5m (15ft) long, is as much an architectural feature as a work of art. It is situated at the end of a bridge that leads to a "wetland living area," where visitors are shown how wildlife and plants coexist in this damp environment.

Petts made the arch from planted willow saplings, using a method of construction similar to that used in basket making. Horizontal, non-living "sticks" of willow were woven through the vertically growing shoots to hold the arch together, to help shape it, and to

BELOW Richard Reames has found an unorthodox way to build a bridge. He is growing one, using five young poplars that he has trained to develop horizontally by tying them to timber stakes. The tips will continue to grow upward, while the horizontal branches that form the bridge will thicken, making it stronger. In time the stakes to which the young trees are secured will become redundant.

45

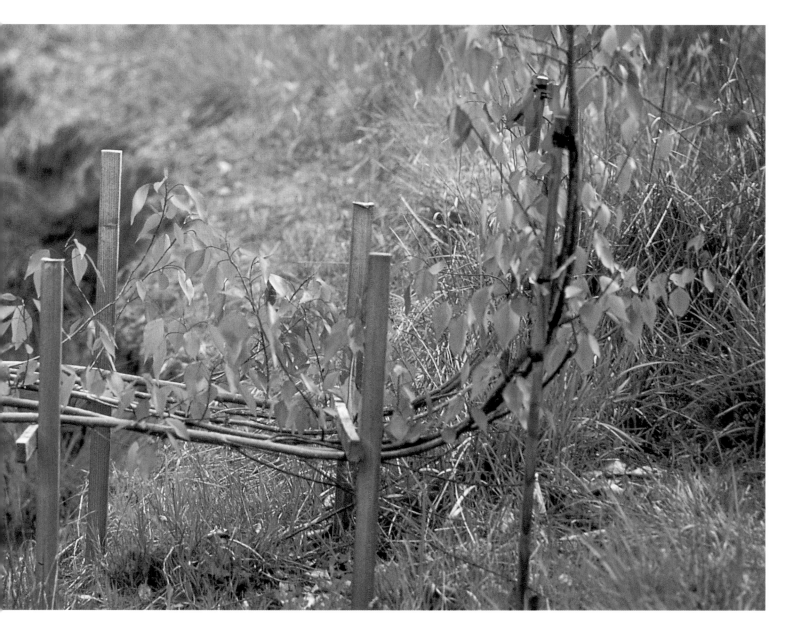

tie it together at the top. Emerging from clumps of *Phragmites communis* – another common wetland plant, often referred to as Norfolk reed – the living willow trees that form the structure are growing in the moist conditions in which they thrive.

The American Richard Reames is another accomplished craftsman who makes most of his work from living plant material. But, unlike Petts, he enjoys the advantage of having his own woodland as a working medium. Around his Arborsmith Studios in the Applegate Valley, near the small town of Williams, in southern Oregon, Reames has more than 4,000 trees. Many of them have been grown together, in the ground or in portable containers, to create extraordinary shapes and structures.

For more than ten years Reames has worked as a self-styled "horticultural artist." He calls his work "arborsculpture," and the result might be described as tree-trunk topiary. Reames works with trees while they are still young, grafting and training them into decorative panels, living furniture, and sometimes houses. Although he sees his work as sculpture, it is usually functional as well as artistic, serving as seats, bridges, and even tools.

Reames's work was originally inspired by his memories of a childhood visit to Axel Erlandson's Scotts Valley Tree Circus, near Santa Cruz, in California. This roadside attraction, created by a Swedish immigrant and former fruit farmer, displayed an astonishing collection of living-tree sculptures. The trees had been grafted and trained into extraordinary shapes, including 9m (30ft) high woven towers and arches on an architectural scale. Others were shaped into living ladders and even spiral staircases. How Erlandson made his tree sculptures is something of a mystery because he always worked in secret, grafting his trees out of sight under a sacking canopy. When he died in 1964, his techniques were still not fully understood.

Remembering his early fascination with Erlandson's creations, Reames was determined to discover his techniques and to use them to create his own living works of art. Following two years of horticultural training, during which he received a grounding in grafting techniques, and after examining early photographs of the remaining Erlandson trees, he set about trying to recreate the tree sculptor's experiments. In one experiment he grafted two red alder branches so that their vascular systems went in opposite directions. In other words, he grafted the two branches together top to top or bottom to bottom, rather than facing in opposite directions, as is customary. He was amazed to discover that the grafts were successful.

OPPOSITE A massive living armchair was created by Markus Gnüchtel for his "Jardin du Petit Prince" at Chaumont, France, in 1996. He made it by weaving willow saplings around a wooden frame, letting the leaves provide the "upholstery."

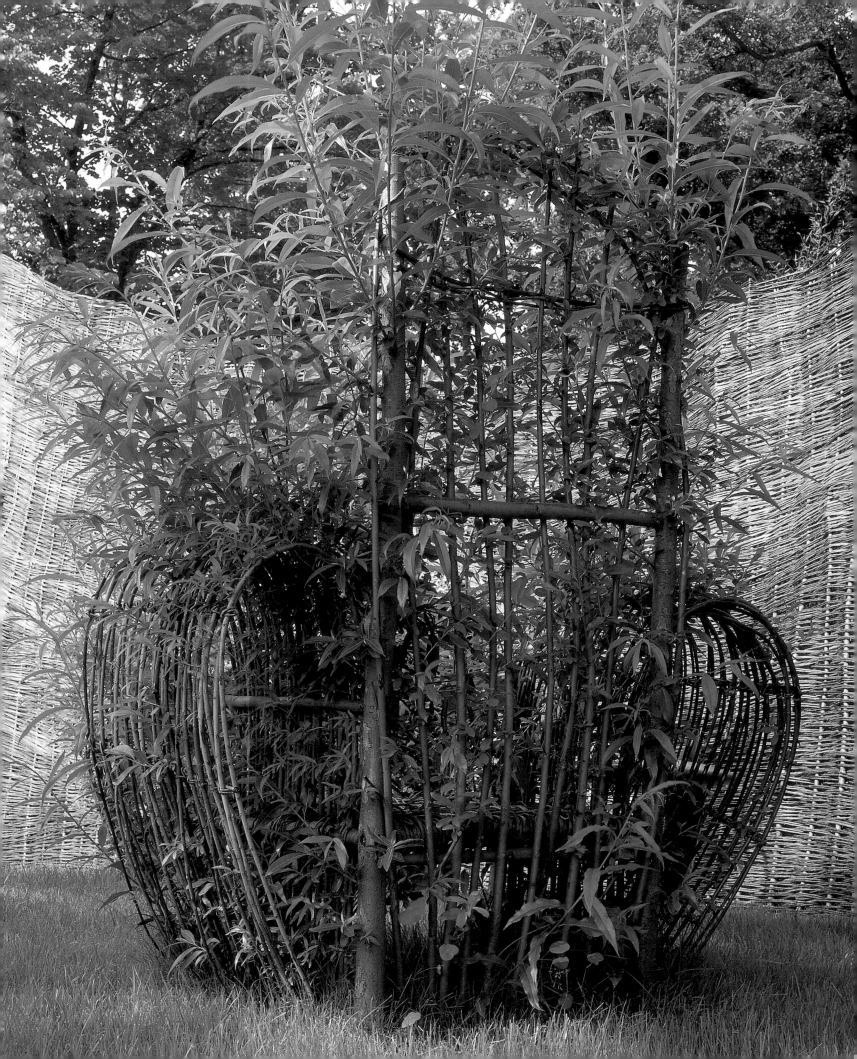

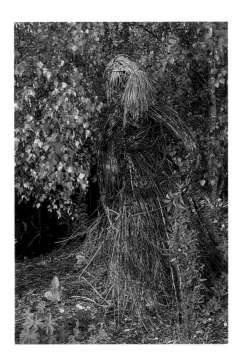

ABOVE This loosely woven sculpture of a woman, by Pam Lewis, was made from lengths of dried willow. The material gives the work a richness of texture not easily achieved in conventional sculpture using a harder medium. Further visual interest is provided by the surrounding undergrowth, which is slowly enveloping the figure.

Today Reames works with various trees, including red alder, poplar, American aspen (*Populus tremuloides*), birch (*Betula papyrifera*), cherry, plum, eucalyptus, black locust, maple, sycamore, and willow, although he finds it easiest to work with flexible woods such as alder and poplar. In late autumn he plants a number of young, field-grown whips. In the following spring he begins the process of bending and weaving the trees into shape, grafting as necessary and tying branches in place. Sometimes the young trees self-graft by rubbing together and joining without any help from Reames. After a season's growth unwanted shoots are pruned and the remainder woven into the main structure.

Arborsmith Studios is full of Reames's growing tree creations. Some are trained and woven together to form tables and chairs. Slowly taking shape at present is a garden bench made from red alder saplings woven together on a wooden framework. Elsewhere the sculptor has bent a number of young poplars to form a bridge that spans a small stream. The slender trunks of the young trees are held horizontally by being tied to crossbars fixed to upright wooden stakes. The non-living supporting structures of both the seats and the bridge gradually become less evident and less necessary as the plants grow and take on the required shape. On a larger scale, Reames has woven saplings together to form lattice screens, and in fact he has developed this idea further by growing "walls" for "living houses." At the outdoor studio two red alder houses are taking shape, the trees arching upwards to a point where they will eventually be intertwined to make a foliage-covered roof. One of the houses already has ready-made windows fixed in position, suspended on the twisted branches.

Because most of Reames's sculptural work is conceived in part as functional, it may be seen as belonging to a popular, essentially craft-based tradition. Many craftspersons are making similar work. For example, at Rougham, in Norfolk, England, a memorial seat has been made out of living willow wands. This sort of work is highly intensive and requires great horticultural skill. These qualities are evident in Reames's creations, where there is immense control of the living medium and considerable attention is paid to the way the growing shoots and branches are woven. Regular pruning and other maintenance are required to nurture the plants so that they grow into, and then retain, the desired shape.

An exhibitor at the Festival International des Jardins at Chaumont-sur-Loire, in France, in 1996 incorporated truly living furniture into his garden. The German designer Markus Gnüchtel's "Le Jardin du Petit Prince" (The Little Prince's Garden) featured two large willow armchairs set within a tall fence of woven willow. The larger-than-life chairs, made

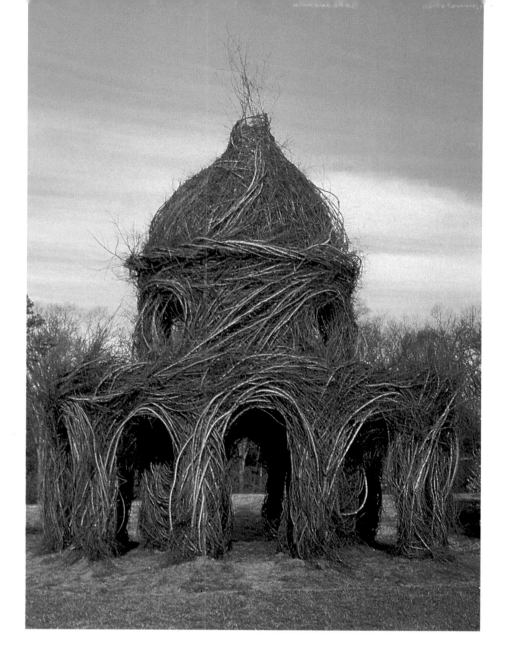

LEFT Patrick Dougherty's temple-like structure "Sittin' Pretty" was constructed entirely from living trees and harvested maple saplings. The American sculptor created the work in 1996 for the South Carolina Botanical Gardens.

from living saplings with their branches sprouting leaves, were less sophisticated than those that Richard Reames has made, but the initial construction was similar. The young willow was bent and fixed to a rigid timber frame and held laterally by being woven onto horizontal wooden slats. No grafting or any subsequent tending was involved. Instead Gnüchtel took advantage of the willow's fast-growing nature, allowing it to grow out from the structure. The new growth, left unpruned, smothered the armchairs with leafy upholstery. In this freer way of working, the leaves are as important as the woven wood in giving each of the chairs its form and texture.

The making of sculpture with non-living, cut and dried willow has been popularized by artists such as the Britons Serena de la Hey and Pam Lewis. Using harvested withies, they have taken the ancient craft of the basket weaver and applied it to the less functional discipline of sculpture to produce life-size willow figures for gardens. Both de

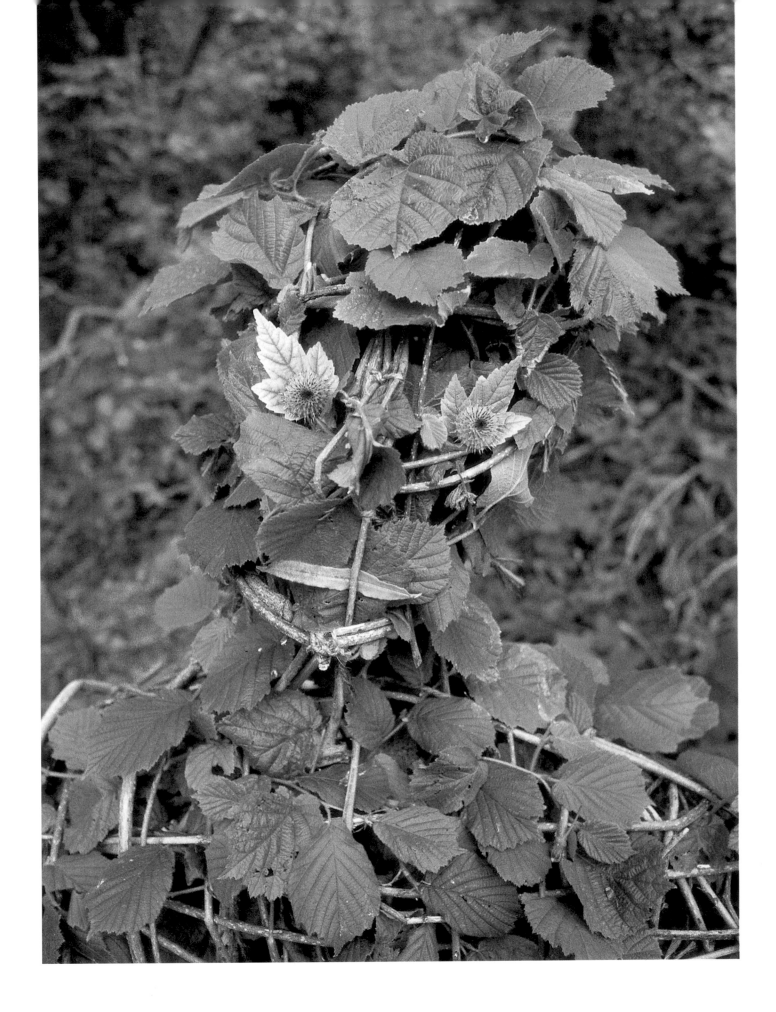

la Hey and Lewis exploit the linear character of the medium to impart a sense of movement and great textural quality to the sinewy figures they create. They do not set out to make living sculpture, but occasionally their works become so by chance, when the surrounding natural vegetation begins to grow up and drape itself over the structures. Most often the culprit is ground-covering ivy.

The American artist Patrick Dougherty also uses harvested wood, but in a less conventional manner. His method of working is altogether different, in technique, scale, and subject matter, from that of de la Hey or Lewis. In their size and formal language his works are more architectural and more dynamic, and in addition Dougherty ignores the traditional techniques of weaving wood in order to achieve his large-scale woven sculptures. Most of his works do not "live" or "grow"; in fact they slowly disintegrate. However, he has intentionally added a living dimension to some of his woven sculptures by building them in growing trees or incorporating these in the work.

Known internationally for his expressive architectural structures built from maple saplings, Dougherty has created more than 120 large-scale works and installations. Among his commissions is a piece for the botanical gardens in Copenhagen, Denmark, called "Natural Selection." Made in 1996, this took the form of a large, nest-like structure and was woven into an existing old tree.

Dougherty's fondness for trees as a sculptural material comes from a childhood spent wandering the forests around Southern Pines, North Carolina. When he turned to sculpture as an adult he was drawn to sticks as a plentiful and renewable resource. He attended art school in the early 1980s and started working in clay, which initially he preferred as a sculpture medium because it was more lively and more like painting and drawing. He wanted to work very large, but the weight of the clay, together with the restrictive size of the kiln used to fire it, posed a problem. Eventually he experimented with the saplings that were growing along the drive at his home and discovered, by trial and error, that he could use them instead of clay as a medium for making works that were both immediate and dynamic. His newly discovered way of working was like drawing in three dimensions, the saplings making lines just as a pencil would. He developed his method of weaving branches by observing the way animals work with twigs, in particular how birds build nests. In working with saplings he realized that they have their own natural method of joining. They easily become entangled, and this tendency inspired his weaving of the material into a variety of large, flowing forms.

51

OPPOSITE A detail of the head of "Green Man," by Mick Petts, reveals a highly intricate woven structure. The fresh foliage indicates that it is living. Made at a woodland site in Norfolk, England, the sculpture was derived from a coppiced hazel tree. The fresh new growth, intertwined with cut material, was twisted and bent to create the shape of the seated figure.

LEFT This dome-shaped canopy, made from a mass
of woven, spiralling, and twisted branches of living
willow, is part of a much larger structure. It is a
section of a larger-than-life water-vole burrow
made by Mick Petts as an educational aid for the
Millennium Coastal Park at Llanelli, in Wales.

In his sculptures Dougherty explores linear energy: the dynamism of supple, young trees and saplings woven, nest-like, into architectural, sculptural, or landscape forms. Many of his works suggest the idea of shelter or habitat, and some have passageways to encourage the viewer to walk inside. All of them are intended to be temporary and, like the sticks from which they are made, they have a natural life cycle. Ultimately, Dougherty says, they "fall prey to the wood chipper and are reduced to compost." He makes about ten site-specific sculptures every year, each usually taking about three weeks to complete. He uses tree saplings, gathered mainly from derelict and abandoned areas near where he is working. This leads him to spend a lot of time around the "green belts" of major cities, looking for areas of trees in the paths of developers. He often finds what he is looking for on ditch banks, beside roads, and under power lines, where mechanized tree cutting has resulted in large quantities of saplings growing evenly and at the same rate.

In some of his commissions Dougherty finds it appropriate to introduce a living, more permanent, component, so he combines his massive woven sculptures with living trees. But whereas in Simon Gerhold's seated figures the non-living woven branches support other living material, in several of Dougherty's sculptures the opposite is true. Here the trunk and branches of a living tree support the non-living, cut material of the sculpture. The shape of the host tree or trees is often altered by the sculptural "parasite," and in later years this change is often the only reminder that the temporary work ever existed.

This was true of "Sittin' Pretty," a work made in 1996 at the South Carolina Botanical Gardens, in Clemson, where Dougherty used both living and harvested maple saplings to create the temple-like structure, 8.5m (28ft) high and 6m (20ft) in diameter. He had been inspired to create the work by a *tempietto*, or little temple, designed by the fifteenth-century Italian architect Bramante. During the construction the living trees were planted and used to help support the matrix of maple sticks. The work survived for several years, and the living limbs were woven into the sculpture as they grew. As the dead wood of the sculpture eventually disintegrated, the living trees emerged, and today the circle they have created is the only reminder of the original work.

One of Dougherty's first sculptures to include living plants was "Brushwork," made in 1985 for the Waterworks Visual Arts Center in Salisbury, North Carolina. The massive structure, 4.5m (15ft) high, 3m (10ft) wide, and 6m (20ft) long, was made with cut and stripped maple saplings that were woven into a living pink-and-white dogwood tree. First the flowers and then the leaves of the growing tree coloured and transformed the work.

54

OPPOSITE The conical form of this willow sculpture, created for an exhibition held at Ness Botanic Gardens, in Cheshire, England, in April 2000, was inspired by the shape of the lily flower. Made in a fashion similar to wickerwork, it incorporates both planted willow saplings and cut young stems. New growth provides the flexibility that the wood must have if it is to be woven.

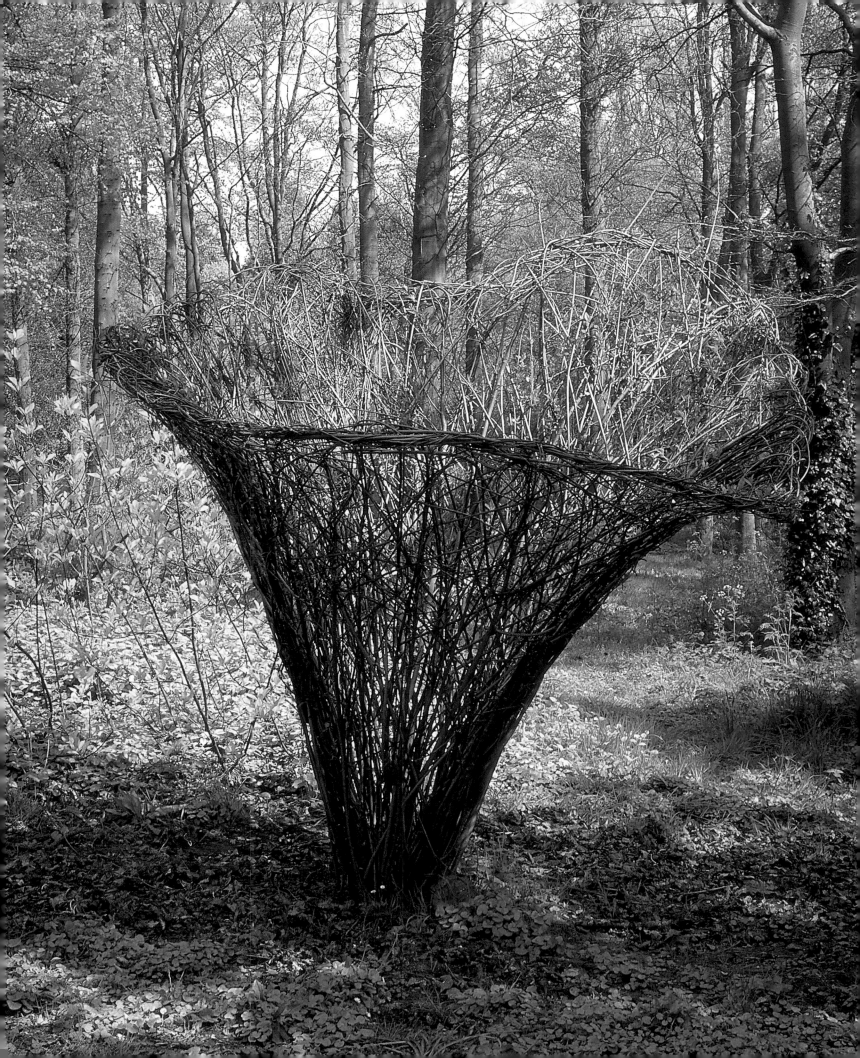

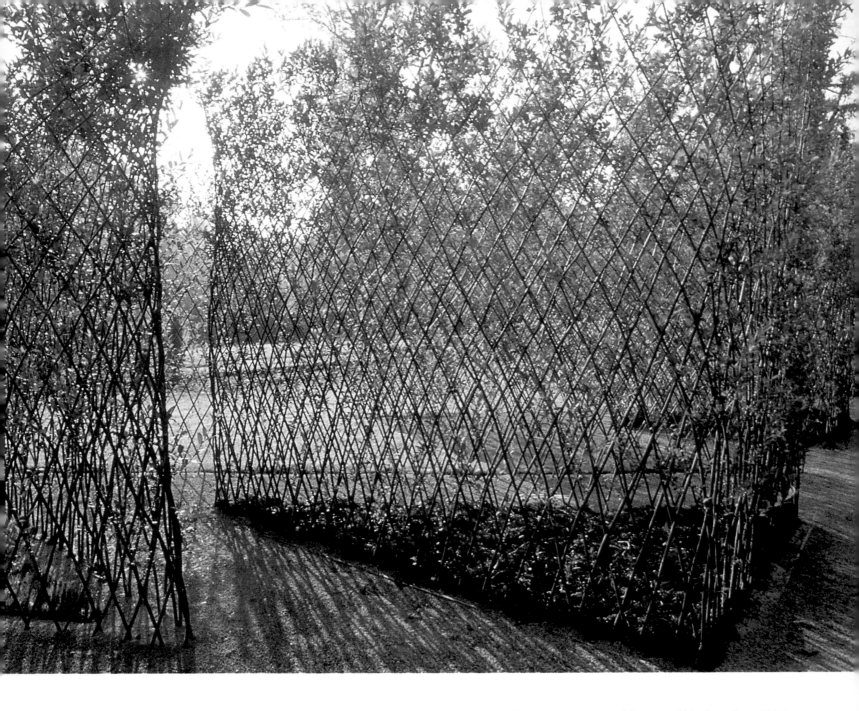

ABOVE Dave and Judy Drew used willow saplings to make these diamond-patterned trellis screens for the garden they showed at the Festival International des Jardins at Chaumont, France, in 1996. The woven trees define and contain a precise, triangular space and are more sculptural than practical.

Dougherty used a living tree in a different way in "Roundabout," which dates from 1997. Made from willow saplings and erected on the lawn in front of the Tallaght Community Arts Centre in Dublin, this work, 13m (42ft) high and 2.5m (8ft) wide, resembled the round towers built in Ireland from the eighth to the tenth century. The structure was woven into the upper branches of a large ash tree, which stabilized it and prevented it from being blown down by the wind.

Another work that relied on the support of growing trees had been created by the artist the previous year at the Tickon Sculpture Park, in Langeland, Denmark. Made from locally grown saplings of various hardwood species, the piece was called "Running in Circles" and festooned a line of poplars along the North Sea coast. One of Dougherty's largest

woven sculptures, and one of the most unusual, the work benefited from a dramatic transformation in the spring when the poplars came into leaf.

Mick Petts, who made the "Willow Arch" described earlier, often uses both living and "dead" wood in his work. He combines these in a very intimate way, with the result that the non-living material is, in many cases, hardly noticeable, for it becomes part of the living fabric of the sculpture. This is particularly so in "Green Man," a representation of a figure from British folklore, made by the artist from a living coppiced hazel bush.

In the wild, hazel will occasionally grow into a small tree with a single trunk, but it is most often seen as a bush forming part of a maintained hedge. It is also "self-coppicing," which means that, if its branches are broken off or their bark is removed by animals, it will send up new shoots from its base. The crop from a hazel has useful properties. The "poles" can be split lengthways, and twisted and bent at sharp angles without breaking. This enables them to be woven, bent back on themselves, and even tied into knots. The traditional product of the hazel is called wattle and was the foundation on which wattle-and-daub walls were built. It is still used today to make fencing and hurdles. Petts used it to make his "Green Man."

This work is situated at Tyrrels Wood, in Norfolk, England, and was commissioned as part of the Trees, Woods and Green Man project organized by the British conservationist group Common Ground. The "Green Man" sits on an oak seat, and visitors can sit beside him. Petts made the seated figure by removing the middle of a thirty-year-old hazel-coppice "stool." When the tree is cut back regularly, right down to its base, a stool, a dense, woody stump, develops, and new growth emerges from this. Petts cut away the older, thicker material, leaving the new, green growth, which he then bent and wove into the shape of a man. Hazel branches are not as flexible as willow, so in some cases he had to cut nicks into the branches so that he could bend them more easily. He then interwove the living shoots with cut, non-living material in order to give the figure a denser structure. The hazel continues to grow and, when spring comes around, its new leaves turn the man green.

Living willows are the material Petts works with most often, and he has used them to create a number of sculptural interpretations of animal habitats, including burrows and nests, for the Wildfowl and Wetlands Trust Centre in the Millennium Coastal Park, near Llanelli, in south Wales. One such work was a larger-than-life reconstruction of a water

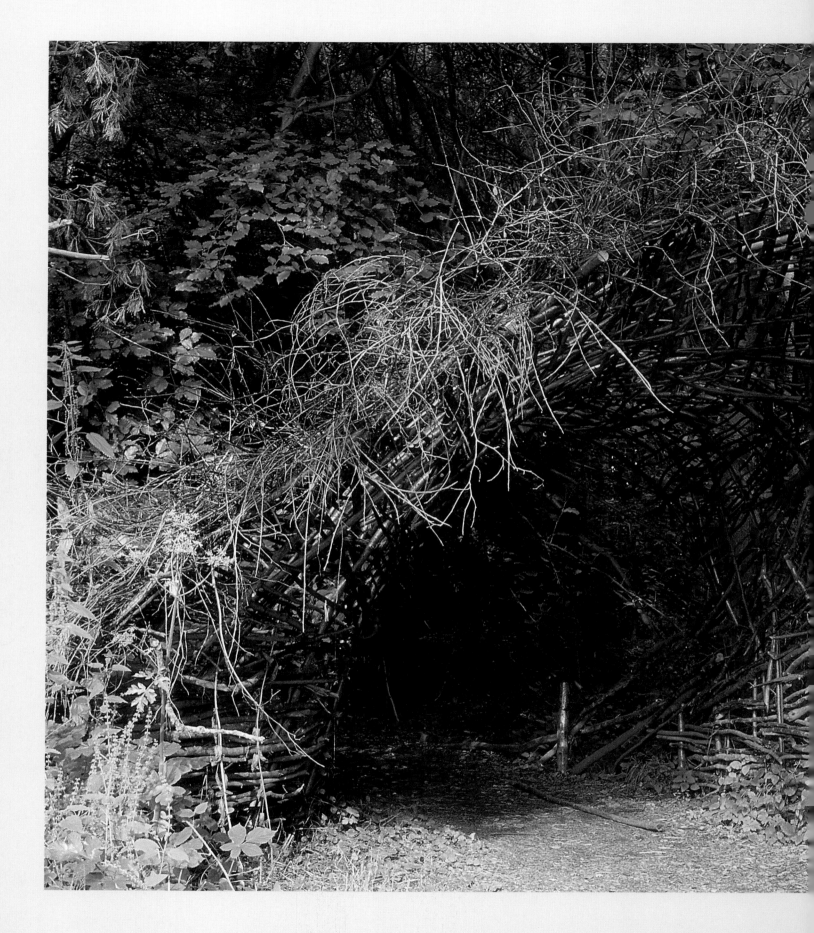

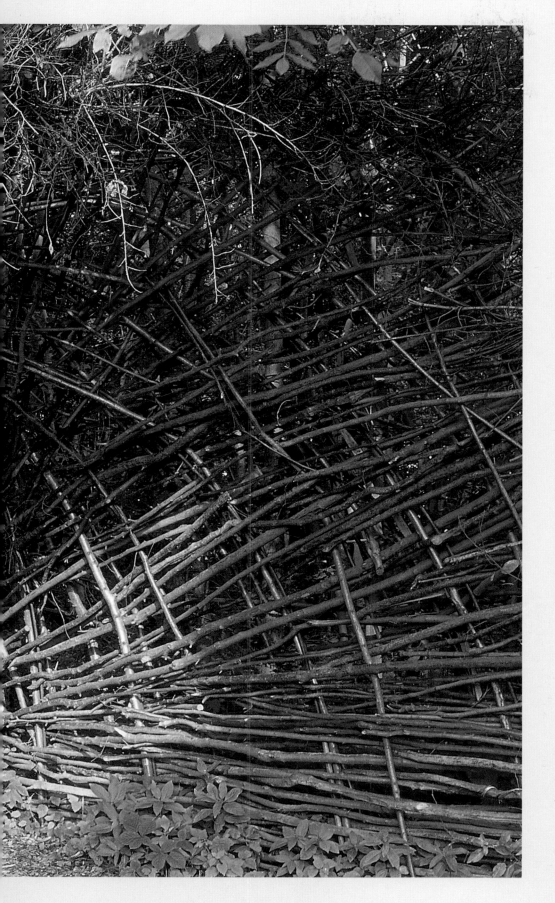

LEFT The garden designer Ivan Hicks used living and cut hazel to create this inviting but mysterious tunnel at Groombridge Place, in Kent, England. He began the work by "laying," or "fletching," the growing hazel. In this traditional hedging technique, a branch is partially cut through, folded over, and then woven into other living branches to form the hedge.

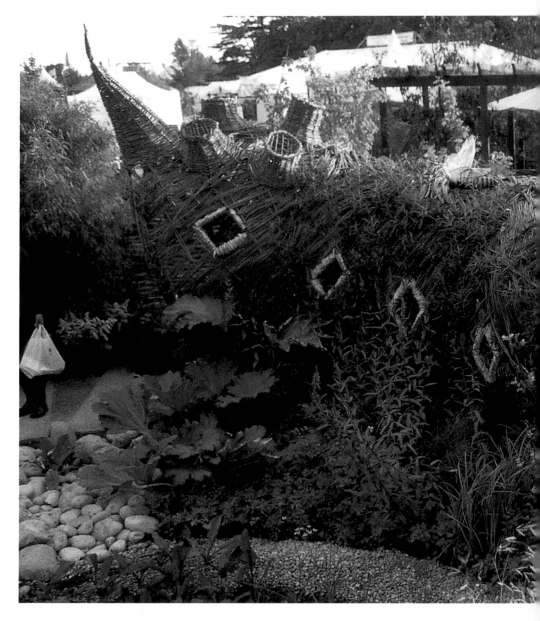

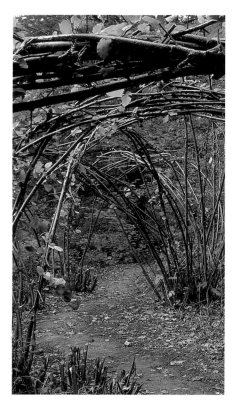

ABOVE Ivan Hicks trained and wove hazel branches together to form a series of arches in a woodland garden. He used the slender new growth that springs up from hazel "stools" to create this piece of living architecture, which, like a wooden or metal arch, can be used to support climbing plants.

vole's burrow. This giant sculpture, into which one can walk, covers an area of 30m (100ft) by 20m (66ft) and consists of a series of interconnecting chambers and tunnels made out of earth and woven live willow. As part of an educational project, it is intended to explain to visitors the water vole's habitat and way of life.

Unsurprisingly, gardens are the most likely place to find examples of art and craft work that is living and growing. It was for a garden at the Festival International des Jardins at Chaumont-sur-Loire in France that the British artists Dave and Judy Drew made their intriguing, diamond-shaped lattice screens. Made from woven living willow, the screens defined and enclosed triangular spaces in the garden, but their function was unclear.

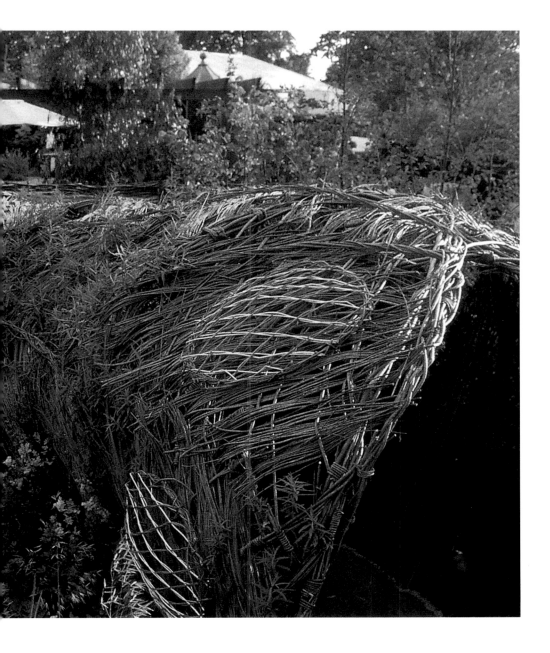

Strongly sculptural, and geometric in form, they seemed to serve no purpose other than to protect and partially conceal the ground-cover planting inside them. The role of the woven walls was essentially visual, and one interesting effect was the way that light shone through the willow lattice to create ever-changing patterns on the surrounding paths.

Less formal in appearance, "Hazel Tunnel," created by the British garden designer Ivan Hicks, has a more obvious purpose. It provides a seductive and mysterious entrance to the dark world of the enchanted forest of the Village of the Groms, a hazel-and-willow world in miniature situated in the gardens of Groombridge Place in Kent. "Hazel Tunnel" was made by methods similar to those used to maintain hedges. As in hedge laying, the

LEFT This fantastic "creature" is a walk-through representation of a chrysalis, made by Mick Petts for the "Action Research Garden" at the Hampton Court Palace Flower Show in Surrey in 1994. The complex, basket-like structure was woven using a mixture of living and harvested willow.

BELOW AND BOTTOM Mick Petts's "Wave Screen" combines functionality and sculptural interest. This birdwatching hide is made of "rods" of living willow, planted diagonally to support bundles of *Phragmites communis*, or Norfolk reed. The larger picture shows the screen with the willow established.

trunks or branches of the trees were partly cut through and inclined, and then woven between upright hazel poles. The hazel regenerates quickly, and the new growth is tied into the structure as necessary. To give additional density to the sides and the roof of the tunnel, horizontal hazel poles have been woven into the living structure. These will eventually decay, but by that time they will no longer be needed, because the growing hazel will have taken over.

A tunnel of a different kind was created for a show garden at England's Hampton Court Palace Flower Show in 1994. Mick Petts, in collaboration with the designers McGreggor-Smith Landscapes, made the 8m (25ft) long, walk-through "Willow Chrysalis" for the "Action Research Garden." Essential to the garden's theme – an exploration of the life cycle of the butterfly – the "living" tunnel connected the caterpillar "garden" to the butterfly "garden." By passing through the chrysalis, children were meant to become aware

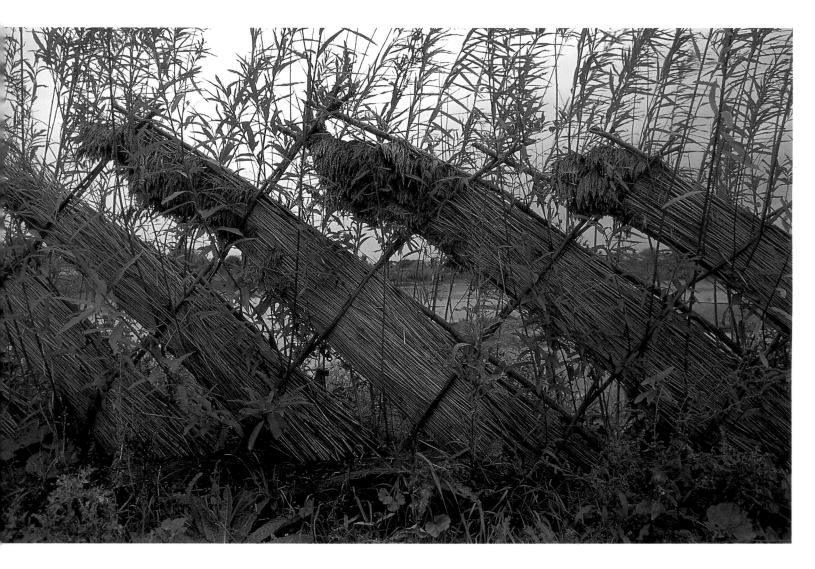

of, and experience, the process of metamorphosis. The tunnel, complete with viewing holes, was made, basket-weave fashion, from both live and harvested branches of several varieties of willow. As the work was intended to be a temporary installation, the willow was grown in boxes before the show, woven together at the site, and dismantled afterwards.

Most of Petts's work is commissioned for environments that are more permanent. He made "Wave Screen," like "Willow Arch," for the Wildfowl and Wetlands Trust Centre at Barnes. His brief was to provide a continuous, undulating hide, 70m (230ft) long, from behind which it would be possible to observe birds without disturbing them. The living screen is composed of two-year-old willow rods that bind together bundles of Norfolk reed. The willow continues to grow and is maintained in such a way that it does not interrupt the birdwatching. The screen grows out of a sculptured earthwork and, despite its great length, integrates perfectly with the surrounding wetland landscape. Petts describes his "Wave Screen" in terms of the "rhythms" that are expressed in both its shape and its life cycle. This sense of rhythm is further emphasized by the shadow play created by light as it passes through the screen, making patterns on the nearby path.

Petts seems particularly at home when working in nature reserves. His use of living materials and his knowledge of the natural environment have brought him many other commissions from the Wildfowl and Wetlands Trust. In addition to his water-vole burrow for the Millennium Coastal Park project at Llanelli in south Wales, he was asked to create a series of enlarged nests to demonstrate to visitors to the site how various birds build their homes. He has constructed two wading birds' nests, each 60cm (2ft) high and made out of large river stones, and six elevated nests of the kind used by reed buntings and warblers. The reed warbler weaves its nest between three or four large, upright reeds, which give it support. Petts's giant sculptural versions of the bird's nest are made from a mixture of grasses and green willow branches. He built them by "weaving" the material on to a close group of two-year-old, 5m (16ft) high, living willows, which represent the reeds. The sculpted nests are intended as a semi-temporary feature and will, like real ones, eventually decompose. Petts's idea is that new nests will be built each year. Meanwhile the existing ones have been adopted by larger birds, including kestrels and short-eared owls.

In the many conservation projects in which Petts has been involved, his woven sculptures of living willow and hazel, many constructed on a large scale, have become a part of the natural landscape. In carrying out this work he takes the art of the woven branch into the domain of land or environmental art.

BELOW These strange-looking structures are Mick Petts's interpretation of reed warblers' nests. He used tightly woven grasses and willow sticks to create the outsized spherical nests for the Millennium Coastal Park, at Llanelli in Wales. Willow trees 5m (16ft) tall are intended to simulate the cluster of reeds that the bird uses to suspend its home.

TURF-WORKS

Left to nature, the soil beneath our feet usually becomes smothered by grass, moss, and wild flowers. This top layer of earth also provides a home for small animals, insects, and micro-organisms. "Turf-works" are the product of making sculpture on or with this part of the land. Some artists have been inspired by ancient earthworks, and in recent years many of them have joined forces with landscape architects in land-restoration projects. Others have been driven by a desire to work outdoors, away from it all. They have made carvings in the earth or used slabs of turf and peat, instead of the conventional materials of sculpture, to create sculptures that are more traditional in appearance. What all turf-works have in common are surfaces that are truly alive.

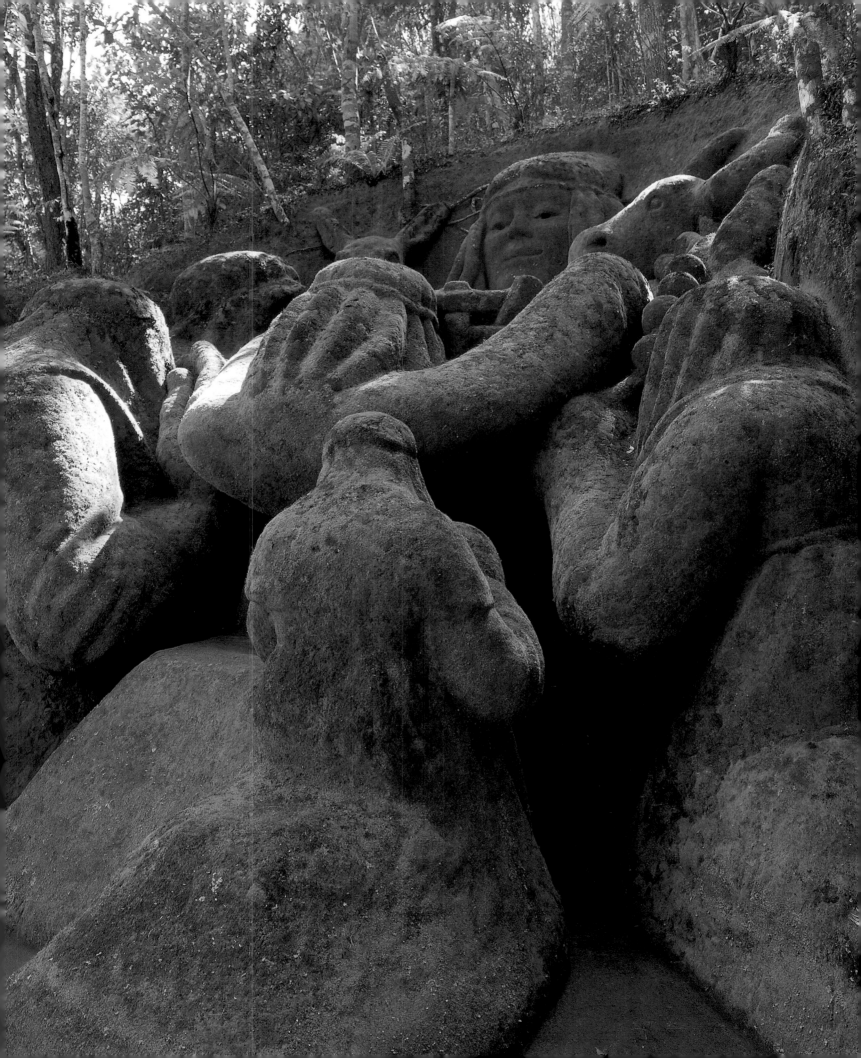

Some artists continue to represent the landscape in painting or photography, but back in the 1960s a number of others chose to leave the comfort of the studio to work more directly with the landscape. They set out to make art, not simply of the landscape, but in it and with it. The first works of this kind, by artists such as the Americans Michael Heizer and Robert Smithson, have come to be referred to as land art or earthworks. Most of the initial ventures were not what could be described as "living." Heizer's "Complex One," begun in 1972, was constructed from concrete, granite, and earth. Its shape, which suggests ancient tombs and pyramids, is more architecture than landscape. Smithson's "Spiral Jetty" of 1970, which projects into the Great Salt Lake in Utah, was simply a bulldozed-level spiral roadway of basalt, limestone rocks, and earth. The direct physical attachment to the landscape makes these works different from traditional sculpture, but it is not just physically that they are linked to the landscape and to their sites. The artists have drawn inspiration from their new work environment – its history, its geography, and even its mythology. It is sculpture with a sense of place and time.

PREVIOUS PAGE Cloaked figures kneel in worship in this unusual interpretation of Christ's birth. Made in Brazil by the group of artists known as Nego Land Art, the complex work was cut out of an earth bank. The simple, heavy, sculptural forms, distinctly South American in style, suit the unconventional medium. Mosses were encouraged to grow, to provide a living surface that helps to maintain the earth forms.

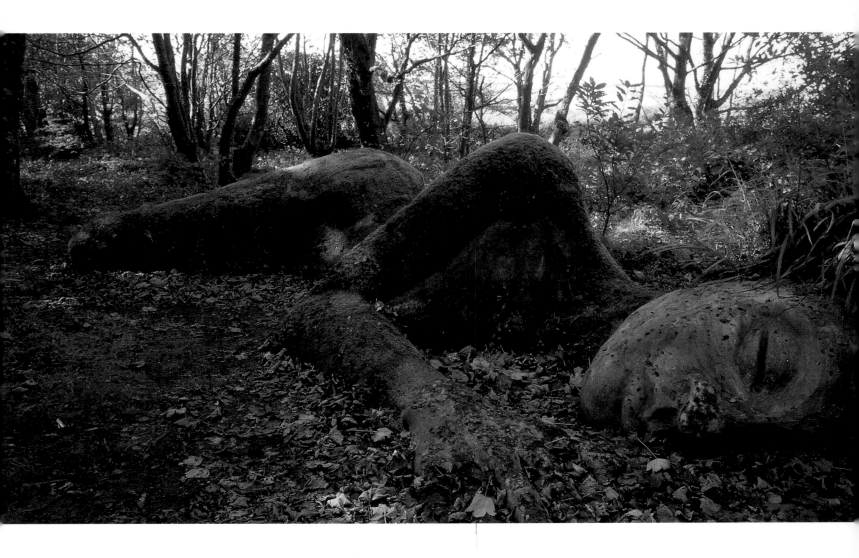

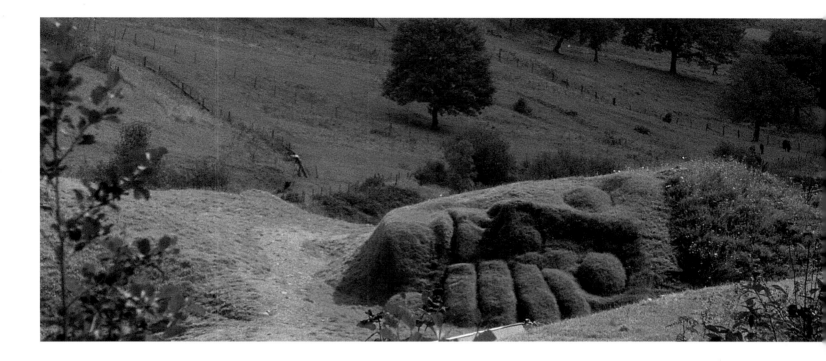

The "Art in the Landscape" movement was stimulated by many factors. One of these was the "flower power" philosophy that emerged during the second half of the 1960s. Its followers, the hippies, desired a return to technological innocence, a less consumerist society, and a closer relationship with the natural world, which they assumed to have been the way of earlier civilizations. A number of contemporary artists were in sympathy with these ideas, and they believed that by reviving an ancient tradition of earthworking as a form of artistic activity and moving to remote locations they could free themselves from the commercial pressures of the modern art world. Their interest in the cultures of prehistory was significant but not new. In many respects these artists were simply continuing a tendency in modern art that had begun in 1907 with Picasso and had drawn fresh ideas from outside the western European art tradition – for example, from African or Oceanic cultures.

The human landscape is littered with the prehistoric remains of man-made earth forms that were constructed as acts of worship or tribute. The simple heaped mound, such as "Seven Barrows" in Wiltshire, England, was understood as a record of a burial throughout the prehistoric world. Around AD 100 the Celts cut a huge white horse into the chalk of the nearby Berkshire Downs. It is only clearly visible from above and was almost certainly made in honour of their gods. Today's earthworking artists may have a more sophisticated understanding of the world than their predecessors, but their purpose is in many ways similar: to create an evocative, meaningful place.

OPPOSITE The small female figure of "Mud Maid," by the British artists Sue and Pete Hill, was formed from clay on which moss was planted. Having become part of the woodland floor, it is almost camouflaged. This anonymity and informality are characteristic of a new generation of artists who have forsaken the studio and the gallery for the freedom of the great outdoors.

ABOVE Mick Petts made his "Mother Earth" on derelict land in Ebbw Vale, Wales, as part of a regeneration scheme for what was once a thriving mining area. Only the head and upper torso of the colossal reclining figure are in view. The detail of the face and hand is to be admired, since to create a work on this scale the artist had to use industrial earth-moving equipment.

The British artist Mick Petts chose the form of Mother Earth when he was commissioned to create a site-specific sculptural work for the Garden Festival of Wales in 1992. Mother Earth is a pre-Christian, pagan symbol representing everything that creates, nurtures, and protects, and so it seemed a particularly apt theme for the project. The derelict site at Ebbw Vale was at the heart of the mining industry that had ravaged the valleys of south Wales since the Industrial Revolution of the nineteenth century. When mining went into decline the festival was seen as an opportunity both to restore the local landscape and to revitalize the area in terms of tourism and employment. Petts's "Mother Earth" emerges from the ground as a symbol for this regeneration.

The massive reclining figure is over 170m (558ft) long and over 8m (26ft) high. Its basic form was established by mounding into shape a mixture of coal shale, slag, "flu-dust" from the local steelworks, and rubble from nearby demolition sites. This was covered with a layer of subsoil and then a dressing of topsoil, and finally "hydro-seeded," a process in which grass seed in a liquid solution is sprayed onto the surface. Because the grass that covered the head of the figure was allowed to grow long, to represent hair, other wild flowers flourished also. Common yarrow, which tolerates dry conditions and is a common lawn weed, colonized the ridges of the sculpture.

68

RIGHT An aerial photograph allows a privileged view of Mick Petts's "Pit Pony Landform." The pony appears to leap across one side of the car park of the newly created Parc Penallta, on the site of an old coal mine at Ystrad Mynach, in south Wales. The "Pit Pony" has a symbolic role. Freed from the mine in which these creatures used to spend their entire working lives, it jumps for joy, with a vigour that represents the new lease of life given to a landscape once dominated by heaps of mining waste.

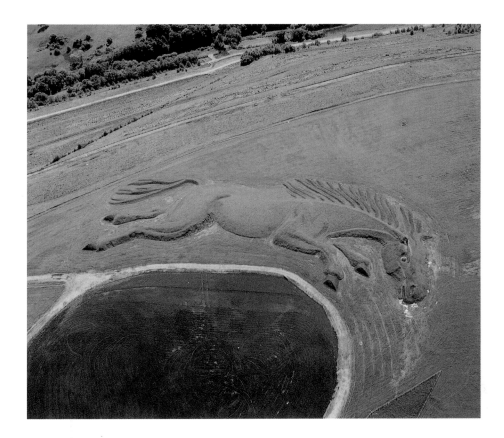

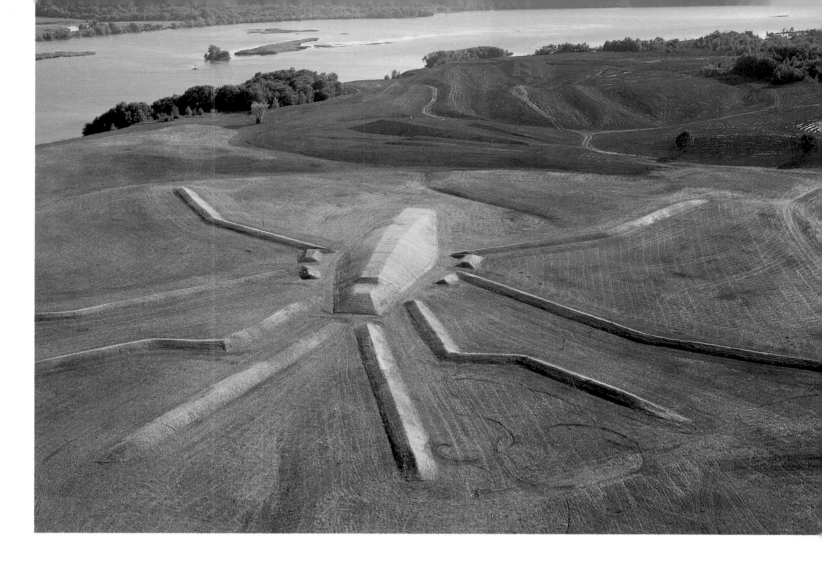

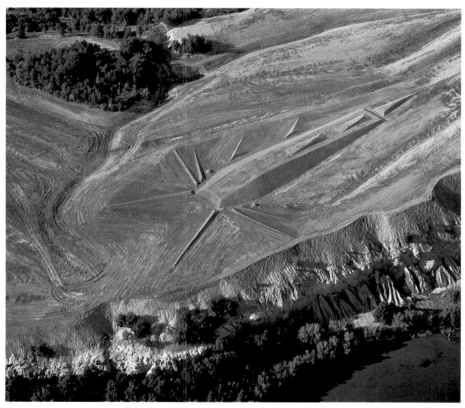

ABOVE Michael Heizer's massive "Water Strider" is one of several "Effigy Tumuli Sculptures" that he created as part of a land-reclamation project at an open-cast mine in Illinois that was polluted by waste and hazardous to all forms of life. Before long the imported fertile earth will be covered with indigenous grasses and plants, which will in turn encourage animals to recolonize the site.

LEFT "Catfish," 235m (770ft) in length, is the largest of Michael Heizer's "Effigy Tumuli Sculptures." The use of animal motifs is apt for a project that includes among its aims the re-establishment of wildlife. The imagery also pays homage to earthworks of earlier cultures, such as the serpent-shaped mound at Chillicothe, Ohio, that dates back to 1000 BC and is attributed to the Hopewell Indians.

ABOVE Concealed within a rocky outcrop is the sculpture of a female figure. The softness of the rounded forms contrasts with the angularity of the rocks. The work, created in Brazil by Nego Land Art, was sculpted from earth and covered with moss.

OPPOSITE Nego Land Art's snake was sculpted out of a bank of earth. The shady, damp location is essential to the work's survival. Exposed to hot, dry conditions, the stabilizing and protective layer of moss would die and the earth-made forms would disintegrate.

The shape and contours of the grass-covered earthwork allowed the creation of paths giving access onto the "body" of the sculpture. Although Petts regarded these as an important element, they were not clearly identified as paths or reinforced in any way. Instead the artist allowed them to develop naturally in order not to distract attention from the sensuous forms of the figure.

"Mother Earth" is a sculpture that has relevance for the community to which it belongs. Similarly pertinent is another work created by Petts in Wales. "Pit Pony Landform," at Parc Penallta, in Ystrad Mynach, near Caerphilly, was completed in August 1999 and is part of a land-reclamation scheme at the site of a disused coal mine. It was made from coal shale covered with a layer of subsoil and topsoil that was then seeded with grass and wild

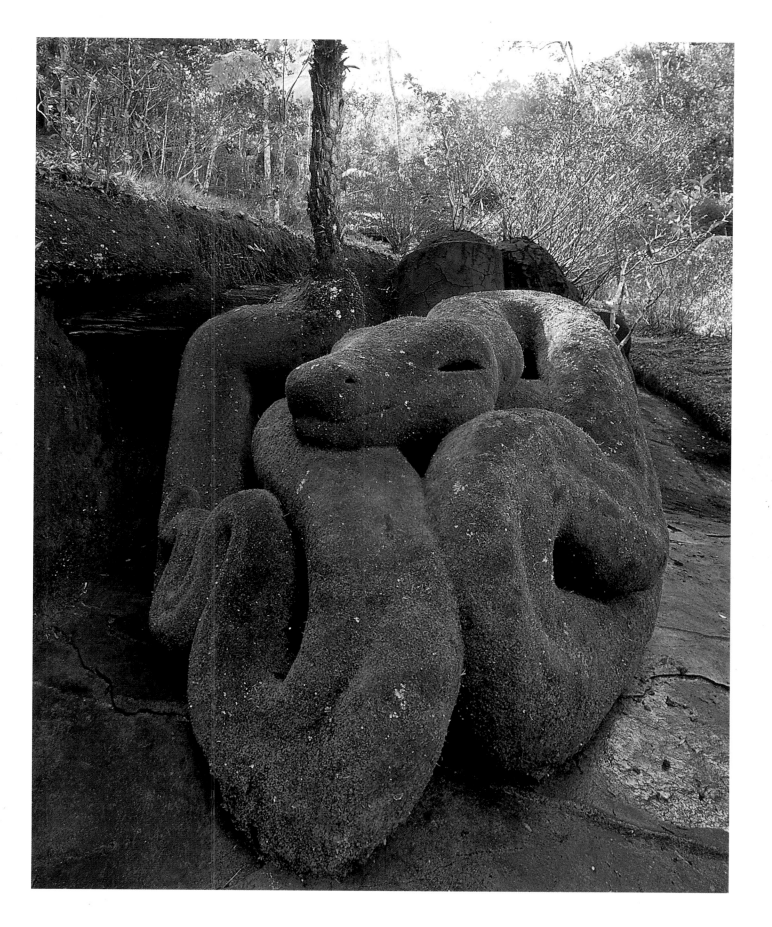

flowers. The "Pit Pony" is mainly a contoured, grass-covered earth form, but there is also considerable attention to detail. The hooves, mane, and tail, for example, were simply left as compacted coal waste with nothing planted on it. The choice of subject matter is evocative, for it highlights the harsh reality of the mining industry, in which a pit pony would spend all its working life in a coal mine. Only when it had grown old and frail would it be allowed to the surface to live out the rest of its days in green fields. Perhaps symbolically, the "Pit Pony," like the White Horse in Berkshire, is only fully visible from the air.

What started in the 1960s with isolated works of art in remote parts of the United States, seen by most of us only in photographs, has now expanded into a wider phenomenon. Sometimes referred to as "environmental art," earthworks created by artists are now seen as a way of enhancing the environment. In the United States artists, helped by public funds, have been encouraged to become involved in land-reclamation schemes or in the creation of parks and recreation areas. Concerned about environmental and

BELOW Visitors to Ritsuko Taho's "Postutopia" provide a sense of scale as they peer into one of the pyramidal pits that form part of this landscape scheme created for a commercial development in Japan. The pit is a negative mirror image of the upright grass pyramid beside it, and Taho says that the positive and negative forms represent a simultaneous digging and mounding of the earth. The rigid geometry of the pyramids is offset by allowing grass to grow unevenly on their surfaces.

ecological issues, many of them have been happy to see art serve a social rather than an elitist function and for it to make a contribution to the restoration of the public landscape.

In fact, as early as 1955 the Austrian-born American painter, graphic designer, and architect Herbert Bayer had created one of the first modern earthworks. His sculptured "Earth and Grass Mound," created at the Aspen Meadows Hotel, in Colorado, consisted of a 12m (40ft)-diameter earth bank inside which were formed a circular mound and a circular hole. In 1982, towards the end of his long career, Bayer was involved in an urban "restoration" landscape project, in the state of Washington. At Mill Creek Canyon, in Kent, a suburb of Seattle, he designed a park containing a group of turf-covered earth rings and mounds, once again circular in form, as part of a storm-water retention system for a badly eroded canyon above the city. The stream meanders through the site and the mounded rings act as dams or water-collecting areas.

The creation of artworks by mounding and shaping subsoil, then dressing it with topsoil and turf or grass seed, is an imaginative although not unconventional application of the techniques of modern landscape architecture. These earthworks fulfil various functions. Usually they provide shelter or hide an unsightly development, and often they are a product of land-reclamation schemes. The "Effigy Tumuli Sculptures" made by Michael Heizer between 1983 and 1985 are an addition to a land-reclamation project. Modern landscape-engineering methods were used to create sculptural earthworks on the site of an abandoned open-cast coal mine in north-eastern Illinois. The 80-hectare (200-acre) site was stripped in the 1930s to extract a narrow seam of coal, but because the mine's toxic overburden was then ignored for forty years, acidified rainwater drained from the site, polluting the nearby Illinois River and a lake.

The area was re-contoured, the acid water treated, and the soil neutralized with limestone before the arrival of the huge earth-moving machines that were the sculptor's tools. Heizer chose to represent the water strider, the frog, the catfish, the turtle, and the snake because he felt that these would be some of the first creatures to recolonize the site. They will become living sculptures as life is regenerated and restored to the worn-out, derelict, and lifeless land.

Three of Heizer's sculptural effigies are situated on the broad, open plateau that is the main feature of the site. One first comes across the "Water Strider," whose body rises 4.25m (14ft) and whose legs measure 209m (685ft). Next to it is the more compact

BELOW "Postutopia" fuses land art and landscape architecture. With its field of grass pyramids, paths, and surrounding lawns, Ritsuko Taho's work functions as both a contemplative piece of land art and a plaza in which to stroll and relax.

"Frog," 5.25m (17 1/2ft) high and 104m (340ft) long. Here also is the mammoth "Catfish," which is an impressive 5.5m (18ft) high and 235m (770ft) long. The mounds are not lifelike imitations of the creatures but abstract geometric representations. Heizer makes no attempt to disguise the fact that they are man-made earth forms. Through the artist's choice of imagery the group of works also makes a reference to the past. The title suggests a link with the tumuli built by prehistoric American Indians. A tumulus is an artificial hill, often constructed over a grave site, and many examples in the upper Midwest were made to resemble animals.

Land art does not have to be on a large scale, nor does it need to have a social or an environmental function. The "earth sculptures" made in Brazil by the group of artists who call themselves Nego Land Art belong to and are inseparable from the hillside in which they are "carved," but their relationship to the onlooker is one of intimacy. Because some of these works are ingeniously hidden, they have to be sought out, and there is real pleasure in locating them. In shape and size they suggest the art of the monumental sculptor or stonemason, but the complex forms of many of them, including a coiled serpent, would present a challenge to a sculptor even if he or she were working in a conventional material such as stone. They were cut directly out of a bank of earth, and the clay exposed by their creation was covered and secured by a layer of moss.

One of the most complicated is a representation of a Nativity scene. Formed from the earth, it depicts a group of worshippers, kneeling and paying homage to the newborn

OPPOSITE A detail of a labyrinth designed by Alex Champion for a private garden in Philo, California. Made in the style of ancient labyrinths, such as those of the Celts in Britain, it consists of a single coiled furrow, which, in this case, was created by cutting into the existing natural vegetation of grasses and sedges.

LEFT This "living island" was designed by Conrad Hamerman for the landscape architect William H. Frederick Jr's garden in the north-east of the United States. The earth sculpture's simple, precise, conical shape is perfectly reflected in the still surface of the sheltered pond. Alive with moss, liverwort, and insects, the island emerges from the water as both an integral part and a microcosm of the whole garden.

75

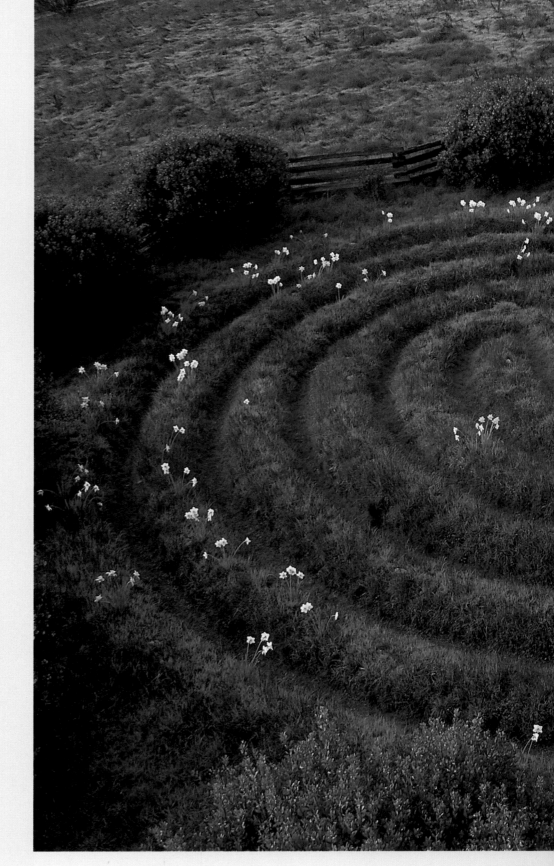

RIGHT To follow Alex Champion's labyrinth at Philo from its start to the centre and back is a long walk, and this provides plenty of time for contemplation and to admire the spring flowers that decorate the ridges. Labyrinths and complex mazes are among the most commonly used motifs in modern earthworks. This is a true labyrinth since, unlike a maze, it does not involve solving a puzzle.

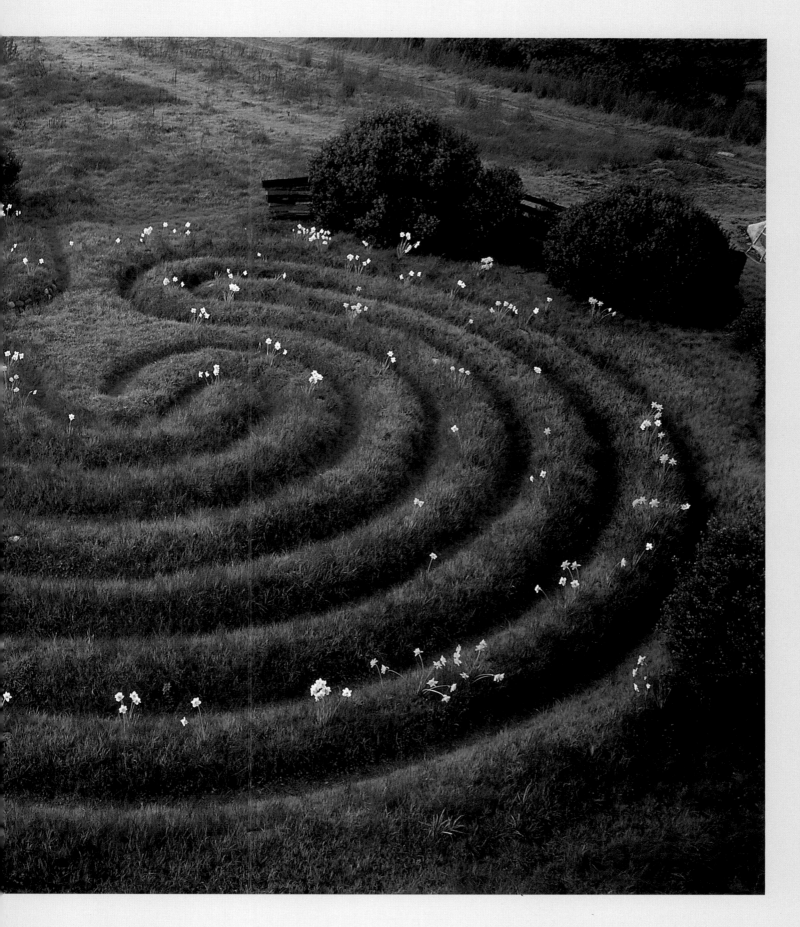

ABOVE David Nash's "Sod Swap" was exhibited at the Serpentine Gallery in London in 1983. For the first stage of the work, Nash dug up a ring of manicured turf from the lawn of Kensington Gardens, outside the gallery, and transplanted it to the wilder context of woodland at Cae'n-y-coed in rural north Wales.

Jesus. In the background the Virgin Mary looks on, flanked on either side by a donkey. Given the limitations of the medium, the attention to detail is extraordinary. It is particularly evident in the depiction of the folds in the fabric of the cloaks and headdresses of the Three Kings. Mary's face, as it looks down on the gathering, is full of expression, a testament to the sculptural skill of the artists.

In the same way that plants require certain conditions in order to survive, so each of Nego Land Art's earth sculptures is dependent on a damp and shady location for its continued existence. Unlike inanimate sculpture, this type of sculpture needs the right conditions to keep it alive and to stimulate continued growth. The landscape architect William H. Frederick Jr engineered a specific set of conditions within his own "Stream Valley Garden" in order to enable his fellow American Conrad Hamerman, a former student of the Brazilian landscape architect Roberto Burle Marx, to sculpt a small "living island."

By diverting and damming a small brook, Frederick had been able to establish a large pond in his valley garden. Overshadowed by the mature ash trees that surrounded it, the moist shore of the pond was the perfect place for a moss lawn. The rich green mat contrasts dramatically with the dark, mirror-like surface of the water that it encircles. Weed growth was discouraged to leave the water free and clear. It is from this idyllic and perfect setting that Hamerman's earth sculpture emerges as an island, its conical shape reflected in the still water. The tiny island is a mound of smoothly battered clay, which,

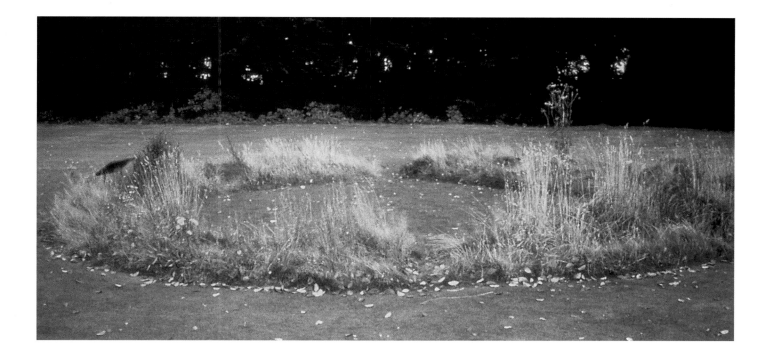

because it is always damp, has become a home for a mixture of greenish-brown moss, liverworts, and insects. Frederick regards the moss island as a "distillation of the essence of the stream valley, in the same way that many traditional Japanese gardens are a distillation of Japanese scenery."

The modest island was designed not by an artist but by a landscape architect as an integral feature of a landscaped garden, and represents a blurring of boundaries between "artscape" and landscape. This meeting of the two disciplines of art and landscape design is evident in Ritsuko Taho's "Postutopia," made in 1994 for the Penta-Ocean Institute of Technology, near Tokyo, in her native Japan. Unlike the many environmental art projects that are linked to public land renovation, this work is part of a newly built private and commercial development. Furthermore, Taho has created not an isolated earthwork but a place designed to function as both plaza and garden.

The design of "Postutopia" consists of a series of closely clipped grassy pyramids that are intersected by a grid of off-white pathways, bordered by a large lawn. The traditional Japanese garden is designed either for static introspection or as a walk that links a series of vistas. Taho has combined these two aspects, and therefore this plaza or garden can be both contemplated – its overall structure is easily understood – and used as a place in which to stroll. The design also draws on the European tradition of the formal garden. Taho's "field" of pyramids, laid out in a tight, geometric pattern, is reminiscent of the

ABOVE After the completion of Nash's living sculpture, the circle of Welsh turf is flourishing and brings a splash of colour to the neat lawn that surrounds it in Kensington Gardens. "Sod Swap" is essentially a piece of conceptual art, since it did not involve the making of an object and the work lacks a finite form.

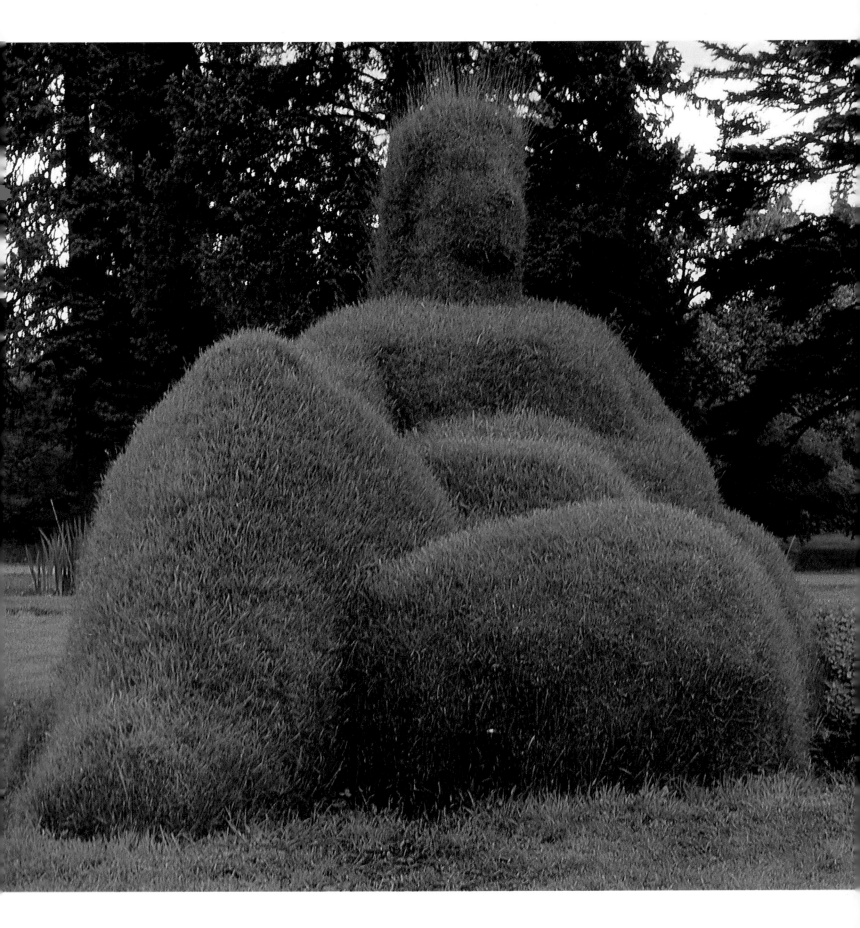

topiary and parterres that were a feature of French formal gardens from the seventeenth century onwards. Each pyramid has its mirror image in the form of a pyramid-shaped pit that is a negative version of it. The pits provide pleasant places to sit in the shade, as the inclines are gentle and they are easy to get into and out of. This combination of positive and negative forms enhances the effects of light and shade, each pyramid or pit catching the sun differently and so creating constantly changing patterns. At certain times of the day the pyramids become fountains, with misty showers erupting from their peaks that help to keep the grassy slopes watered.

The precise, geometric shape of a pyramid seems an appropriate choice of design motif for a project at a scientific research establishment, as it suggests stability and mathematical order. However, Taho's pyramids imply much more. They are alive and the grass on their surfaces grows irregularly, some sides growing better than others, depending on the season and the position of the sun. Taho understands that order and regularity are not a true reflection of the natural world.

The plan of "Postutopia", with its choice of many routes through the work, is like a labyrinth, a device that occurs in much modern land art. Prehistoric Britain is full of "henges" – circles of upright stones or pieces of wood, of which Stonehenge is the most familiar example – but today it is the labyrinth that is the most utilized of the ancient historic features. It is popular because it can be created easily in turf. A Celtic "maze" is really a labyrinth and was walked as a form of contemplation or to symbolize a journey or pilgrimage. Normally this form of maze is laid out flat on the ground and can be easily entered and exited, unlike the classical maze, which was designed as an intellectual challenge. Traditionally the Celtic labyrinth takes the form of a spiral and has no straight lines. The American artist Alex Champion borrowed this circular arrangement to create a low, mounded labyrinth in a private garden in Philo, California. It would be impossible to get lost here, but the enjoyment is in following the single furrow, which coils inwards and outwards until it eventually reaches the centre. At the right time of year the long walk is enhanced by the flowers of spring bulbs that have been planted on the ridges.

The contemporary desire to include a turf labyrinth or maze, with its ancient associations, as a feature in a garden is regarded by the art historian John Beardsley as a re-emergence of the eighteenth-century idea of making landscapes after the manner of painting a picture. The predominantly English Picturesque approach to landscape design was inspired by the landscape paintings of Salvator Rosa and Claude Lorrain. Classical

81

OPPOSITE Lena Lervik's reclining "Terra Mater" (Mother Earth) was made, appropriately, from mounded earth and grass. She was created for the "Grasskulpture I Tradgarten" exhibition held in Stockholm in 1998. The heavy, curvilinear form was perhaps determined by the limitations of the medium, but the effect is to suggest a rolling, undulating landscape similar to the shapes created by the British sculptor Henry Moore in his early figure carvings.

antiquity was depicted in these painted landscapes and inspired the creation of mock-historical ruins and temples in English gardens such as those at Stowe, in Buckinghamshire, and Stourhead, in Wiltshire.

There is certainly an element of the idea of the Picturesque in the landscape that James Pierce created at Pratt Farm, on the Kennebec River, in Maine. His landscaped park contains many features that have rich historical associations. Begun in 1970, it includes two forts, a burial mound, a turf maze, and two earthworks. The "Triangular Redoubt" and "Circular Redoubt" are made of mounded turf and are similar to the fortifications used by British and French colonial troops in North America during the eighteenth century. The "Burial Mound" is based on Native-American prototypes and is intended to be used eventually by the artist. The triangular "Turf Maze" is formed from earth, like its medieval predecessors. It is dug into the ground, raised walkways have been created, and, like a true maze, it has dead-ends.

Also made from mounded earth and grass are the two earthworks "Earthwoman" and "Suntreeman." The first, 9m (30ft) long and 1.5m (5ft) high, is unusual in that the

BELOW Turf can be used for more than making lawns. It is sometimes sculpted into living garden furniture. A huge grass sofa and coffee table were made at Meijetuin, in The Netherlands. This work continues a tradition of building garden seats from turf that dates back to the thirteenth century.

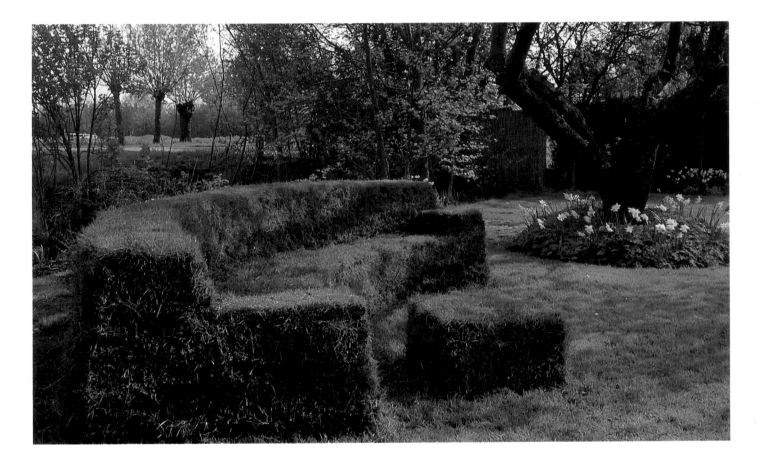

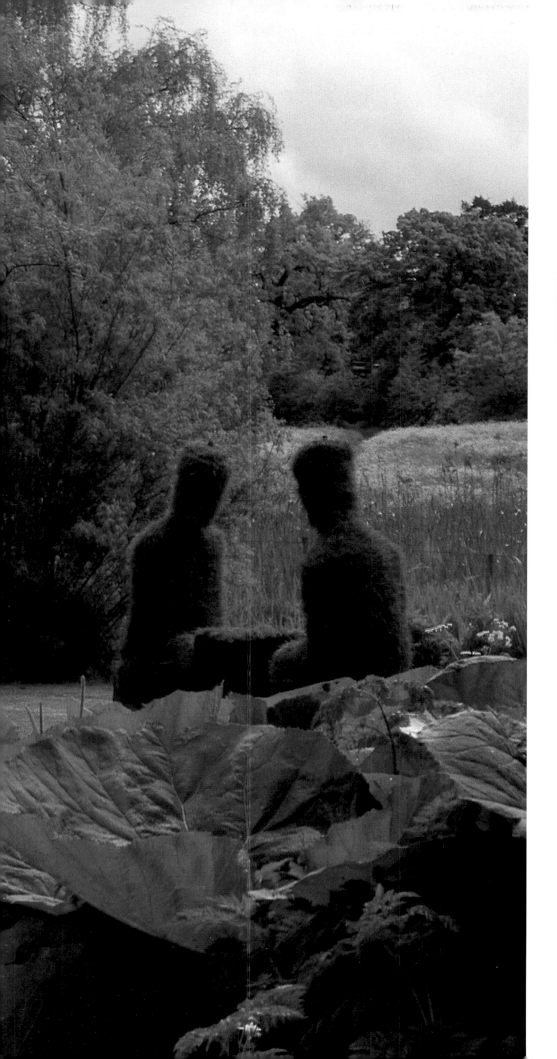

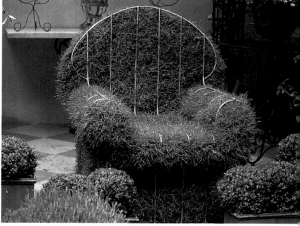

ABOVE To make this sophisticated grass chair, shown at the Chelsea Flower Show, London, in 1997, growing turf was used to "upholster" an outdoor armchair. An elaborate metal frame provides the shape and the structure that holds the turf in place. A frame allows complex shapes to be made and avoids the bulkiness of more traditional turf seats.

LEFT "Chess Players," by the Swedish artist Liv Due, was one of several turf sculptures displayed in different parts of Stockholm in 1998, when the city was Cultural Capital of Europe. The players and the chessboard were built by pinning turf onto blocks of peat. The stools and the table were left bare of turf, forming a contrast that highlights the two figures and the board between them. An odd but essential detail is the irrigation nozzles that protrude from the players' heads, which keep the turf moist.

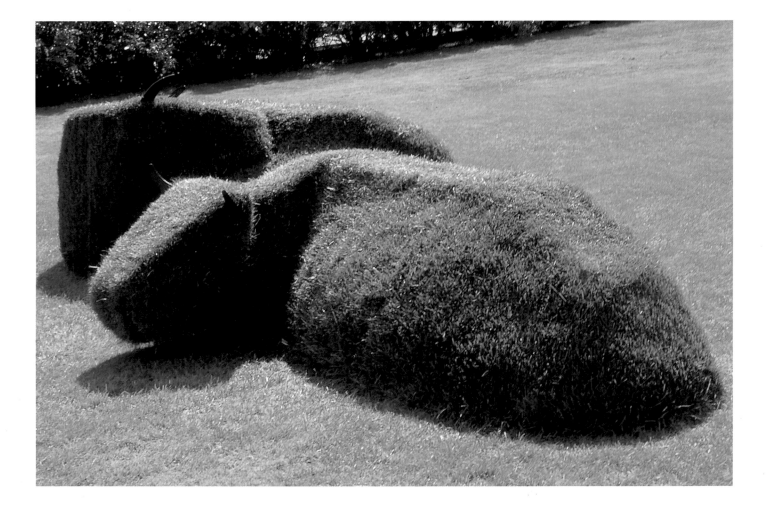

ABOVE There is humour in this depiction in turf of two grass-chewing cows, but the work also has great sculptural quality. In making "Two Ruminating Cows" Inga Hellman-Lindahl was "true to the material," allowing the underlying peat blocks and heavy turf to dictate the way the animals are represented. Rather than attempting to depict them in a realistic fashion, she preferred a more abstract interpretation, using bold, geometric forms.

figure is presented lying spreadeagled, face down. Apparently the cleft in her upturned buttocks is orientated to sunrise on the summer solstice. "Suntreeman" lies nearby, face up. This has arms like branches, and its head, which acts as a fire pit, represents the sun. There is a similarity between this figure and the Cerne Abbas Giant in Dorset, England, not least in the erect phallus. However, the works at Pratt Farm were not made as copies of historic originals, but are intended to evoke rather than imitate the past.

While it is true that land art and earthworks have links to ancient cultures, their existence today owes as much to a contemporary redefinition of art as it does to the past. In sculpture this has taken the form of a rejection by some artists of the well-crafted sculptural object made by, for example, carving, modelling, or constructing, in favour of an art that is more concerned with ideas. Conceptual art, as it is often called, manifested itself in installations, happenings, and performances. Since it was neither studio nor gallery-based, it provided the perfect justification for artists who wanted to work outdoors, using the land and living ingredients as their medium.

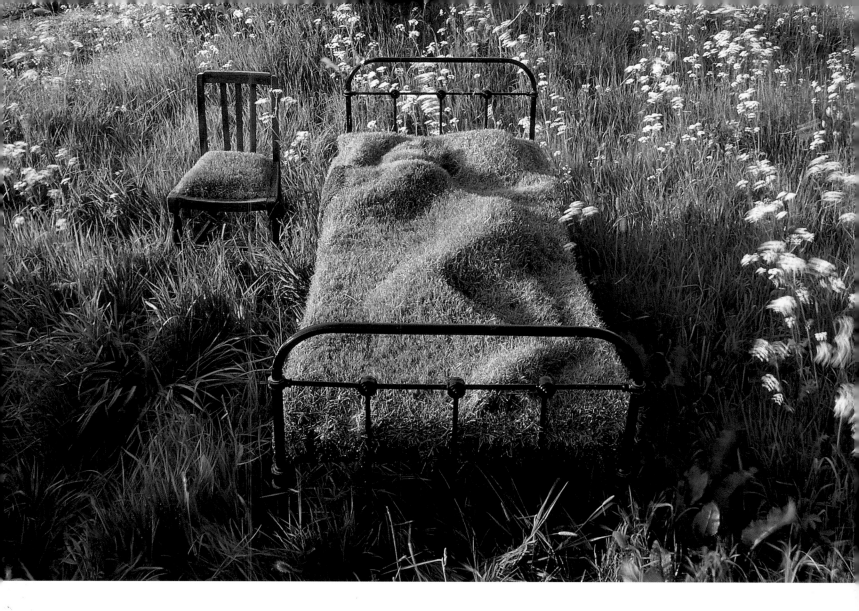

A turf-work by the British artist David Nash sums up this association between "idea art" and "land" or "environmental" art. In "Sod Swap" a circular patch of London turf was transplanted to Wales and a similar patch of Welsh turf to London. The "planted sculpture" took place in London in 1983, at the Serpentine Gallery in Kensington Gardens, as part of an exhibition of British sculpture entitled "The Sculpture Show."

Nash was allocated a space outside the gallery and, not wanting to simply deposit an existing sculpture outdoors, he decided to use the plot of land itself, the turf, and all it contained. His idea involved the careful removal of a measured circle of lawn in front of the gallery. The sections of neatly tended grass were then loaded on to a truck, kept moist, and transported to rural north Wales. Here, on his own plot of land at Cae'n-y-coed, Nash had already removed an identical circle of turf. The Welsh turf was replaced with the turf from London. Meanwhile the sections of rough Welsh turf, complete with weeds, docks, thistles, and wild flowers, were taken and placed in the circular area of bare earth that had been left in the lawn in Kensington Gardens. The turf was watered

ABOVE An iron bedstead and an old chair lie abandoned in a grassy meadow. What at first seems like discarded rubbish is in fact a turf sculpture created by George Wright in his garden in Dorset, England. The soft coverings of the furniture are replaced with turf, trimmed to provide a stark contrast to the surrounding vegetation. A grassy blanket outlines the contours of a sleeping man, his head sinking into a grass pillow. The incongruity of the scene lies in the fact that it includes both real and imagined forms.

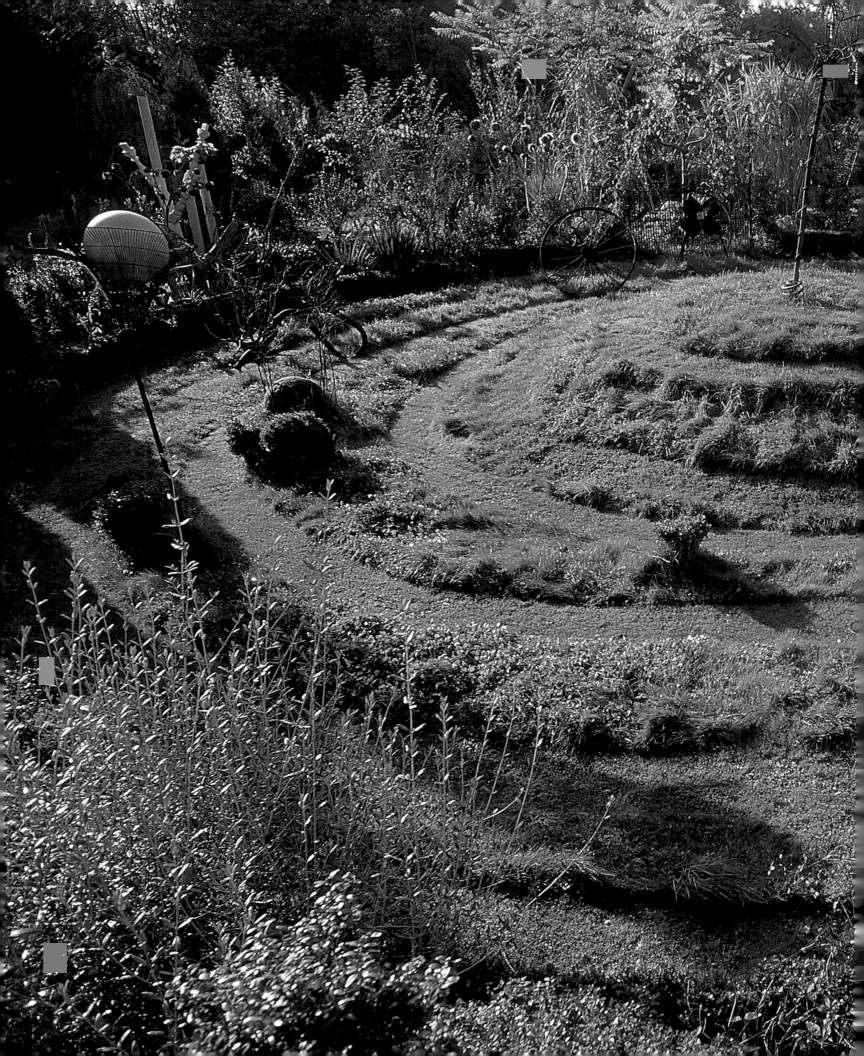

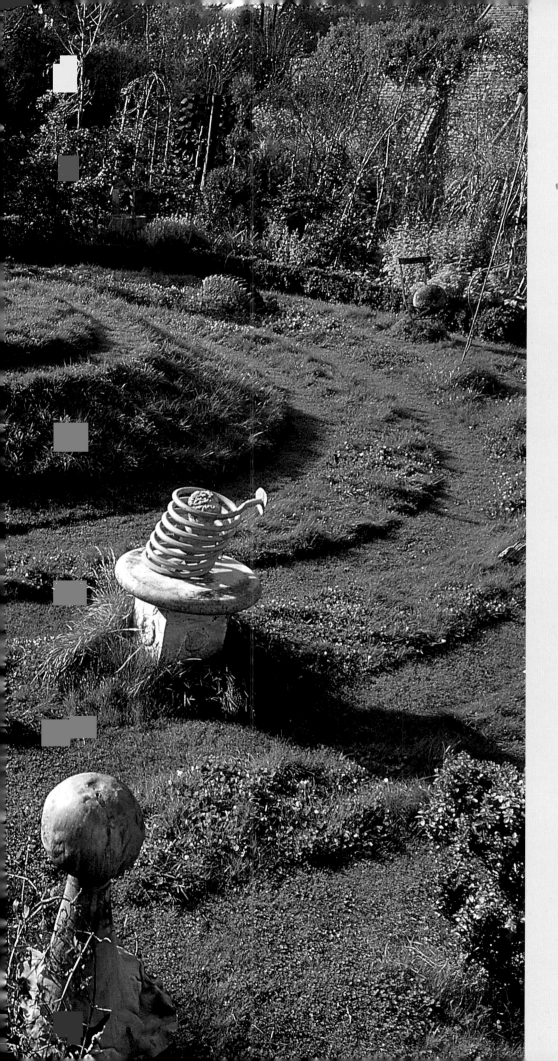

LEFT Strange objects litter the floor of this circular, grass-covered mound, and a mown spiral path leads to the top. The lawn, an essential ingredient in the typical English garden, receives an atypical treatment from the designer Ivan Hicks, who gives it a more three-dimensional look.

and soon the wild plants revived to provide a living piece of Wales in the middle of London. Later a botanist discovered that the turf originally from London contained five species of plants, whereas the turf from Wales contained twenty-six.

Around the same time Nash created another, similarly conceptual, planted work, this time using bluebells. "Blue Ring" was visible only during the short season when the bluebells were in flower. For just a few weeks in spring in many woods in Britain, bluebells transform the woodland floor into a spectacular blue carpet. Nash dug up thousands of bluebell bulbs and planted them densely on an open bank in a 30m (100ft)-diameter ring. He left the surrounding bluebells untouched so that when it came into flower the planted ring would show up as a soft dense circle against them. The transitory nature of "Blue Ring" and its use of natural life-cycles are important aspects of much of Nash's work.

For most of us turf is not the material of conceptual art but an indispensable ingredient in the making of a pleasant garden. Turf is widely used to make lawns, and in Britain in particular its association with the pursuit of the perfect lawn has perhaps limited its use as a sculptural or an artistic medium. At the time when the French garden was adorned with intricately patterned, flower-filled parterres, the English garden was dominated by large, flat stretches of flower-free turf known as plats. This style was then the peak of fashion, intended solely for ornament and demanding a lot of attention, and it is probably responsible for the British obsession with the lawn that is still evident today.

Contemporary designers have begun using turf in a more three-dimensional way, building with it as opposed to laying it on a single level. The British garden designer Ivan Hicks added impact to his own garden with a fairly small, labyrinth-like mound, complete with a mown spiral pathway. It acts as a contoured setting for the strange objects that "inhabit" his Surrealist-inspired garden.

Turf has been used in construction for centuries. The dry-stone walls that divide up large parts of Britain's rural landscape were often topped with turf. Even garden seats were made of clumps of turf. The history of the turf seat goes back to the thirteenth century, when stacks of turf were placed round a square or rectangle. In the fifteenth and sixteenth centuries circular tree seats were made from the versatile material. A wattle construction was built around the tree, and this was filled with soil and topped with turf. Today more sophisticated versions are made in which wood is replaced by metal frames, shaped to form armchairs or sofas and to support the turf upholstery.

OPPOSITE In 1993 the artists Heather Ackroyd and Dan Harvey covered the front wall of the Theaterhaus Gessnerallee, in Zurich, Switzerland, with a mixture of grass seed, mud, and water. Despite being vertical, the "lawn" will continue to grow if it is regularly watered.

The idea of making sculptures out of turf seems to be a relatively modern one. They are popular in Sweden and may well have originated there. It is thought that some of the first were made in 1995 by Weibulls, a seed company in Hammenhög, in the south of the country, and since then they have been a regular feature of the firm's annual exhibitions. Many turf sculptures were to be found throughout Stockholm in 1998, when the city was Cultural Capital of Europe, including the charming "Chess Players" by Liv Due at Bergiansk. The upright, seated figures are constructed using "lettuce peat" – old peat so called because it was used by lettuce growers – which is carefully packed and stacked into the desired shape of the sculpture. Some artists then sow grass seed while others use ready-grown turf, which has to be pinned in place until the grass gets established. Turf sculpture is different from land art or earthworks in that it does not involve cutting into or shaping the landscape. The works sit on the ground and can be built almost anywhere outdoors. In this sense they are more like conventional sculpture. The crucial difference is that because their surfaces are living they need cutting from time to time.

Artists have attempted to represent all sorts of subjects in turf, with varying degrees of success. One of the most successful was "Two Ruminating Cows" by the Swedish artist Inga Hellman-Lindahl. Although unusual, the work was a perfectly appropriate choice for a turf sculpture, since the mass and weight of the two cows find perfect expression in the solidity and bulkiness of the peat-and-turf mixture. The simple form of one animal's head is depicted raised slightly off the ground, and this lends the sculpture a sense of animation not often found in this type of work. Real horns were given to the cows, providing an element of wit, but, more importantly, helping us to recognize immediately what the simple mounded grass forms are meant to be.

ABOVE A detail of "The Undertaking," made by Heather Ackroyd and Dan Harvey in 1992 for the exhibition "Les Arts Etonnants 2" at the Palais de Chaillot, in Paris. The stone walls and steps are seen here soon after they were sprayed with grass seed, mud, and water. The surfaces had been prepared beforehand in order to help the mixture stick.

OPPOSITE A week after the spraying the grass was well established on the seemingly unwelcoming surfaces, creating a soft, lush, green stairway that is both mysterious and seductive. The desire to touch the grassy walls and the soft steps is compelling.

Using turf to make sculptural features requires great skill and considerable horticultural knowledge. Artists working in the medium need to be able to recognize good-quality turf that is strong enough to be handled easily. Turf grown on sandy or peaty soil has the advantage of being lighter than that from a clay soil. One of the most expert of the artists who work with turf is the Swede Lena Lervik, for whom a recurring subject is Mother Earth. She constructed one such turf-work in two weeks at the 1997 Sofiero Garden Festival in Sweden. This version of Mother Earth was unusual in that the large figure was made in such a way that she appeared to be partly submerged in the ground. Only her head, upper torso, and knees were visible, all modelled, like Lervik's other work, in compressed peat overlaid with turf. A nice touch was to allow the grass of her hair to grow long, and tiny ivies were planted to represent her ears.

When discussing turf sculptures it would be remiss not to mention the intriguing "Sleeping Man" sculpture in the garden of the British photographer George Wright at Rampisham, in Dorset. Not only does this predate the Swedish grass sculptures by several years, but also Wright constructed it quite differently. An old iron bedstead and a chair provided the framework for this living sculpture, in which grass replaces the customary fabric of the chair, blanket, and pillow. The form of the man was achieved by laying and shaping chicken wire over a model. The wire was lined with a water-retaining membrane and then covered with earth and sown with grass seed. The resulting "living" blanket cleverly conceals, yet at the same time suggests, the human form beneath.

The idea of using grass seed rather than pre-grown turf has also been inventively pursued by the British artists Heather Ackroyd and Dan Harvey. However, the technique they use to create their unusual living artworks is far removed from those of the domestic gardener. They have realized the possibilities of modern landscape-restoration methods. Modern land reclamation, encouraged by environmental awareness and enlightened government policy, has adopted many new techniques. Abandoned landscapes ravaged by the Industrial Revolution are being rebuilt. Worked-out quarries are landscaped with "restoration" blasting to create the look of natural escarpments. The resulting scree slopes are planted using a process in which a slurry of wild-flower and grass seed, compost, and fertilizer is sprayed onto surfaces that are often steep and inaccessible.

BELOW A serpentine mound of earth and turf emerges from a gravel pit. Larger than most turf-works, "The Soul of the Grass," by the Swedish artist Ulla Viotti, is more like an earthwork or a landscape feature. Turf-works usually sit on the ground rather than shaping it, as this piece does.

92

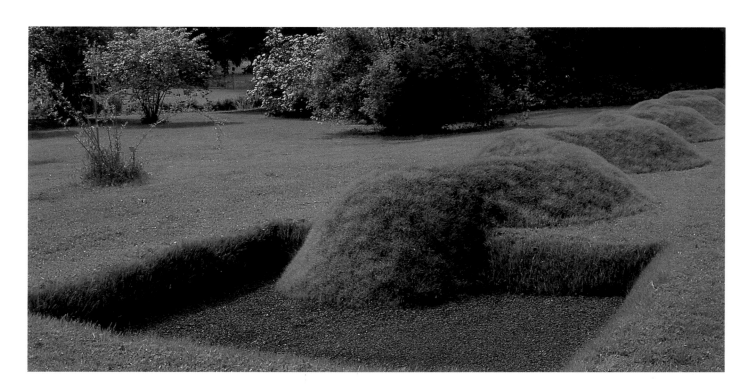

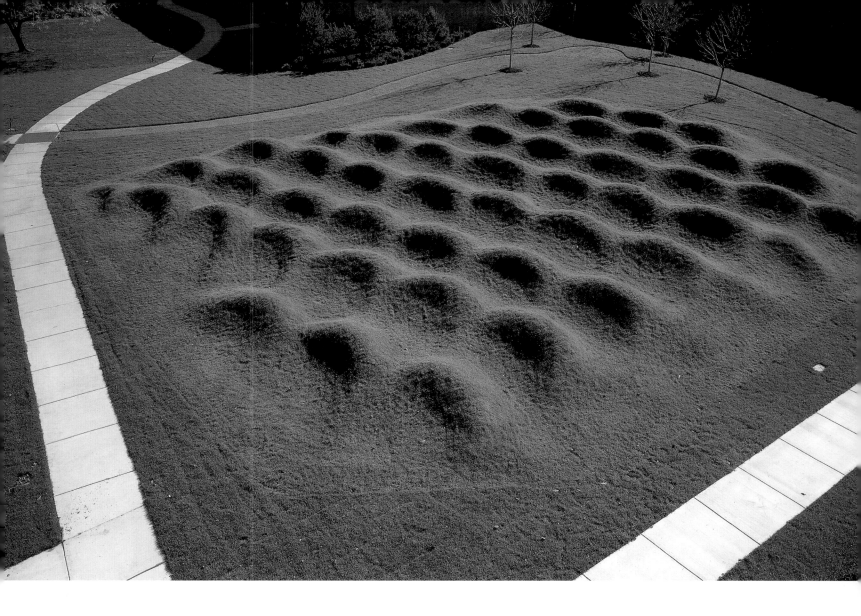

Ackroyd and Harvey have exploited this method of sowing seeds on vertical and inhospitable surfaces to create lawns in the most unlikely places, such as on the façade of the Theaterhaus Gessnerallee, in Zurich, Switzerland, in 1993. Using their growth-generating mixture of grass seeds, clay, and water, they transform ordinary objects and places into living works of art. Aesthetic rather than functional, their grassed walls and steps intrigue the viewer with the unexpected. One of the most poetic works was "The Undertaking," a grassed flight of stone steps at the Palais de Chaillot, in Paris. Dadaist in spirit, their creations recall in particular the art objects of the Swiss artist Meret Oppenheim, whose "Lunch in Fur" of 1936 consisted of a teacup, saucer, and spoon covered with fur fabric.

Although very much a part of contemporary art, Ackroyd and Harvey's work is not without historical precedent. In northern countries such as Norway and Iceland, where winters are harsh, it was a tradition to cover the roofs of cottages with peat onto which heather and coarse grasses were encouraged to establish. The result was a "living roof" that provided excellent insulation.

ABOVE Maya Lin's inspiration for "Wave Field" was a cropped photograph of ocean waves. The turf-covered earthwork is intended to evoke the work carried out in the University of Michigan's Aerospace Engineering Building, for which it was commissioned. Irregular in size and shape, the "waves" combine with the changing effects of light and shade to create a sense of movement across the grass surface.

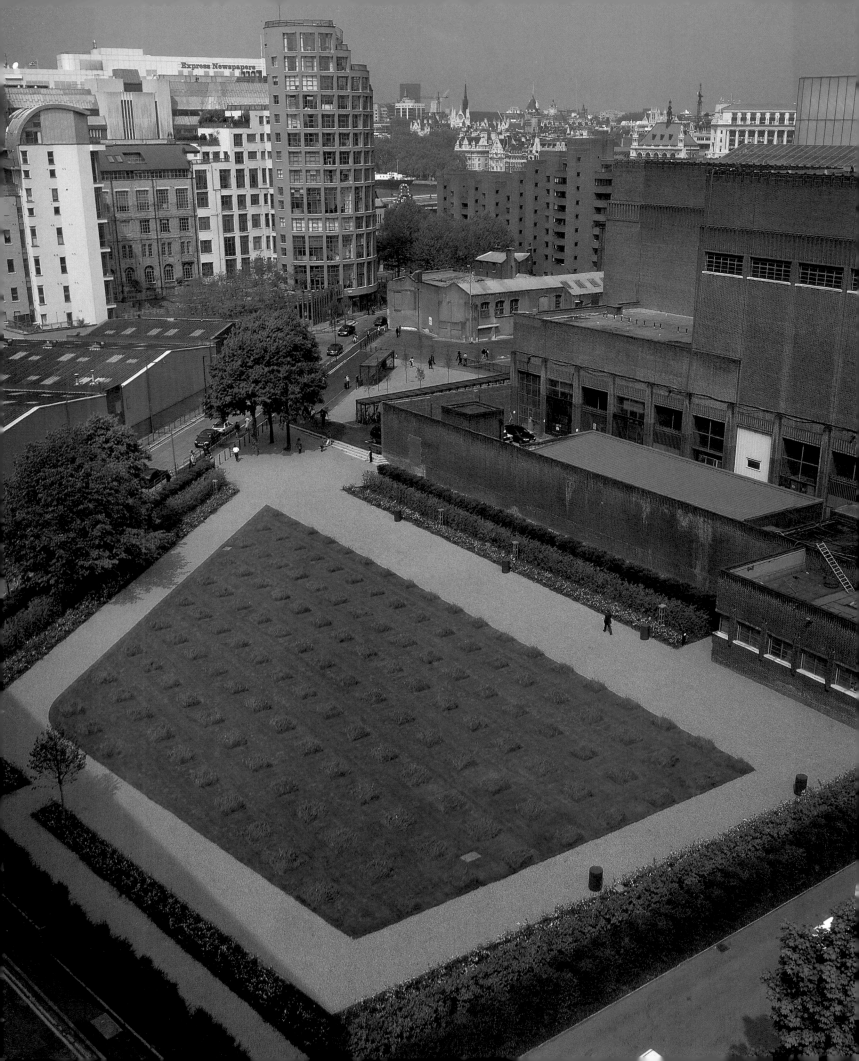

The possibilities of turf and grass continue to be explored by artists and landscape architects alike. These materials provide two of the simplest and quickest ways of making living sculptures. When this also involves the shaping of the land, it can easily become landscape architecture rather than art or sculpture.

"Wave Field," commissioned from the American artist Maya Lin for the Aerospace Engineering Building at the University of Michigan, belongs firmly in the domain of landscape sculpture. This earthwork dating from 1955 is made from the land but is essentially a self-contained work of art, separated by paths from the surrounding landscaping. Unlike the designed landscape of which it is a part, "Wave Field" serves no obvious function. Instead it refers to and identifies the work carried out in the building that it sits next to. The undulating grass shapes relate to the science of fluid dynamics, which is central to the physics of flight. The overall form of the work, a rectangular field of low, wave-like, grassy mounds, was inspired by a photograph of ocean waves. Each mound is different in height and width, and, although they are not primarily intended for use, the "waves" have become popular places on which to sit and read.

In contrast, the turf-based landscaping outside the Tate Modern art gallery in London was created by a team of landscape architects and is intended to be used by the public. Designed by Kienast Vogt Associates and Charles Funke Associates, the scheme was conceived to match the plain design of the disused mid-twentieth-century power station that was converted to form the new gallery. As a result, it is not a typical English garden landscape with curves and flower beds, and even the traditional partiality for a large, open expanse of lawn was considered in a new way. In short it has become a minimalist turf-work. The design consists of a regular pattern of very slightly raised earth squares on which the grass is allowed to grow long. When this longer growth is eventually cut back, the cropped grass is paler than the regularly mown grass in between the squares, and the effect is that of a two-tone lawn.

What the Tate Modern project highlights is the influence that land and environmental artists have had on recent landscape design. The living works of art created in earth, turf, or grass have stimulated a more imaginative and expansive approach among many landscape architects. It is one that is more three-dimensionally aware and that seeks a new visual language rather than relying on historical models. There is irony here, since much of the work by the first land and environmental artists was inspired by the man-made landscapes of ancient cultures.

95

OPPOSITE This large-scale turf-work outside the Tate Modern art gallery in London was designed not by an artist but by a team of landscape architects. Kienast Vogt Associates and Charles Funke Associates wanted to create a public recreation area that was more than just the ubiquitous flat expanse of lawn. The solution, with its slightly raised squares of longer, less frequently mown grass, is both simple and effective.

TREE SCULPTURE

An ancient oak, its distinctive shape formed over many centuries, is an awe-inspiring sight for most of us. Who would want to alter such a natural creation? Surprisingly, perhaps, the answer is gardeners and artists. In Japan generations of gardeners have shaped trees into idealized and stylized forms. Until recently sculptors preferred to carve "dead" wood. But now, using the traditional methods of horticultural husbandry and tree surgery, artists and gardeners are making sculpture from living trees. Using techniques such as pollarding or grafting, they work with trees to make sculptural and architectural structures. Environmental issues and a desire to conserve rural skills motivate many of these "tree shapers" as they create a living art that is in sympathy with nature.

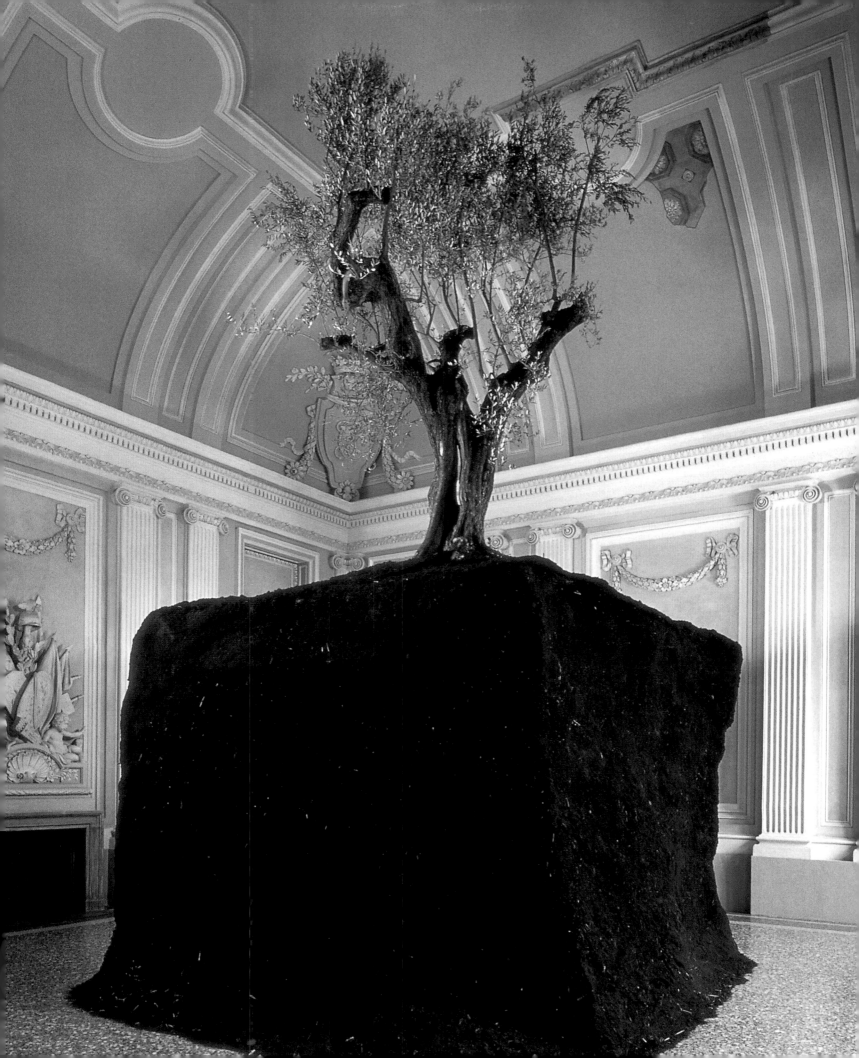

When Maurizio Cattelan exhibited an unaltered olive tree as a sculpture in 1999, it could have been interpreted as a reaction against those artists, craftsmen, and gardeners throughout the centuries who have sought to "improve" the natural shape of a tree. Here was an artist who chose not to alter what nature had provided, but instead to leave it in its natural form, preferring to regard it as a sculpture in its own right.

Nevertheless, the work, known as "Senza Titolo" (Untitled), gave the impression of belonging in the unlikely setting of the museum room when it was exhibited at the Castello di Rivoli, near Turin, in Cattelan's native Italy. Although a living tree, it owes its existence more to the ideas of twentieth-century art than to any moral desire to leave nature alone. Considerable plantsmanship was required to "transplant" the tree safely, complete with its root-ball, from its original location to the middle of an art gallery, but this tree sculpture has nothing to do with horticulture. Instead it is offered simply as a ready-made work of art. It is a modern-day "living" equivalent of objects such as the bicycle wheels and bottle racks that, from around 1912, were presented as *objet trouvé* sculptures by the French-born Dada artist Marcel Duchamp.

PREVIOUS PAGE Maurizio Cattelan's "Senza Titolo" (Untitled), created in 1998, was exhibited the following year at the Castello di Rivoli Museo d'Arte Contemporaneo, in Rivoli, near Turin, Italy. It is neither a sculpture of a tree nor one made from a tree. The sculpture is the tree itself, complete with its living world of roots, earth, leaves, sap, and insects.

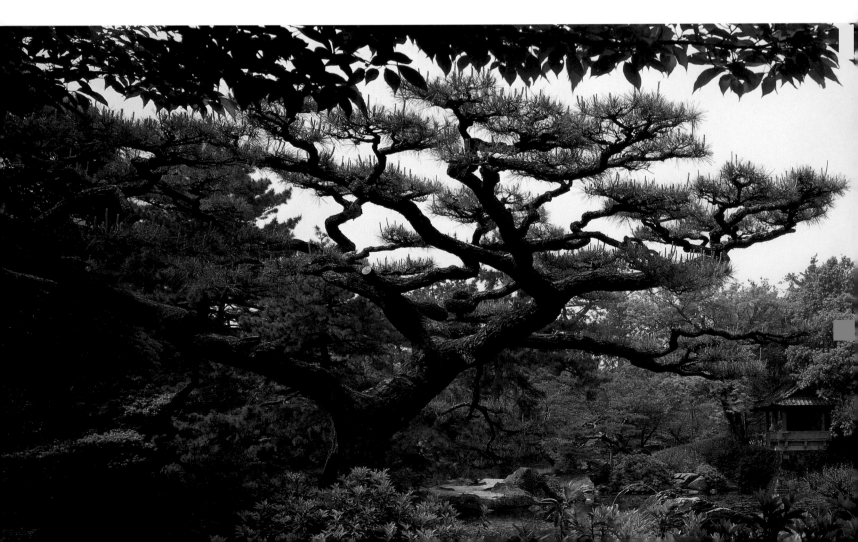

Cattelan's tree can be regarded as an essay in conceptual art, which took its lead from Duchamp's "ready-mades" and first came to public notice in the 1960s. It is an art in which the idea that the artist intends to convey is more important than the art object or the physical means by which it is presented. The traditional definition of sculpture, which involves the working of a given material into a new form, is rejected. Many artists in the 1970s were stimulated by this idea-based approach to art, but for the British artist David Nash it encouraged a diversion into making living sculpture using trees. Unlike Cattelan, he set about growing and altering the shape of trees to make his sculptures. Nash's work has a conceptual basis since his sculptures rely on "growing," as both trees and artwork, to achieve the final form and this can take many years – if the trees survive.

Between 1965 and 1977 Nash worked with wood in a conventional way, although his methods were more akin to rural craftsmanship, employing hand tools such as axes, saws, chisels, and wedges rather than traditional sculpture-carving methods. At first he worked with pre-cut milled timber, but he soon moved on to wood from trees he cut himself. He also worked with fallen trees, and often the form of the tree was retained in the completed work. His finished sculptures revealed an empathy with the material. They

BELOW The branches of this pine in the Ritsurin Garden in Takamatsu were shaped into interesting clusters of foliage by the expertise of a traditional Japanese gardener. Large, open spaces are left, or created, to reveal the beautiful pattern of the branches and to preserve the view of the landscape beyond.

99

ABOVE A "living" tunnel of trees was formed at Birr Castle, in County Offaly, Ireland, by pleaching two rows of hornbeams. These have grown together to create an effect that has been likened to rococo stonework. The tunnel, planted in the second half of the twentieth century, remains one of the finest examples of tree sculpture in Europe.

were non-representational, and in many cases the finished form was inspired by the character and original shape of the wood. Sometimes they took the form of constructions held together by the traditional means of wooden pegs instead of screws.

In the mid-1970s Nash became concerned with how to create outdoors a large wooden sculpture that would not rot, and this may have led him to consider making a sculpture from living trees. Producing sculpture in this way is not new, as the ancient art of topiary demonstrates. But the clipping and training used in topiary are intended to impose a new shape on a shrub or a tree rather than to express the inherent structure of the specimen. Nash's work belongs more to the school of the traditional Japanese gardener. He views a tree as an artist or a sculptor might, aiming to prune and shape it into a natural work of art.

In traditional Japanese culture any natural phenomenon – a rock, a waterfall, or a fine tree – can be an object of worship, and the Japanese garden is intended as an idealized expression of the beauty of nature. t is therefore important to shape garden trees so that they harmonize with their surrouncings and emphasize the natural beauty of the whole garden. Most types of large and medium-sized trees can be shaped into graceful lines by pruning and cutting back, in a way that retains and indeed enhances their natural form. Each type has its own characteristic growth habit, texture, and form, and these are emphasized. The shape given to a pine is different from that given to a juniper, because the two trees grow differently, anc each "sculpture" represents a stylized vision of the tree. In fact pines are among the trees used most often in Japan. They are cut back regularly, and in some cases the branches are trained by being attached to bamboo frames.

Pruning is regarded in Japan as a sculptural process within the art of the garden, but in Europe this cutting back, or pollarding, is usually associated with the needs of horticultural husbandry. Its use in the maintenance of trees and woodland is utilitarian rather than aesthetic. Topiary is seen as the principal horticultural art form in the Western garden. However, a rural craft that came to be employed in an aesthetic and design context was pleaching. Developed originally as a method to construct or repair a hedge, it involves the interlacing or weaving of the growing shoots of a tree or shrub. One of the finest examples of pleaching is at B rr Castle, in Ireland. The garden features a hornbeam tunnel that has grown in such a contorted manner that it looks like ornate rococo masonry. This extraordinary architectural feature was achieved by pleaching the canopies of the hornbeams together to form an arch. The adoption of pleaching to create screens, arches, tunnels, and other architectural features had been an essential element in the

BELOW LEFT These distinctively shaped trees are part of a Japanese-style garden in Portland, Oregon, in the United States. This type of shaping, in which low-growing trees and shrubs are trimmed into compact forms, is one of the most popular in Japan and gives authenticity to this American version.

101

BELOW The Japanese shape certain types of tree into compact forms so that they are in harmony with the surrounding planting. Once the shape is established, seasonal trimming maintains the smooth, rounded clusters that are encouraged to form on the branches.

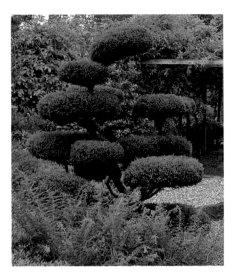

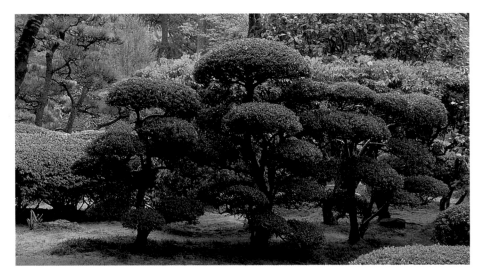

TOP AND ABOVE David Nash began work on his "Divided Oaks" in 1985, when the young trees were planted, and the sculpture has gradually taken shape as they have grown. The division was achieved through the traditional rural craft of "laying," or "fletching," used to make livestock-proof hedges.

development of the formal garden in Europe. The Frenchman Dezallier d'Argentville recommended, in his book *La théorie et la pratique du jardinage* of 1709, cutting and pleaching to form arches and finials in what might be called "rural architecture."

David Nash drew on another horticultural maintenance technique to make his own sculptural version of rural architecture. In north Wales he had seen hedgerows made into a living fence by "fletching" – that is, cutting the trunk or branch partly through and then bending it over and weaving it through upright wooden stakes. Nash was also interested in the history of the area and had read about shipping in the local harbour of Porthmadog, where early shipbuilders had trained trees to grow in certain configurations to produce strong, thick beams with a curve. Encouraged by this knowledge, he set about, in the spring of 1977, creating a dome using growing trees. His intention was to make a sculpture from living wood that would be intrinsically linked with the natural elements of its location. Twenty-two ash saplings were planted in a 9m (30ft) circle on a

slightly dome-shaped area of raised ground in the Cae'n-y-coed wood, near Blaenau Ffestiniog. Nash decided that there should be no entrance or doorway into the space because this would spoil the work's symmetry. Over a period of 30 years the trees would be fletched three or more times and in this way coaxed to grow into a work he calls "Ash Dome." He chose ash because he had noticed that it adapted well to fletching and cutting in hedge-making, and did not suffer unduly when bent. Ash is a very resilient and vigorous plant, able to recover quickly from pruning wounds. This was essential because in order to form the dome Nash would need to make considerable "physical interventions," as he describes them, in the growing process over the coming years.

Nash would have to visit the work regularly and nurture it as it grew. Great arboricultural skill would be needed, in particular to create the bends in the trees. In shaping the dome the sculptor had to ensure that each tree had enough leaf growth to sustain it and that none of the limbs developed in such a way as to affect the growth of the main trunk.

ABOVE "Green Cathedral," the idea of the Czech landscape designer Vladimir Sitta, was built at the Homestead Estate, in New South Wales, Australia. Alder trees were persuaded to grow at an angle by being secured to a timber frame that will be removed once the desired shape has been achieved.

TREE SCULPTURE

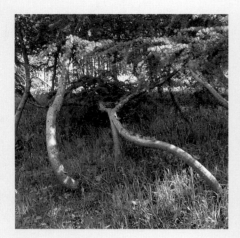

104

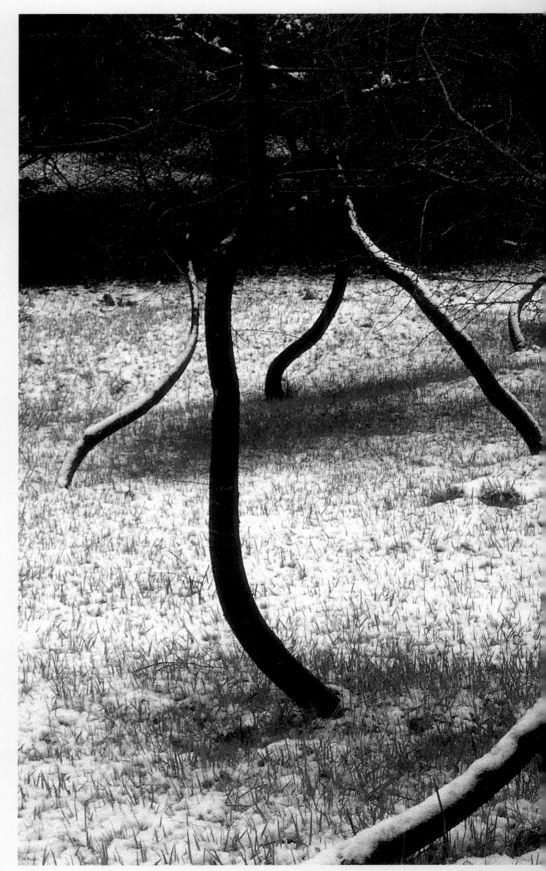

ABOVE AND RIGHT In "Leaning out of Square,"
planted in 1978, David Nash persuaded larches to
grow sideways by bending the young saplings and
fixing them to rigid stakes. Although the trees were
planted in a grid pattern, it is a sculpture without any
intended clear final shape; the trees were allowed to
develop naturally after initially being restrained. This
is art that is not about object-making. Instead it is
concerned with the act of growing, and in particular
with the style of planting in modern-day woodlands.

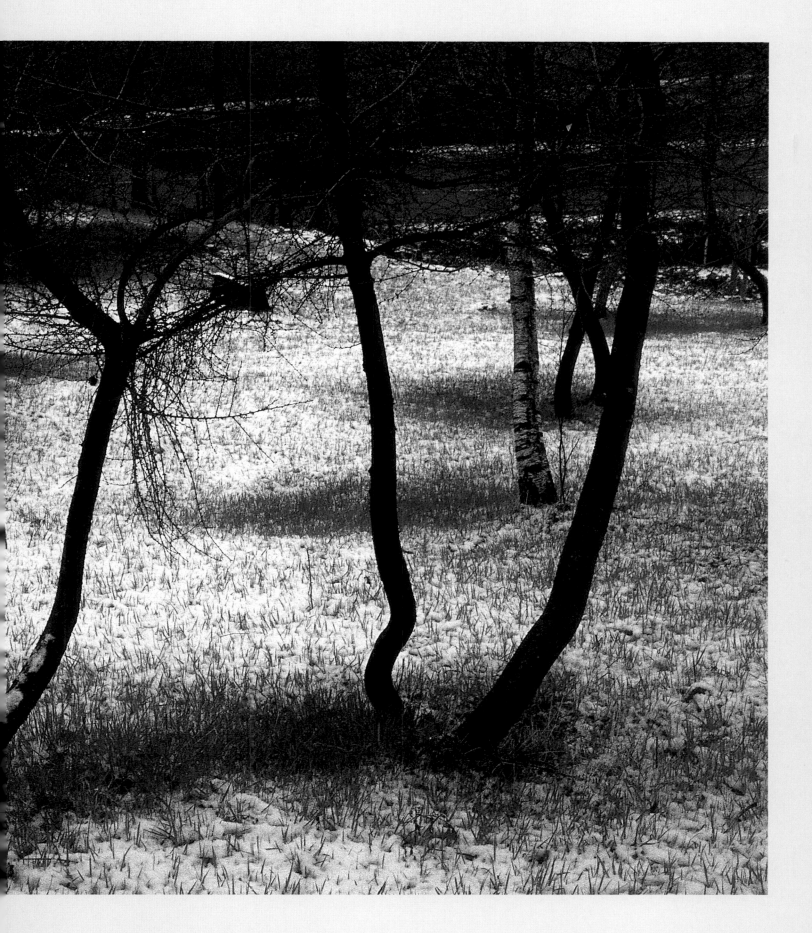

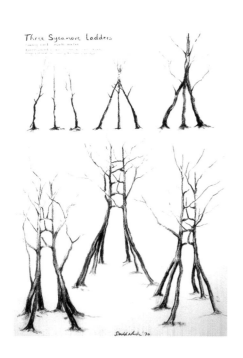

Three Sycamore Ladders

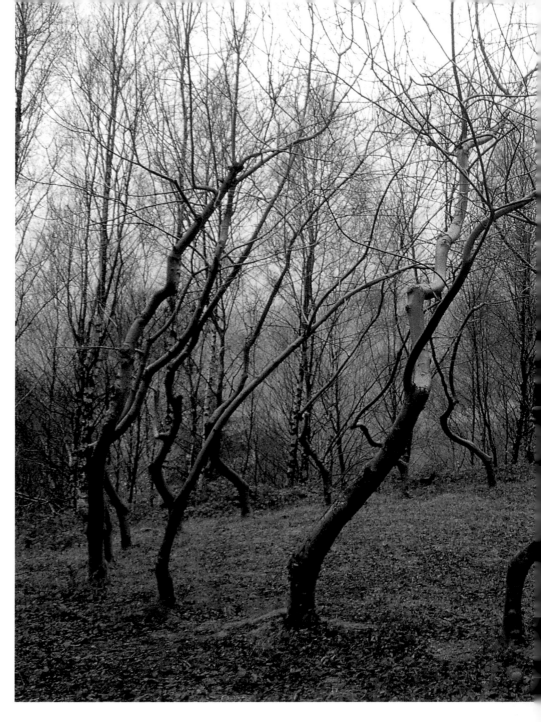

ABOVE David Nash never made the three sycamore "ladders" seen here in concept drawings. But he did attempt to create a ladder from willow saplings. In this work, in Grizedale Forest, Cumbria, England, he used two young trees growing parallel to each other. The intention was to graft each new lateral branch onto the opposite trunk to form the rungs of the ladder, and to prune unsuitable branches. The sculpture did not survive, but had it done so it would have required skilled attention over a long period of time.

There was also the problem of light being restricted as the upper part of the trees grew closer together to form the intended hemisphere. As a lack of light to any part of the trees would inhibit growth, judicious pruning was essential to maintain a constant supply.

In 1978 Nash accepted a post as artist in residence at Grizedale Forest, in Cumbria, and two further sculptures were planted here. One was a ring of larches planted on the diagonal to give them the appearance of sweeping down a slope. The other was "Willow Ladder," for which two young willow trees were cut down and inverted in the soil. Willows are unusual in that they will root and establish quite happily from any point on the trunk or branches. The idea demanded that these upside-down trees would sprout

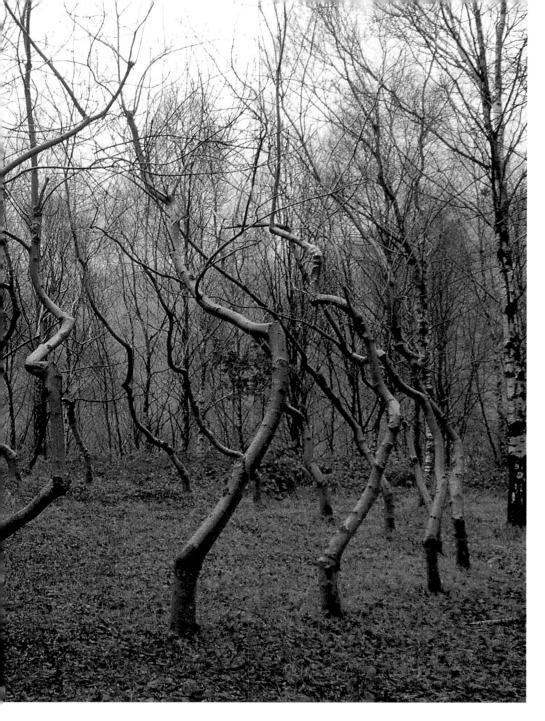

shoots from their trunks that could be entwined to form a ladder-like structure. After the first attempt was eaten by a deer, further attempts failed because, after his residency ended, Nash could not make enough visits to Grizedale to adequately maintain the piece. "Sweeping Larch Enclosure," which he attempted at Grizedale and then, in 1981, at the Yorkshire Sculpture Park, also failed, not from neglect but because of the elements. Both works were "burned" by strong winds that eventually killed the young trees.

Nash has been more successful at the Kröller-Müller Museum at Otterlo, in The Netherlands, where his "Divided Oaks" and "Turning Pines" have established well in response to his regular attention. He has continued to experiment with planted work at

ABOVE AND ABOVE LEFT "Ash Dome" is one of David Nash's most successful attempts at a living tree sculpture. He planted it in 1977, close to his studio home near Blaenau Ffestiniog, in north Wales. Nearly thirty years later the work is beginning to take on the domed form that he intended. Through his acquired skill in "fletching," and with considerable patience, Nash has revived the horticultural art of creating "living architecture," a practice rarely seen in today's more instant gardens.

OPPOSITE To protect newly pollarded trees from frost damage, Japanese gardeners wrap hessian bandages around the trunks. By accident rather than intent the effect is quite sculptural.

RIGHT Unlike the hessian-wrapped trees opposite, these trees in Fukuoka, Japan, were bound with rope for purely artistic rather than horticultural reasons.

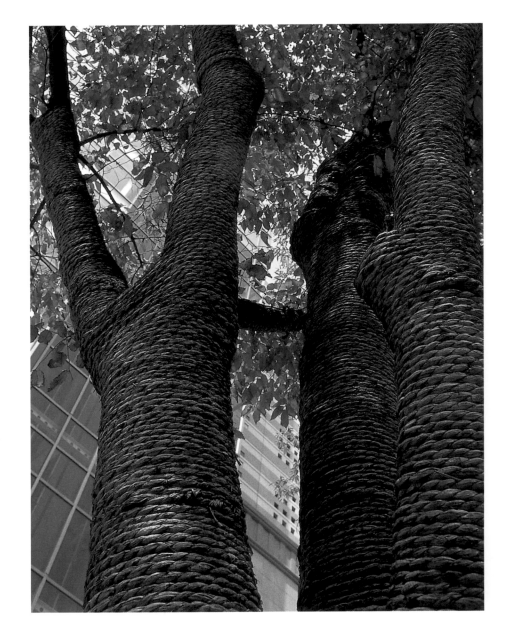

Cae'n-y-coed. One of the most successful examples is "Leaning out of Square," begun in 1978, a comment on the Forestry Commission's habit of planting in regimented lines. Sixteen larches were planted in a grid format, but each tree leans at 45 degrees so that as they grow away from one another the original square layout gradually disappears.

The environmental movement was already gaining ground in the early 1970s when Nash began his "Ash Dome" tree sculpture, and since then the ecological lobby has highlighted the need for "the greening of industry." In some ways his work is part of the legacy of the nineteenth-century Arts and Crafts movement, which preferred rural crafts to contemporary industrial manufacturing. Certainly "Ash Dome" is not without artistic

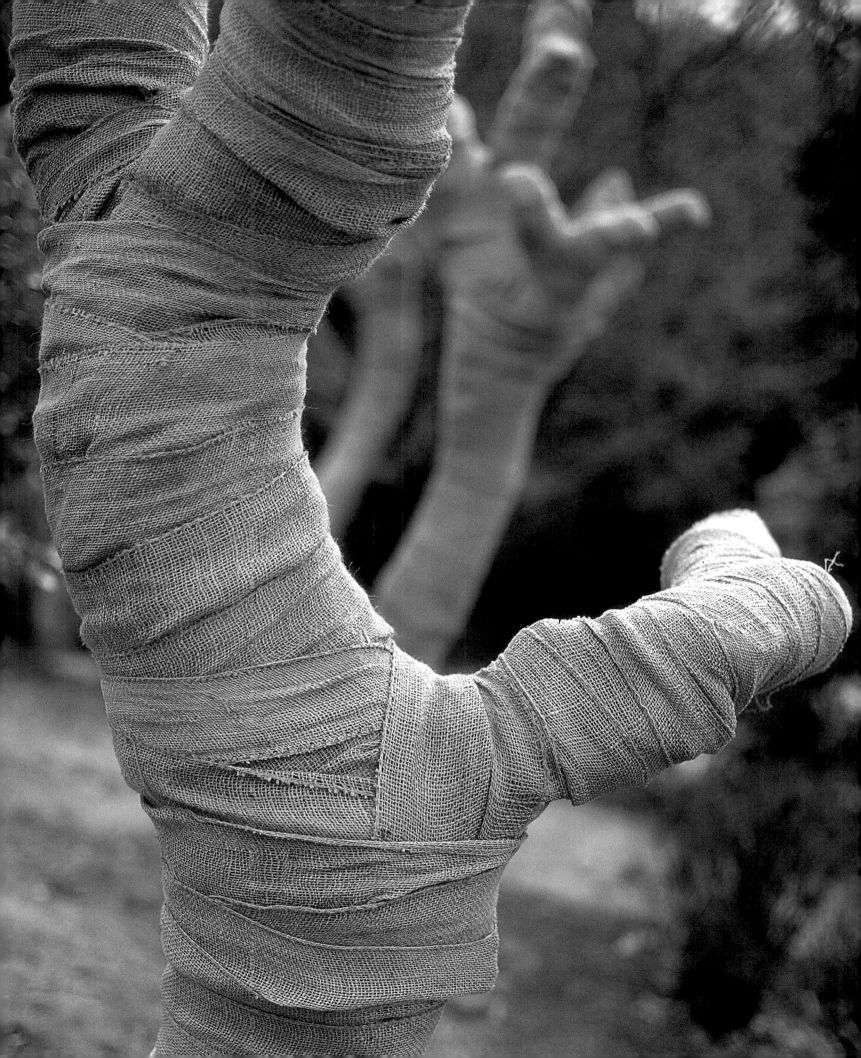

RIGHT The trunk and branches of this magnolia were painted dark blue. Although some might see this as an act of vandalism, the water-based paint does no long-term harm to the tree and in fact helps to show off its delicate pink flowers. Decorating trees with paint has become a popular way to enliven older or uninteresting garden trees. In 1997 painted trees even appeared, with official approval, at the Chelsea Flower Show in London. The "Garden of Life," made for the charity Age Concern, contained silver birches whose trunks had been decorated with bold orange and blue rings.

precedent. The method was used to create topiary chambers in medieval gardens, and the eighteenth-century writer Alexander Pope considered planting in his garden a group of trees that could be encouraged to grow to resemble a Gothic cathedral.

It is not known whether Pope ever attempted his "cathedral," but in 1991 the Czech landscape designer Vladimir Sitta designed and built his "Green Cathedral" for clients in Australia. This consists of a circle of alder trees planted around a circular, grassy pit. A removable timber frame pulls the trees inwards as they grow, and a stepped spiral path descends to the central area that they enclose. Here, under the leafy canopy of the "cathedral," the visitor can enjoy the effects created by the combination of light, sky, and trees. Sitta's overall plan for his clients' estate included many contemporary features, but this tree sculpture belongs to the centuries-old tradition of creating "living architecture" by topiary or pleaching.

Not all artists and designers have sought to change the shapes of trees for artistic ends. Some have simply worked on a tree to create a temporary artwork, without affecting it in the long term. A Japanese practice may have inspired some artists to wrap up trees. In Japan gardeners often bind pollarded trees with hessian to protect the new growth from

ABOVE LEFT A dead oak tree was given a new lease of life when the British artists Heather Ackroyd and Dan Harvey planted a "lawn" on it. They sprayed the skeletal tree with a mixture of grass seed, clay, and water, which easily adhered to the rough, textured surface of the trunk and branches. The ancient oak is now covered by a soft, luxuriant, green carpet.

ABOVE A strange face peers out through a hole in the bark of a tree. This surreal sculpture was carved into the living tree by the garden designer Ivan Hicks. The damage to the tree is only superficial (animals such as deer can inflict greater injury), and the surprise it produces justifies the means.

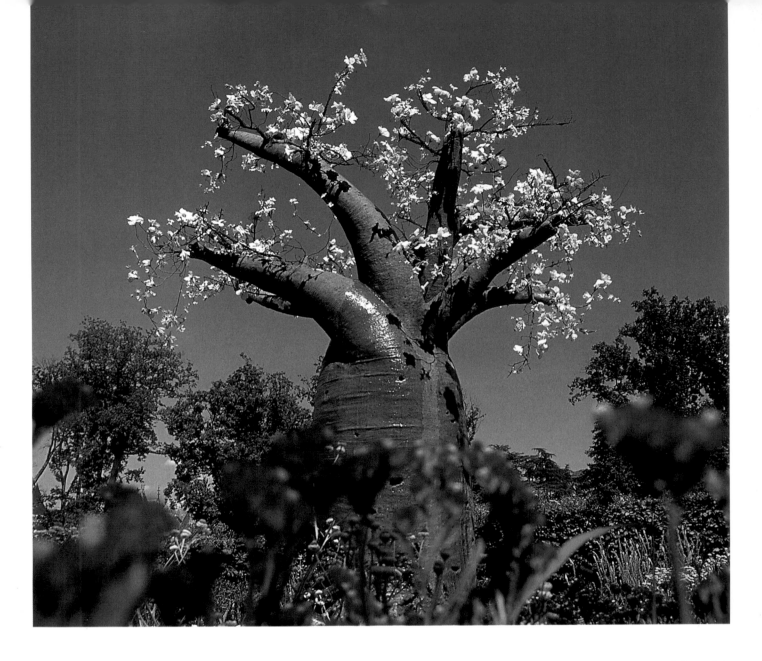

ABOVE "Le Baobab qui pleure" (The Weeping Baobab) is in the Conservatoire at Chaumont, in France. This tropical African baobab, with its characteristic swollen trunk and minimal branches, was cut back to give it a stark, sculptural form.

OPPOSITE This topiary *Olea europaea* adorns a sunken garden on the Filoli Estate, in Woodside, California, in the United States. Severe pruning and clipping have virtually eradicated the olive's natural growing pattern and shape in order to form this precise, geometric work.

the frost, but those shown on page 108 bound in rope were wrapped for solely ornamental reasons. Another recent idea is to coat trees with paint for artistic effect. Modern weatherproof, water-based paint has made this possible since it allows the tree to "breathe" and causes no lasting damage.

Two artists who were not concerned with keeping a tree alive but rather with giving it a new life were Heather Ackroyd and Dan Harvey. In 1999 they surrounded an ancient, long-dead oak with scaffolding. They sprayed the skeletal tree with a combination of grass seed, clay, and water, and now it is clothed with a luxuriant "lawn."

The British garden designer Ivan Hicks has frequently flirted with making "living sculptures." Planted typewriters and filing cabinets have been among his repertoire of Surrealist-inspired "living" objects. In his characteristic dream-like fashion the tree

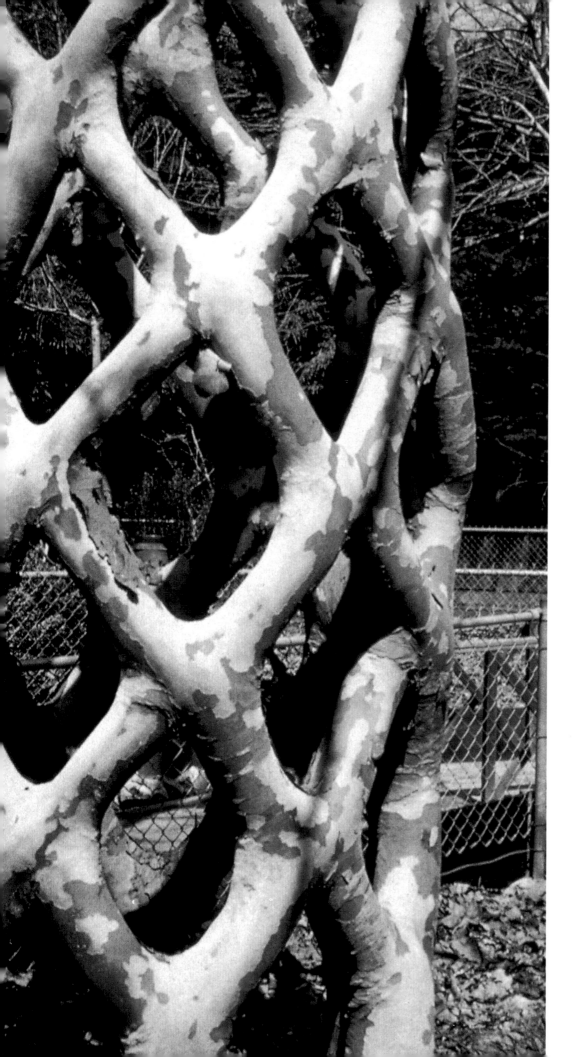

PREVIOUS PAGES The work of Ron Simple is both
decorative and practical. By grafting several fruit trees
together to form a single specimen he creates a fruit
tree that bears a variety of fruits. Simple often grows
a number of these grafted fruit trees together in a
line, using the espalier technique, in which horizontal
wires strung between posts within a frame force the
branches to grow horizontally. This allows him to
graft the branches together to form patterns and
motifs. The result is an attractive garden screen.

LEFT A lattice-like cage forms the trunk of a growing
tree that was created by a combination of grafting,
pleaching, and bending. It is the work of Axel
Erlandson, who began his weird manipulations of
trees in the early twentieth century. Despite their
unnatural appearance, many examples of his work
outlived their creator.

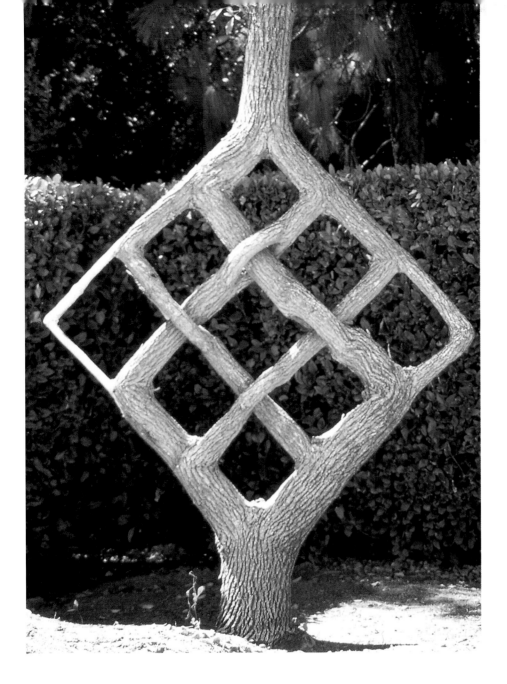

LEFT Axel Erlandson gave wonderfully descriptive names to his tree sculptures. This is the "Needle and Thread" ash. Other noteworthy members of his Scotts Valley Tree Circus, in California, were "Spiral Staircase," "Cathedral Window," and "Revolving Door." Reproductions of Erlandson's sculpted trees were featured in *Ripley's Believe It Or Not*, an American cornucopia of the weird and the wonderful.

sculpture "Head in Tree" consists of a trunk with its bark removed to reveal a face. This apparent vandalism is just a more sophisticated version of an old tradition found in many cultures – carving one's name or symbol on a tree.

Such acts make only a superficial change to the appearance of a tree. Pleaching, fletching, pruning, pollarding, and topiary may be physical attacks, but in most cases they do no harm to the tree and are often used to improve its growth and strength. But while topiary or fletching can alter the natural shape of a tree, another horticultural technique actually interferes with the biology of the plant. Grafting is a technique of joining two parts of different plants together so that they unite and continue their growth as one, usually to improve a crop or to propagate a difficult specimen. One man who is a self-taught expert in this technique and many others is the American Ron Simple. But he

sees grafting more as an art form than as a means to improve a crop of fruit. Simple lives in Honeybrook, Pennsylvania, where he grows and works all of his own trees. He describes himself as "Simple the roving garden artist" and offers to create topiary, trellis work, façades, and espaliers. He specializes in grafting and once grafted five different apple cultivars onto a single tree. What made this "family tree," as the result of such multiple grafting is known, special was that he created a heart shape at its centre (*see pp.114–115*).

Even Simple's delightful tamperings look quite normal when compared with the work of Axel Erlandson, the founder of the Scotts Valley Tree Circus, in California. Born in Sweden in 1884, Erlandson emigrated with his family to the United States, ending up on the West Coast. Having always been interested in arboriculture, he opened his own tree nursery, and this led him to notice the ability of sycamores to naturally self-graft, or inosculate. The branches of a tree become entwined in such a way that their surfaces break, allowing them to join. Out of curiosity Erlandson began to experiment with other trees such as box, elder, ashleaf maple, oak, willow, mulberry, and acacia. He carried out the work over a period of fifty years, during which he employed techniques such as grafting, bending (often using extremely elaborate wooden forms), and pleaching. The result of these experiments was the creation of eighty extraordinary tree sculptures, forty of which were still alive when he died in 1964.

Impressive as they are, Erlandson's tree sculptures hardly respect the natural characteristics of the original trees. It is sometimes quite difficult to tell the species from which these "mutants" were grown, and it is quite likely that there are those who would find such work sacrilegious. The tree, above all other plant life, is especially revered, possibly because of its distinctive shape and size, but certainly because many trees have lifespans far longer than ours. Preservation orders are put on trees to preserve our green heritage, and the plundering of tropical rainforests for hardwood causes a public outcry. The tree has become a symbol for the preservation of life on earth.

The German artist Joseph Beuys was aware of the powerful associations of trees when, in 1982, he set about planting 7,000 oaks as his contribution to an international art exhibition in Germany. He wanted to embark on a work that was concerned with "regenerating the life of humankind within the body of society." Beuys saw a tree as "an element of regeneration which in itself is a concept of time." He chose the oak for his purposes "because it is a slow-growing tree with a kind of really solid heart wood" and because for him it has always been "a form of sculpture, a symbol for this planet."

OPPOSITE A young oak, its distinctive shape clearly visible, stands alone at the side of a road. It was planted on the instructions of the German artist Joseph Beuys, who had 7,000 oaks planted as part of an environmental artwork. Each tree was accompanied by a standing stone inserted into the ground, and they were installed throughout Germany, many in urban areas.

ABOVE The first tree planted in Beuys's project was sited outside an art gallery in Kassel. The artist died in 1986, but thousands of young oaks live on as a fitting memorial to an artist whose work was always concerned with social and political issues.

MIXED MEDIA

Plants have been a source of inspiration for artists and designers for centuries. They have inspired decorative styles that have enlivened architecture and enriched furnishings and fabrics. Now there are artists and designers who are not content simply to copy plant forms but who choose to work directly with plants. Some use living plants as their principal medium in making a sculpture, while others use them with other materials. These mixed-media creations are often made, at least in part, in the studio rather than outdoors. Many are designed to make us think about environmental issues. Others are made simply for fun – to amaze and entertain.

A mixed-media sculpture is one in which the artist employs more than one evident material to express a visual idea. This type of sculpture emerged around the beginning of the twentieth century and was pioneered by artists such as Picasso and those associated with the Russian Constructivist movement. It rejected the traditional materials of sculpture, such as stone, clay, and bronze, in favour of experimentation with less conventional ones, including plastic, steel, and glass. Each of the materials employed played a significant and visible role in works that were often abstract compositions. Mixed-media sculpture is now commonplace and has extended its boundaries further to include living materials.

Many forms of living sculpture rely on non-living elements or materials for their realization. Historically, complex topiary could not have been achieved without the use of wooden frames on which to train the plants. Modern topiary, which more often uses climbing plants, employs sophisticated metal structures for this purpose. The same is true of turf-work, in which an armature is often required to support the sods of turf. However, in all these instances the other, non-living medium plays a subordinate role and is not intended to be visible. In mixed-media living sculpture the relationship between the living and non-living materials is more symbiotic. Both elements are intended to be part of the visible form of the sculpture.

The combining of a living plant with a man-made element in the cause of art or decoration has been practised for centuries. In China, during the reign of the Emperor Yangdi of the Sui dynasty in the seventh century, the natural features of the landscape were frequently embellished. It is said that during the winter the leafless trees in the great parks would be decked out with artificial flowers made of silk. In what is now Thailand the traditional Siamese style of gardening concerned itself above all with details and was particularly interested in gnarled and clipped trees, which were often given a sculptural symbolic role by the addition of elements such as carved heads. At the Pimai ruins in Thailand a stone head has become an integral part of a growing tree.

The desire to combine a living medium with an artifact is an enduringly popular impulse, and in everyday life it is probably most evident in the development of the ornamental planter. In gardens everywhere one can see mass-produced, gargoyle-like, "scalped" heads, usually made from terracotta or other ceramics, into which one is supposed to plant suitable house plants or shrubs to represent the hair. But even without contrived containers and human intervention plants will integrate with other non-living materials.

PREVIOUS PAGE In Laura Stein's sculpture "Filled" tomatoes were forced to develop into unnatural shapes by being grown in vacuum-formed moulds. The cartoon face adds a macabre sense of fun to a work that is intended as a comment on the dangers of tampering with nature.

OPPOSITE Many centuries ago a stone head was inserted between the vertical folds of a tree trunk growing along the wall of the main hall at Pimai, in Thailand. Over the years the tree has grown to accommodate the carved head, which has become a part of its venerable structure.

RIGHT Given the right conditions, moss can be encouraged to grow on all kinds of surfaces. Here it has been transplanted onto a carved head. The moss brings the head to life by providing it with a growing crop of "hair" and a bushy "beard."

Some plants will adhere to surfaces quite naturally. Self-clinging ivy, for example, can transform a brick wall into a living tapestry and create a home for wildlife. Moss and slow-growing lichens can camouflage or disguise stone. The nature of the host often gives the plant its final form.

A trellis screen or a ceramic pot might support and shape a living plant, but its role has more to do with the craft of gardening than that of making living sculpture. Decades ago the plastic arts ceased to be restricted to the application of paint to canvas or chisel to stone. Nor was art any longer confined to the studio, and its relationship with life has become ever more intimate. One consequence of this change is that living plants have become an accepted medium in the making of sculptures, and nowadays they are often used in combination with other materials to create mixed-media works.

LEFT This imitation miniature tree was made by combining living and non-living media. The trunk was modelled in clay, which also acts as a container for an evergreen dwarf hebe that provides the "tree" with its green canopy. The plant is clipped regularly to maintain its tree-like shape.

Artists have many reasons for making art that includes roots, stems, branches, leaves, and flowers. For some the motivation may simply be an aesthetic one, perhaps a desire to "paint" with natural living colours rather than chemical pigments. But for others, such as the American Laura Stein, it is a direct means of making art about the social and ecological issues of today. Among the issues Stein addresses is the widespread fear of genetic engineering, and her anthropomorphic vegetables bring to mind radiation-induced mutations and horror-movie freaks.

Stein works with high-tech horticultural techniques to grow bizarre objects seemingly inspired by Frankenstein's monster. In 1996 she created "Filled, " one of a series of works on the same theme that involved interfering with the growth of a tomato by confining it in a vacuum-formed mould. The moulds she used, shaped like the faces of cartoon

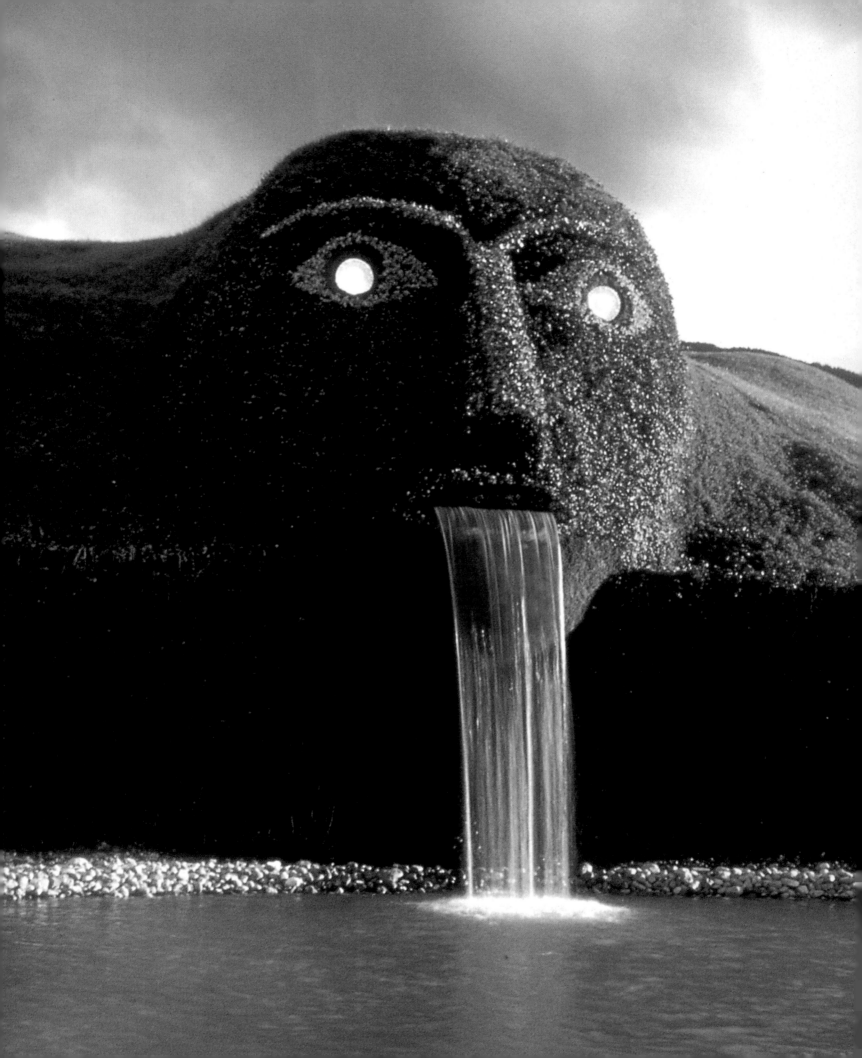

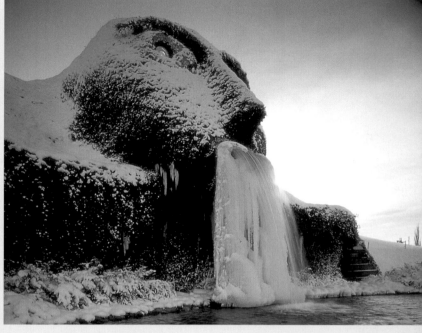

ABOVE AND LEFT This huge, water-spouting head at
the Swarovski Crystal Worlds glasswork collection in
Austria is a piece of living architecture. Covered
with various types of ivy, some of which serve to
distinguish the features of the face, the landscaped
head projects from a hill that contains a number of
interconnected, subterranean chambers and galleries.
In winter the snow and the ice make the monstrous
head look even more dramatic.

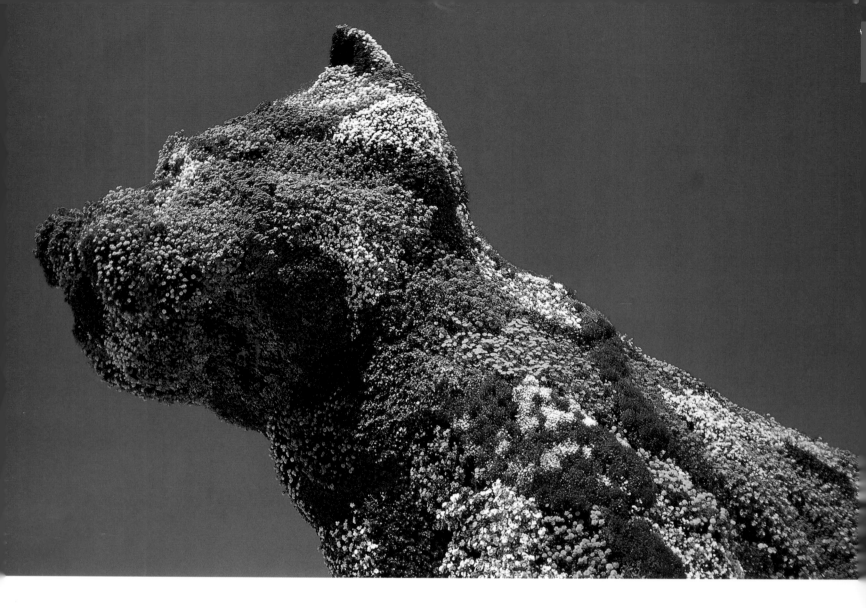

ABOVE Jeff Koons created his outsize "Puppy" in 1992 from 17,000 bedding plants, fixed to a steel and timber frame. In order to maintain the colourful surface the plants have to be replaced on a seasonal basis. When the plants are in full flower, as here, the mixture of vibrant colours turns the puppy's "coat" into an abstract expressionist vision.

animals, were first secured over the young, emerging tomatoes. As they were transparent they permitted light to reach the developing fruit, but their shape restricted and altered the way the fruit would normally develop. A growing tomato can exert great physical strength, and during the "growing" of these sculptures Stein discovered that many of the tomatoes would try to break out of their restrictive moulds. Some were too strong to be contained, but most conformed to the imposed shape. The mutant tomatoes were often exhibited with their vacuum packaging still in place, as if to highlight the disturbing manner of their production. For Stein the method is as important as the result. Here the process is a comment on both natural creation and the scientific experimentation that is pursued nowadays with the aim of improving on nature. Stein once commented that she liked the adaptability of fruit and vegetables, and that her restrictions on them were similar to the impositions placed on us all in daily life.

While Stein's creations satirize the contemporary desire to manipulate and have power over nature, they also highlight an attitude that has existed since man actively began to

cultivate crops. Ever since then gardeners all over the world have delighted in improving vegetables and flowers to make them bigger, tastier, more hardy, or more free-flowering. The list of natural characteristics that seem to need improvement is endless. Even the natural shape of a shrub or tree can be altered or improved by employing long-established techniques such as pollarding or grafting. By encouraging plants to behave and grow in a particular manner on man-made structures and forms, we can make them an integral ingredient in both artistic and architectural expression.

Part architecture and part horticulture, the feature constructed in 1995 to house the Swarovski Crystal Worlds collection of glasswork at Wattens, in the Austrian Tyrol, is extremely impressive. It was conceived and designed by the Austrian multi-media artist André Heller, whose output includes garden art, parades, and the written word, as well as performances at circuses and on stage. The building was sculpted from the landscape, and the resulting grass-covered mound conceals a series of interconnected chambers, on three storeys, that cover an area of 2,000 square metres (21,500 sq ft). The most spectacular feature of the structure is a huge, gargoyle-like head. Water cascades from its mouth into a lake below, and at night beams of light shine out of its crystal eyes. The form of the giant head is rendered in different types of ivy, which gently merge with the grassy mound that surrounds it. The details of the face are identified through the controlled use of variegated ivy, which is tended to maintain the distinctive features.

ABOVE Jeff Koons's huge floral sculpture "Puppy" welcomes visitors to the new Guggenheim Museum in Bilbao, Spain. When the work, 11.5m (38ft) high, is viewed from a distance it is hard to imagine what it is made of; only on close inspection does one realize that it is constructed from plants. Both the subject matter and the material depart radically from conventional monumental sculpture.

LEFT In this mixed-media turf-work by the Swedish artist Bitte Jonasson-Akerlund the combination of a simple wooden form, which also acts as a planter, and clumps of grass is sufficient to create a recognizable caricature of a poodle.

ABOVE "Inukshuk" was shown at a mosaiculture festival in Montreal in 2000. The massive sculpture's surface was made from a mass of tightly packed seasonal bedding and low-growing foliage plants.

This idea of creating a large, representational sculpture that is not free-standing but is an integral part of a garden landscape has its origins in the gardens of Renaissance Italy. Many of these had large, sculptural features that were either built into or made from the landscape. The garden of the Villa Orsini in Lazio, created by the Duke of Bomarzo, is renowned for its colossal sculpture and includes a huge, open-mouthed, laughing mask, cut directly into a rock face. One of the most famous colossal statues was made for the sixteenth-century Medici garden at Pratolino, near Florence. Behind the villa the rising ground was cut in the form of an amphitheatre that was dominated by an enormous statue of "Appennino," attributed to the Florentine artist Giovanni da Bologna. The bearded giant crouches on a rock with his hand pressing on the head of a monster so that water gushes out of its mouth and into a semicircular pool below. The rock was planted, and the vegetation has now crept up the figure and begun to clothe it. The massive landscaped sculpture is all that now remains of this once great garden; the rest was destroyed in 1819 and an English-style garden was formed.

The modern, organic, planted sculpture that surrounds the Swarovski Crystal Worlds is intended to be a permanent feature, and it is given regular maintenance so that it retains

its appearance. Longevity, however, has not been an issue for most of the artists who have chosen to work with living plants. On the contrary, it is often their changing and transient nature that makes them attractive as a sculptural medium. For artists for whom colour is important, flowers are the logical choice. But colour is the most short-lived feature of a plant, and therefore to maintain a colour effect throughout the seasons it would be necessary to replace plants several times. The idea of "painting" a sculpture with flowers would seem to be folly. To plant flowers on a sculpture of architectural proportions seems even more futile.

This did not deter the American artist Jeff Koons, who chose the innocuous form of a puppy as the theme for a monumental flower-bedecked artwork. A first version was erected in 1992 at the castle in the German town of Arolsen. The outline of "Puppy" was formed from a framework of wood and steel, which was secured to a concrete base. This was then smothered with living flowers. The predominant colours of red, yellow, and white gave the dog a surreal quality but also added tonal variation to the surface. "Puppy" required 17,000 flowers, planted in receptacles containing 20cm (8in) of earth, to cover it completely. Koons chose those that would grow and remain in flower for the

BELOW In this three-dimensional version of carpet bedding, colour and form combine to create a lifelike representation of ducks taking off from water. The fascination of this sculptural mosaiculture derives not just from the skill required to weave countless small plants together with great accuracy, but also from the ambitious choice of subject matter.

131

four summer months during which the piece was to be exhibited. After that it would have to be replanted, but the next time it could be created with spring flowers. One of Koons's main concerns was that the structure should be able to withstand the weather, particularly the wind, without the flowers breaking off. Since the plants were exposed to full sun, it was also essential that they could be kept moist.

It was not the natural elements that threatened "Puppy" when it was next exhibited, in front of the Guggenheim Museum in Bilbao, in northern Spain. The monumental piece, a somewhat pretentious but in all other respects innocent work of carnival art, became implicated in local politics when it was installed in 1997. Just before the formal opening of the new museum three Basque terrorists disguised as gardeners tried to deliver a truckload of replacement potted flowers in which they had planted grenades. The plot was thwarted, but not before a local policeman was tragically gunned down when he interrupted them. Ironically, Koons, who loves Baroque architecture, had intended "Puppy," with its interior resembling a church, as an image that would communicate warmth and love to those who saw it.

The elevated status of "Puppy" as a work of avant-garde art conceals the fact that its origins lie in the traditional seasonal English flower bed, which in turn developed into the art of mosaiculture. A form of decorative bedding that evolved in France during the mid-nineteenth century, mosaiculture combines carpet bedding – the use of low-growing or creeping foliage plants – with the style that uses seasonal flowers. During the twentieth century this decorative and pictorial floral art has literally taken on another dimension: it has been adapted to cover three-dimensional objects with colourful designs.

In Canada in 2000 a major festival was organized to celebrate this popular, multicultural activity. The event was hosted by the city of Montreal, where a formerly derelict canal basin was transformed for the purpose. Adopting the theme "The planet is a mosaic," the festival displayed forty exhibits from fourteen countries. Real expertise in the art has developed in the Chinese cities of Shanghai and Harbin, and Montreal's relationship with these was a contributing factor in the decision to stage the festival. The works were made by fixing carpet bedding and low-growing flowers to pre-formed frames to produce elaborate and, in some cases, massive sculptures. Very small specimens are packed together tightly to create the desired effect, and in this way extraordinary detail can be achieved. One of the most impressive sights was a depiction of a flock of ducks taking off from the canal. Their plumage in particular showed a remarkable degree of realism.

This type of floral art is rarely intended to be permanent because it requires a lot of maintenance. It is mainly associated with events such as flower shows and short-term commemorative displays in public parks. While many mosaiculture creations are undeniably spectacular, most are the work of nurserymen and gardeners with no training as artists, so that some of the sculptural ideas inevitably border on the kitsch. This pitfall was avoided by the British designers Hill and Heather in their garden for the Anthony Nolan Bone Marrow Trust at the Hampton Court Palace Flower Show in 1995. The garden was based on the surreal world of Lewis Carroll's book *Alice in Wonderland*, which provided the perfect justification for fantastic planted sculptures, including giant cups and saucers.

The free-standing sculptural and floral creations seen at Montreal or Hampton Court would not have been possible without elaborate internal structures to hold all the plants

ABOVE The garden designed by the Hill and Heather partnership and shown at the Hampton Court Palace Flower Show in 1995 was inspired by the dreamlike world of Lewis Carroll. It contained planted familiar hard objects, such as teacups, as outsize soft sculptures, while grass squares created a huge chessboard. Other materials were used to complement the living sculptures and to complete a fantasy world of enlargement and illusion.

LEFT All the elements in Samm Kunce's multi-media installation "Law of Desire" function collectively as a life-support system for the grass suspended from the ceiling of the exhibition space. Pumps circulate water from simple reservoirs on the floor, while tubular lights fixed to the walls provide light of the right wavelength to promote photosynthesis by the grass and the resultant growth of this living sculpture.

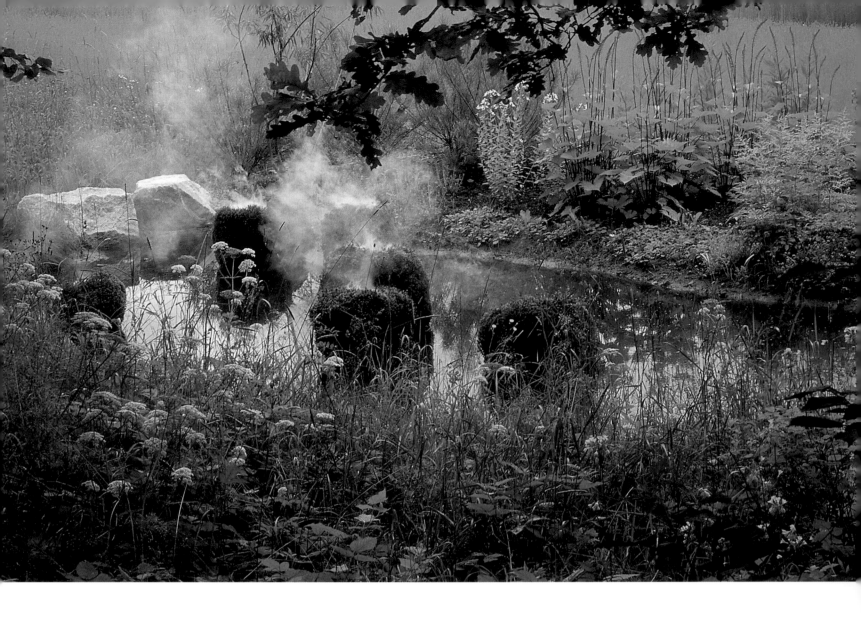

ABOVE Scattered about a wildlife pond, these rounded forms appear to be no more than moss-covered rocks — until they puff out clouds of mist. They are in fact sculptures, made by Thomas Nordström and Annika Oskarsson. The moss conceals a chicken-wire structure that houses a pipe connected to a discreetly located mist-generating machine.

in place. These act like the armature used in a conventional sculpture of plaster or clay. Although this support is essential in shaping the sculpture, it usually remains invisible. This is not the case in the mixed-media living sculptures of the American artist Samm Kunce. In her work every aspect is on show — not just the support but also the means by which the plants are maintained and kept alive.

The sculptural installations that Kunce devises are about growing. More precisely, they are about the nurturing of healthy plants in the absence of natural conditions. Her hydroponic "gardens" have produced strawberries, lettuce, grasses, and moss in indoor environments totally deprived of both sunlight and soil. They are completely dependent on their visually interesting artificial life-support systems. Vinyl-lined reservoirs, pumps, and hoses supply water and nutrients, while powerful halide lamps enable the plants to photosynthesize and develop. In a work named "Law of Desire," which she created in 1995, Kunce persuaded grass to grow indoors in cylindrical, felt-clad clumps suspended from the ceiling of an art gallery.

Kunce grew up near Disneyland, Florida. Her parents' house had a garden with a thriving green lawn that existed where it should not have. The whole surrounding suburban landscape was an artificial oasis created in what was naturally a desert. Kunce's consequent awareness, early in her life, of the artificiality of man-made environments has influenced her work. Her sculptures are a comment on modern technology's ability to interfere with the processes of nature, in a world where the difference between what is natural and what is artificial is often blurred.

There is something deliberately disconcerting about the relationship between the plants and their artificial life-support systems in Kunce's installations. Her work, like Laura Stein's, belongs to a genre of living art that is openly concerned with ecological issues. Other artists, craftsmen, and even gardeners have explored a less disturbing and more positive relationship between plants and the context in which they are grown. In encouraging them to flourish in unlikely situations they have frequently achieved spectacular and surprising results.

Mosses are adaptable plants, and although they prefer moist and shady horizontal situations, they can establish quite happily on vertical and unusual surfaces given the correct conditions. The Swedes Thomas Nordström and Annika Oskarsson used the versatility of moss to good effect in a wildlife garden at a Swedish garden festival in 1998. The event, which took place in Stockholm when the city was Cultural Capital of Europe, was intended to bring together craftsmen and gardeners. The two artists' contribution appeared to be simply a group of moss-covered rocks set in a dark pool. But there was more to these than was at first obvious, as they were capable of suddenly puffing out clouds of white smoke. In reality the "rocks" were moulded balls, made from chicken wire, which were filled with compost and covered with live moss. They were held up in the water by concealed metal supports, and the mysterious smoke came through pipes from a nearby fog machine controlled by a random timer. In this unusual piece of kinetic sculpture the living moss acts as a decoy, making one think that the piece is natural and has not been engineered in any way.

Growing plants for the more conventional purpose of providing fresh food is just part of Marilyn Abbott's aim as a gardener. Her design for her vegetable patch in the walled garden at West Green House in Hampshire, England, combines practicality with visual effect. The centrepiece is the "Bean House," which was created to form a frame to support runner beans but is also a work of horticultural architecture. The single-storey

137

ABOVE A gravel path leads to the red doorframe of Marilyn Abbott's "Bean House." The structure's main function is to act as a support for a generous crop of runner beans, but this modest piece of horticultural architecture also provides her vegetable garden with an unusual focal point.

building, of frame construction, is complete with a chimney and is reached by a narrow path that leads to a red doorframe with blue-painted windows on either side. At the height of the growing season this "cottage of trellis work," as its creator calls it, is covered with runner beans in four colours: purple on the front wall, red and white on the sides, and green at the back.

Vertical gardening has also interested the designer Patrice Blanc. His concept garden for growing plants on vertical surfaces was first seen at the Festival International des Jardins, at Chaumont, in Blanc's native France, in 1992. His "Vegetal Wall" consisted of two steeply inclined, back-to-back surfaces. These were covered with felt-like capillary matting with pockets in which a variety of plants were placed. The plants were sustained by water that constantly streamed down the face of the walls into a reservoir below. This fusion of sculpture and garden is now being put into practice in Paris, to create gardens where space on the ground is limited.

The American artist Vito Acconci had a similar idea when he was asked to propose a sculptural work for Atlanta, Georgia, to coincide with the city's hosting of the 1996 Olympic Games. His "High Rise of Trees" consisted of four trees stacked one on top of the other. Each tree was planted in an earth-filled container made of clear Plexiglass, and the tower they formed was supported by an external steel frame. For Acconci plants are an essential part of his intentionally disorientating sculptural compositions. We do not expect to come across trees growing in this way.

ABOVE Seen here lit up at night, Vito Acconci's towering "High Rise of Trees" was one of several works of art commissioned for the Olympic Games in Atlanta, Georgia, in 1996. The painted steel structure enabled the artist to present the living trees in an unnatural and somewhat disorientating context.

OPPOSITE Patrice Blanc's "Vegetal Wall" is a free-standing living sculpture that draws its water supply from the slim, rectangular pool in which it sits. The portable structure could be located in any place that has a pond to provide water for circulation over its planted surfaces.

Acconci works with the elements of the man-made environment, such as architecture and engineering, to create unusual spatial contexts for plants. The idea of "context" has been of interest to many of the artists who have created mixed-media planted sculptures. Some have chosen to employ "found" objects as a setting for a "garden." An old car destined for the scrap heap was given a new lease of life by one artist, who planted it with a collection of foliage plants. Other artists have elaborated on more conventional means of growing plants, designing purpose-built containers to create planted sculptures. The form and texture of the chosen plant becomes an integral part of the abstract sculptural composition.

"Out of context" is the best way to describe a planted, multi-media work by Meg Webster. In 1989, at the Whitney Museum in New York, the American artist recreated a slice of a natural wetland landscape. Made of rubber sheeting stretched over

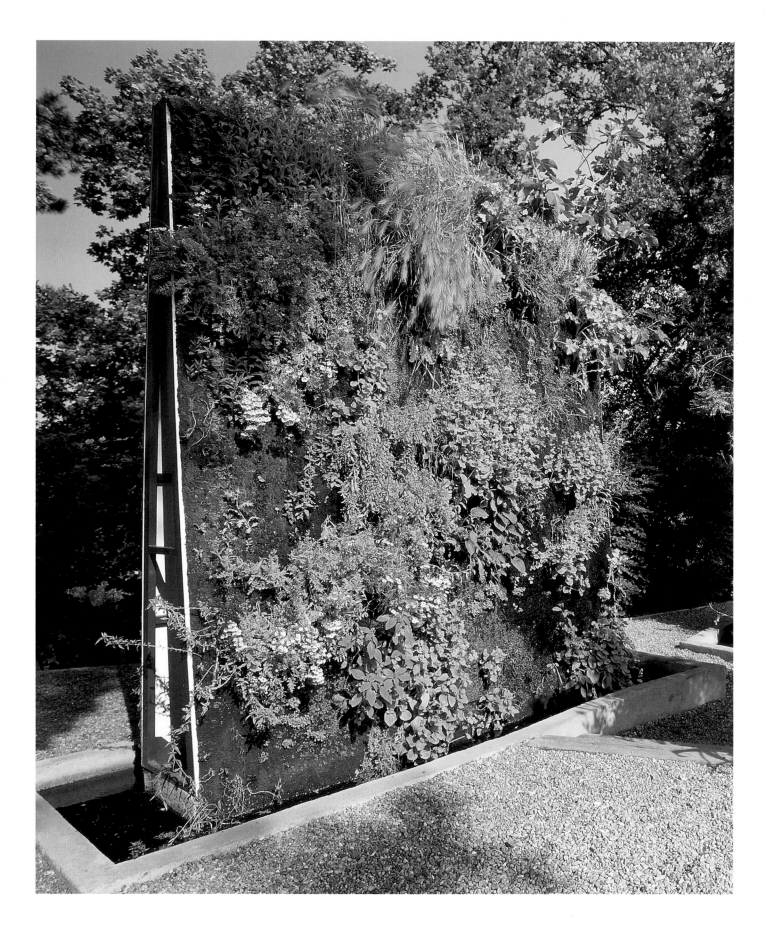

ABOVE LEFT An old car was customized by turning it into a "car-den." The ultimate "green" car, it perhaps coveys the message that we need to control one of the world's biggest polluters.

ABOVE RIGHT The sculpture "Quincunx II" was made by the author from fibre-glass. A slit-like opening allowed stones, soil, and living plants to be inserted. After a period of time the precise geometry of the sphere was replaced by a more organic form as the plants began to grow over its surface.

a steel-and-wood construction, the broad, table-like structure held up the fragment of wetland environment for close inspection. A concealed pump kept water circulating through the work. Like an animal in a zoo, this vulnerable bit of nature, normally out of our reach in the wild, was brought to us at our convenience. Webster's intention was to highlight the futility of controlling and imitating nature in the cause of entertainment.

Because living sculpture is about living forms it can also involve the natural processes of decay that accompany life. The British artist Sally Matthews's sculpture of a group of wild boars began to disintegrate almost as soon as it was completed. "Wild Boar Clearing" was made between 1987 and 1989 at Grizedale Forest, in Cumbria. What started for Matthews as a short sculpture residency during which she would make a single wild boar was soon extended to enable her to increase the family.

Working in the forest rather than her studio, she discovered dead wood, twisted roots, and other forest debris appropriate for creating the visual character of the animals. As a site she chose a boggy hole, away from the gravel forestry track, which meant people

would stumble upon the work by accident. She felt that this gave it the "opportunity of being seen as animals with us, rather than animals as art." The boars certainly looked real, not least because their natural behaviour was mirrored in the way they were shaped. They wallowed, they drank, they rubbed their behinds on the trees, and several looked alarmed, as if disturbed by the spectator. The two boars wallowing in the bog were made out of the mud in which they lay. Matthews added cement to mud and pine needles to make them more permanent, but they soon began to decay. Moss grew on their backs, part of the process that was returning them and the others to the forest floor from which they came. The "living" aspect of this sculpture is almost accidental. The boars may look alive, but the living biological content derives as much from the biodegradable nature of the materials as it does from any intention to make a living work of art.

Ian Hamilton Finlay has also found inspiration through working alongside and with the living environment. The British poet, sculptor, and gardener has chosen the garden as his principal means of artistic expression. His most comprehensive project is his own ongoing garden at Little Sparta, near Dunsyre, in the Pentland Hills of Scotland. Like that of Sally

ABOVE A living wetland was recreated and exhibited as a work of art by the sculptor Meg Webster. Made in 1989 at the Whitney Museum in New York, the work consisted of wood, steel, pumps, a waterproof liner, water, soil, rocks, and wetland plants. Webster's mixed-media installation was intended to highlight the importance of wetlands as an ecological habitat.

OVERLEAF Sally Matthews's highly lifelike sculptures of wild boars were originally made from forest debris held together by mud. Although not a true "living" work of art, they were made from materials that soon decayed naturally. Living plants, moss, and fungi grew on the boars, adding to the process of deterioration.

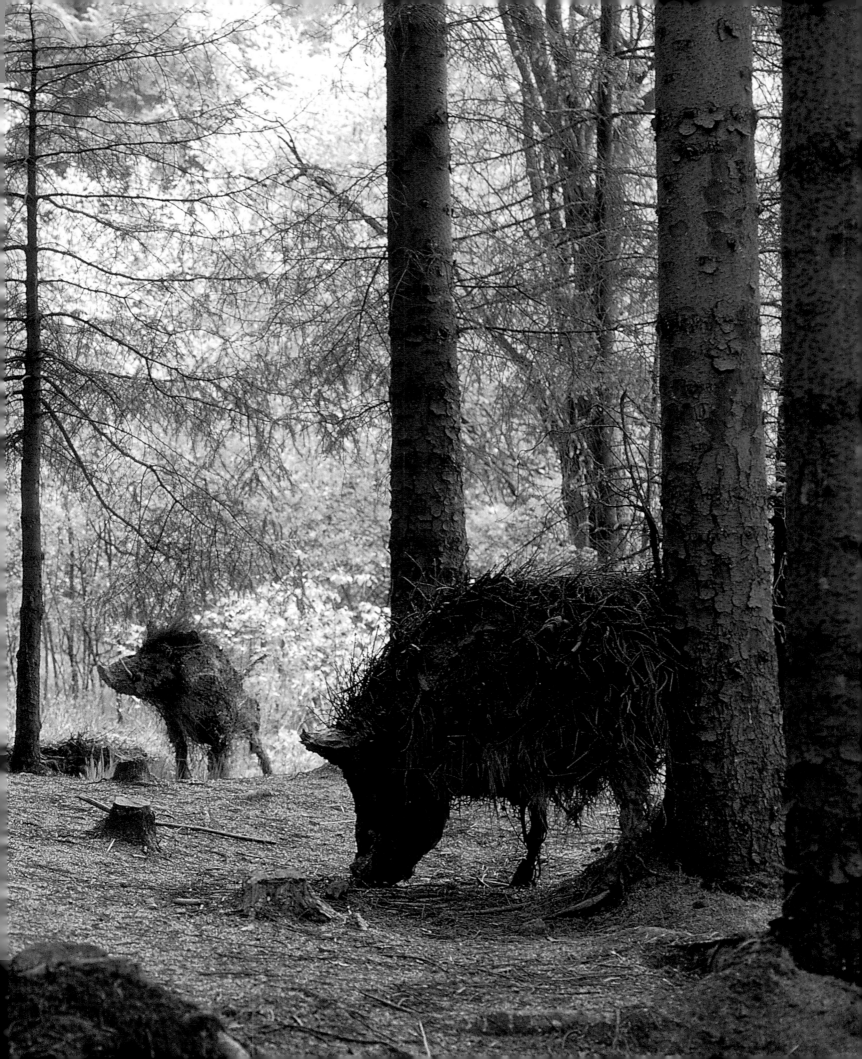

RIGHT As part of the "Hillside Pantheon" in Ian Hamilton Finlay's garden at Little Sparta, in Lanarkshire, Scotland, a stone column surrounds the base of a silver birch. The inscription "Michelet" on the stone makes tree and plinth into an architectural feature and a tribute to the French historian.

Matthews, his work does not directly involve the shaping of living material. Topiary, pollarding, pleaching, and other horticultural methods are not his sculptural techniques. Instead he adds to the living world. He lends poetic and sculptural meaning to trees and plants by placing inanimate objects in close proximity to them. The combination of the two elements becomes a work of three-dimensional poetry.

Finlay believes that gardens should appeal to all the senses. As well as being places that we tend for pleasure and relax in, they should stimulate thought and provide inspiration. To achieve his aim Finlay has rediscovered the art of emblematic garden design.

Emblematic gardens have existed for centuries and were particularly popular in Roman times and the Renaissance. In this approach to making a garden it was intended that the association of arranged plants and inanimate objects could be considered on two levels. The garden could please with its shapes, colours, and composition, but it could also evoke an intellectual response, in that each element was used to symbolize something else.

It is in this spirit that Finlay continues to transform and add poetic meaning to the garden of his hill farmstead. Little Sparta has become one of Britain's most thought-provoking and, at times, most controversial gardens. First and foremost a poet, Finlay understands

ABOVE Ian Hamilton Finlay uses emblems, often in the form of inscribed tablets of stone, to place trees and other natural elements of his garden in Scotland in a poetic context. In this typical juxtaposition of the living and the inanimate the structure and texture of the branches of a mountain ash are brought to our attention by the monogram of Dürer. Appropriately, the detailed drawings of the German artist emphasize the beauty to be found in simple natural objects.

the power of the written word, and its use dominates the sculptural and architectural forms that are arranged about the garden.

There is much wit in Finlay's superbly crafted and inscribed stones. An inscription on a free-standing stone near a circular temple of young sycamores reads, "Bring back the Birch." At every turn there is poetic or witty wordplay to be seen on carved stone classical memorials, concrete slabs, columns, and sundials. Finlay made a dandelion clock, a carved stone with two recesses into which each year he plants clumps of dandelions to make the clock "work." A stone tablet hanging from the branches of a tree, like a giant botanical label, carries the signature of the early sixteenth-century German artist Albrecht Dürer. Elsewhere Finlay has commemorated a detailed drawing by Dürer of a piece of turf. He has recreated "The Great Piece of Turf" as an island at the edge of the garden's courtyard pond. This miniature landscape of marsh grasses and flowers, a living evocation of the German artist's drawing, is also "signed" with a stone bearing Dürer's monogram.

What is most significant about this garden is that many of the poetic emblems are not just situated next to, or associated with, the plants but are a part of them. Finlay goes beyond traditional emblematic gardening by combining the inanimate with the living. For example, around the bottom of a group of trees he has placed a series of cut-stone plinths, out of which the trees appear to grow, like columns. One such plinth is inscribed to the nineteenth-century French historian Michelet. The tree becomes both a living column and a memorial to the writer, whose monumental history of France culminated with and celebrated the French Revolution of 1789. Michelet is an appropriate hero for a garden that has been the subject of political conflict. Finlay once did battle with the local authorities when he declared his garden to be an independent state free from Scottish rule.

Finlay's garden draws on the eighteenth-century search in England for the "picturesque" in the landscape. The Picturesque tradition was inspired by the works of the French painters Claude and Poussin, whose idealized vistas were littered with classical antiquities. But, unlike "Capability" Brown and other protagonists of the movement, Finlay does not aim for the appearance of nature untouched. Instead he aspires to a concept of nature improved by the intellect and the addition of the man-made.

Working with the landscape to make gardens or to create living landmarks in it requires the use of materials that are often more geological than biological. In sculpted earthworks the living turf covers and conceals a supporting sub-base that is composed of

147

OPPOSITE In this work by the Czech landscape designer Vladimir Sitta the roots that project through the arching wooden structure belong to trees that have had their canopies "planted" out of sight, on the other side. The shaped and bent timber planks of the curved wall make an interesting contrast to the living wood of the trees.

rocks and rubble. Occasionally, however, both geological and biological elements are intentionally visible side by side, as in a labyrinth created by the British artist Jim Buchanan in the Galloway Forest, in Scotland. Here the pattern of the labyrinth is defined by gravels and local debris as well as by the indigenous grasses and scrub of the pine-forest floor. As with Sally Matthews's "Wild Boar Clearing," this work is not typical of mixed-media living sculpture. Made exclusively from materials found to hand and worked with at the site, it is far removed from the more frequently encountered studio- and gallery-based examples of the art form.

The whole of Ian Hamilton Finlay's landscaped garden could be regarded as a living work of art, created by working with the landscape and using living plants. It is clearly not made for exhibition in a gallery. However, the sculptural items that he has introduced into the garden to relate emblematically to the plants are produced in the artist's studio or the stonemason's workshop. It is here that plaques are inscribed and architectural fragments and other elements are carved from stone. In this sense Finlay differs from artists who make living sculpture purely by using growing trees and shrubs or by shaping the natural landscape. Many other artists who make mixed-media living sculpture are, like

BELOW In Jim Buchanan's "Galloway Forest Labyrinth," made in Scotland in 1999, the pattern of the labyrinth is defined by a path built 1m (3ft) above the ground. Stone chips form the surface of the path, and the gullies between its coils are filled with stone debris. The sloping sides of the path are seeded with wild local grasses. At the centre of the labyrinth there is a stone cairn that is surrounded by water when a nearby stream overflows.

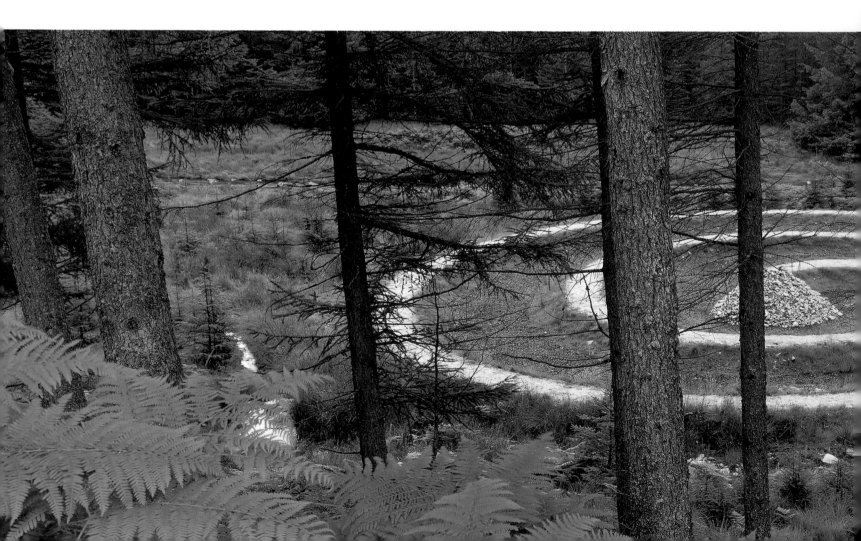

him, not driven by a desire to return to nature. Indeed some seem to be unconcerned by any moral obligation to conserve and respect nature. The plants in Jeff Koons's "Puppy," for example, are regarded as surplus to requirements when they are not in flower, and are discarded to make way for the next flowers to come into season. In fact in all floral displays that use bedding plants there is an element of exploitation of the living material.

For mixed-media artists who work with living plants out of respect for nature and wish to make statements about environmental issues, there is no need for work to be overtly "of the environment," nor for it to be seen in some remote wilderness. To them it is more important that their work should be installed in a public art gallery, where its accessibility allows it to communicate its message to its intended audience. In addition, in the installations by Meg Webster or Samm Kunce it is not natural processes that make the work transient but the duration of the display. Outdoor works, such as those made by Vito Acconci, are more like non-living, modern public sculptures in their appearance. The man-made element provides the work with a visible and permanent structure. The plant material is an essential ingredient but replaceable when it outgrows its function. Mixed-media living sculpture is not the art of the living plant world, but art that uses living plants.

149

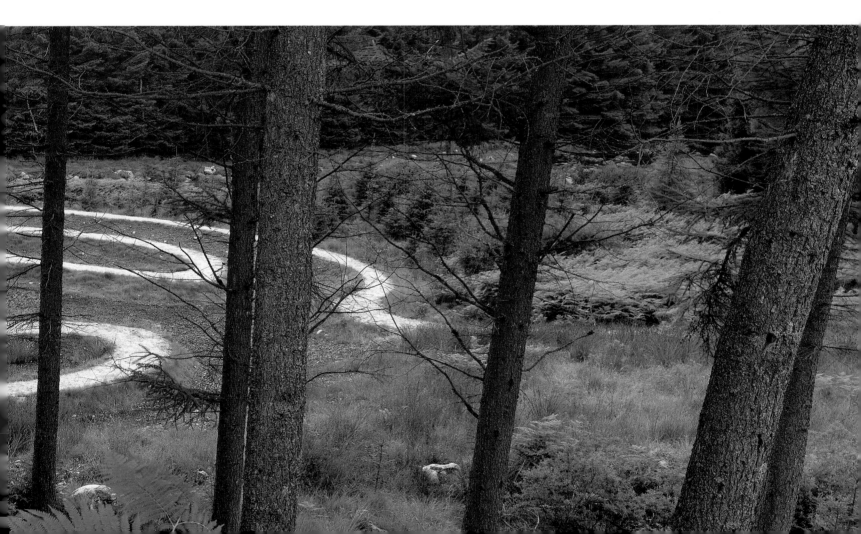

CROP ART

Crops are cultivated plants and embrace grasses and cereals, fruits and vegetables. Since the nineteenth century flowers also have been regarded as a commercial crop, and grown in vast quantities for the market. It seems unlikely that any kind of crop could be a means for making art, not least because of their transitory nature. Yet it is this very fleeting existence that has attracted artists to the idea of using them. "Crop art" is often harvested or allowed to disappear under new growth, leaving no trace of the artist's hand. It fits with the concept of "environmental" or "land" art, where the gallery and the dealer are rejected in favour of a way of working that has no interest in the permanent, marketable object. Crop artists have abandoned their studios for a more public arena.

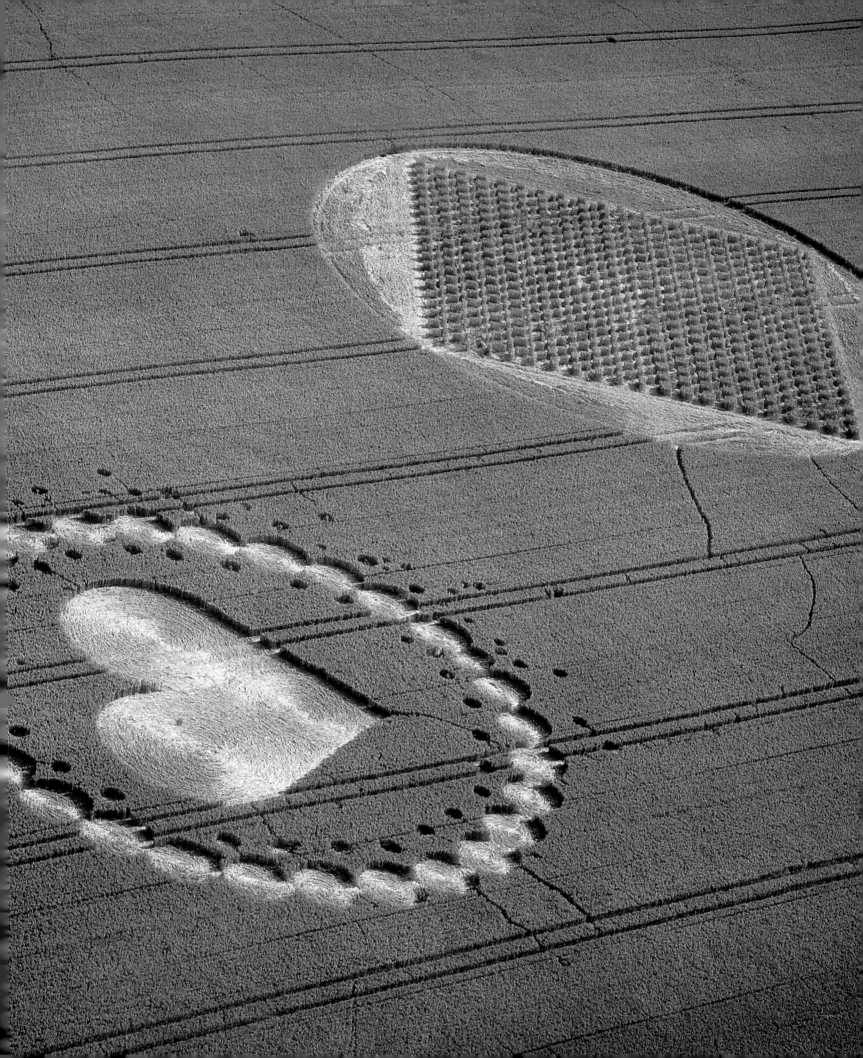

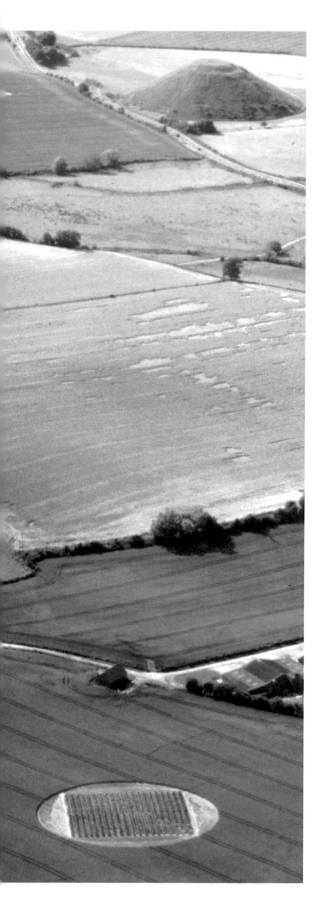

Just as there is a great variety of crops now being grown, so there is an enormous diversity in the work of those artists who have chosen to use cultivated plants as their principal medium. In Britain "crop art" is most commonly associated with "crop circles," a phenomenon that came to public notice during the 1970s and recurs in some form at harvest time every year.

A crop circle is an area within a standing crop where the plants have been flattened. Originally crop circles were thought to be a natural phenomenon, and it is possible that the less sophisticated of these round circles are caused by natural forces, perhaps by freak winds. A more fanciful point of view attributes them to visits by alien spaceships. But if there is a scientific explanation for the simpler circles, the more intricate patterns are almost certainly the work of hoaxers, who usually create them under the cover of darkness to lessen the chances of their being detected.

Two impressive crop circles were created in one night in July 2000, in a wheat field near Marlborough, in Wiltshire, England. The proximity of the ancient earthwork of Silbury Hill lent a sense of history to the site. The more complex and unusual work consisted of a 61m (200ft) diameter circle of flattened plants within which a central square was inscribed. Inside the square the wheat was further "sculpted" by being trampled into a grid of almost 800 squares and rectangles. Viewed from the ground, the whole work was a baffling maze of flattened pathways and swirls, but when studied from the air its geometry became clear. From above it could be seen that the numerous rectangular and square forms were designed to modulate light and shade to reveal four additional squares within the larger square. It was never discovered who created this landmark, a work of both imagination and precision. Nearby was the second work: a heart within a decorative circle of similar diameter to the other one.

The trampling of crops is seen as senseless destruction by landowners. But making a design by the way in which one mows a lawn is an acceptable method of exploiting a "crop" and is an art form that adds interest to a garden. The lawn dates back to the thirteenth century, when it was probably no more than a well-maintained field used as a setting for ornamental trees and shrubs. By the seventeenth century in France a clearly defined area of maintained grass had become known as a *tapis vert*, or green carpet. Since then the term has taken on a wider meaning, and is now used to describe grass that has been mowed at various heights to produce patterns. A popular approach has been to base patterns on the ancient labyrinth or maze, which is a frequently used motif in land

art. Creative grass cutting is a simple, unobtrusive, and unpretentious form of crop art, in which modest effort can produce dramatic effects. Changes in light and shadow, and the presence of early-morning dew or frost can add a further dimension to the design.

Grass of a more ornamental variety has been exploited by the garden designer Jacques Wirtz in the garden he designed for a modern house near Antwerp in his native Belgium. Within a large, open lawn he included large and spectacular sweeps of 2m (6½ft) high *Miscanthus sinensis* 'Gracillimus'. This ornamental grass was planted on gently rising mounds to produce a contrast with the surrounding flat landscape. In the summer it stands erect, blowing in the wind. At the end of the growing season the islands of *Miscanthus* are prepared for the winter. But, in place of conventional cutting back, the necessary maintenance of the plant has been turned into a creative process. The dead leaves, gold in colour, are cut and arranged in a considered manner to make a feature of what would otherwise be simply an out-of-season plant. The result is a sculptured winter landscape of broad, swirling, three-dimensional brushstrokes of colour. Wirtz is above all

PAGE 151 Nowadays many crop circles are of a complex geometrical design. However, these recent examples in Wiltshire, England, were, despite their technical sophistication, based on simpler forms.

OPPOSITE It is unlikely to be a coincidence that the crop circle in the foreground was made within sight of the ancient earthwork of Silbury Hill, England.

BELOW A round lawn was enlivened simply by mowing. The idea of a labyrinth inspired this design, in which a mown walk is defined by a series of interconnected rings of less frequently mown grass.

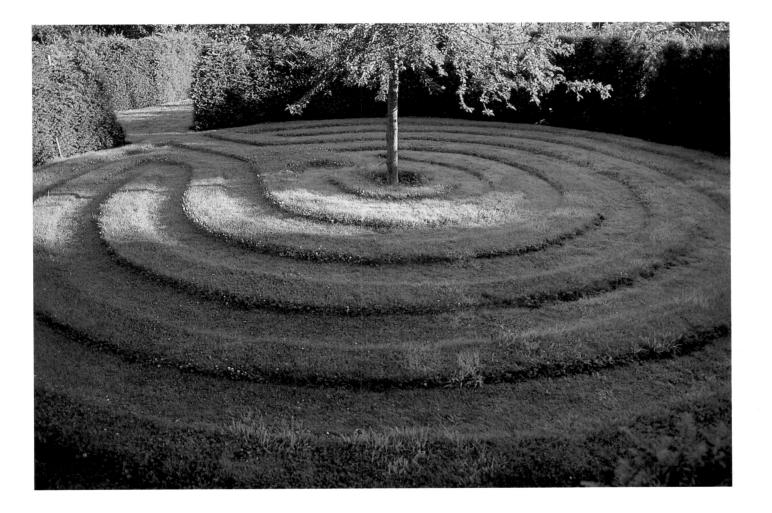

a plantsman, and here he is exploiting a plant's potential to provide all-year-round interest. His crop art also contributes to the upkeep of the garden.

For the artist and sculptor, horticultural husbandry is not the primary motivation for working with living plants. Their decision to use a crop as a sculptural medium is stimulated by other concerns. For the American artist Dennis Oppenheim it provides the opportunity to create art that is transitory rather than permanent, and remote rather than accessible. Today only a photographic record remains of his "Branded Mountain," a work created in 1969 that consisted of a 9m (30ft) diameter copy of a branding-iron mark burned into the coarse grass of rough-grazing land near San Pablo, California. The work evoked the American West of cattle barons, rustlers, and honest cowboys. It was not long before the scorched ground had recovered and new growth began to slowly eliminate all trace of Oppenheim's artwork.

The series of works made by the French artist Pierre Vivant in 1990 was also intentionally short-lived. Each work consisted of the "writing" of a single word, in capital letters, in a field. In one, the word "past" was formed in a field of poppies, while in another "green" and "yellow" were cut into a field of oilseed rape as part of the "Green Yellow Triptych." The works were made by projecting a word onto a field at night, then picking, trampling, or cutting the crop until the word had taken shape. The words were only properly legible from the point from which they had been projected. Once it was completed, Vivant simply left his works in the hands of nature. Eventually the oilseed rape and the poppies grew back and the words vanished.

The captivating quality of Vivant's crop art lies partly in its transitory nature but also in his choice of subject matter – simple words. The clean outlines of the letters have a formal regularity that contrasts with the crop's organic character. The words are chosen to lend further meaning to the work. In "Past" there is a connection between the word and the poppies of which it is made, as this flower is used in ceremonies of remembrance. "Green Yellow Triptych" is equally formal, but is more playful, for the word "green" eradicated the yellow flowers of the oilseed to reveal the lower green stems of the plant, while the word "yellow" highlighted the flowers against the green leaves and stems of the crop.

Vivant's works are as much poetry as art. A variation on the "concrete" poetry of the late 1960s, in which words were given additional meaning by the way in which they were displayed, they could be described as minimalist "crop poetry."

OPPOSITE A modest domestic lawn was transformed into a "green carpet" by mowing and maintaining the grass at different heights. The repeating squares and rectangles of longer grass provide textural and tonal variation between more closely cropped grass paths.

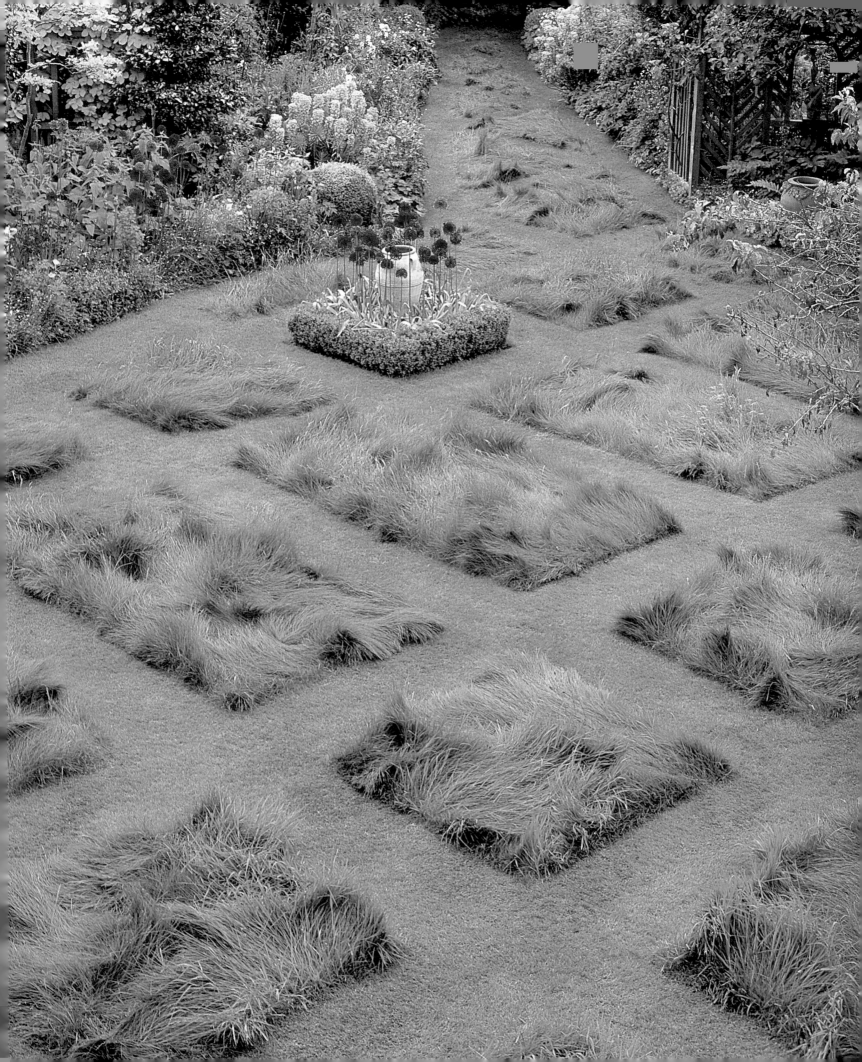

ABOVE These island beds of the deciduous grass *Miscanthus sinensis* 'Gracillimus', seen here in winter, have long since lost their green colour and no longer stand straight and tall. But the Belgian garden designer Jacques Wirtz, using a combination of imagination and good horticultural practice, cut and layered the dead growth to form dramatic sculptural mounds of swirling golden foliage.

OPPOSITE At San Pablo, California, in 1969 an outsize branding-iron mark was burned into a patch of grazing land. This short-lived work by Dennis Oppenheim was one of the first examples of modern land art to use the growing landscape. Oppenheim has also created "living" land art by making indentations in fields similar to those seen in crop circles.

The makers of prehistoric and ancient landmarks preferred to communicate through symbols and images rather than words. Early civilizations sometimes created huge images set within the landscape for this purpose. The white outline of a giant cut into a grass-covered chalk hill at Cerne Abbas, in Dorset, England, is one example of an ancient art where large-scale images were created by using the local geology. Today the British artist Simon English is extending this form of land art in his own way. But, instead of cutting into the ground, he creates more temporary images by using the grass and crops that cover it. Animals are his main subject, and his method of working usually involves cutting into a crop. He once made a group of rabbits, one over 55m (180ft) wide, on a grassy hill near Stratford-upon-Avon. The outline of each animal was drawn using rope and wooden stakes. Because the site sloped there was a foreshortening effect, and so English elongated the rabbits to rectify this and make them look right when seen from the nearby road. The artwork needed regular mowing to prevent it from fading back into the field.

English has also exploited agricultural practices to create his works. Until recently British farmers were permitted to prepare a field for the new crop by burning off unwanted

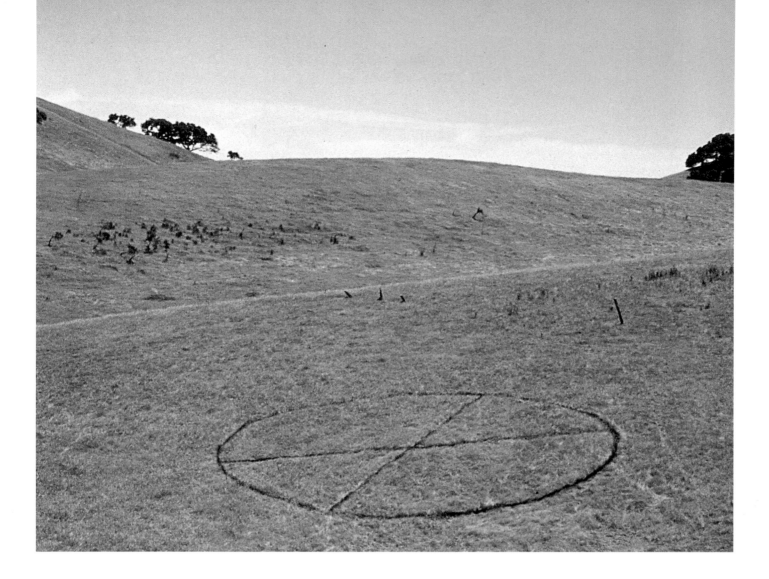

stubble. English used a similar technique to provide a 90m (330ft)- long zebra with its dark stripes. These were made from carefully raked rows of hay, which were then set alight. Once burned black, they cleverly imitated the animal's black markings.

Agricultural methods also inspired one of America's most prolific crop artists, Stan Herd. The son and grandson of farmers, he grew up on his family's farm in Kansas and found a way to combine his enthusiasm for art with his background in agriculture. Herd has made farming an art form, realizing that "all over the world farmers draw with the plough, harrow, and harvesting combine, and paint with the colours of their crops." What distinguishes his work from that of Pierre Vivant or Simon English is that he sows the seeds of the crops that create his field-sized works of art..

Herd began to "paint" by planting in the early 1980s, when he grew massive portraits of important local figures. In 1985 he planted what was to become his most photographed and reproduced image, "Sunflower Still Life," a version of Vincent Van Gogh's famous painting, but made with real sunflowers.

OVERLEAF "Past," an extract from the "Made in England" series by Pierre Vivant, 1990. The sudden death of age-old rural landscapes was heralded in 1990 by a red wave across the English countryside. This colourful flash was the result of the European agricultural policy of set-aside, which awarded substantial subsidy to farmers for keeping their land redundant. The subsidy was conditional on a yearly ploughing which created, just like the shelling of the fields of Flanders, the right conditions for the poppy, whose seed can remain dormant deep in the earth for centuries, to emerge and take over. The "Made in England" series set out to show the specificity of the English landscape, whose continued "prettiness" is but a screen that conceals the massive changes in the production of food. The field is now a golf course.

RIGHT Simon English is best known for his crop-art images of native wild animals, which he makes by simply mowing their shape into grass fields normally grazed by livestock. His decision to create a field-sized zebra presented a new challenge, in particular how to represent the animal's distinctive stripes. Fire was the unusual solution he hit upon. The charred remains of hay raked into piles and then burned with precision created the dark stripes.

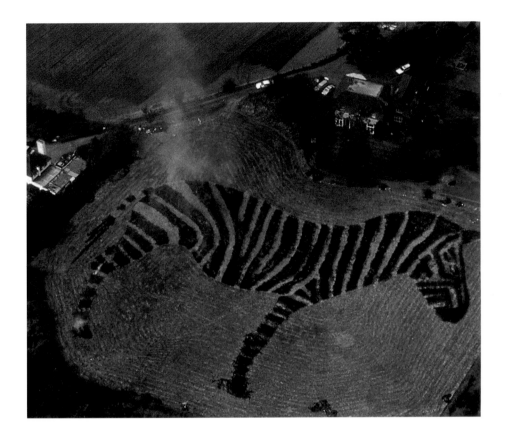

the comfortable and controlled home environment into the garden is too often paramount in garden planning. The artist's planted sculptures not only provide a sensory experience but, provoked by her growing fear of ecological crisis, are intended to remind us of our responsibility for our surroundings and to show how the natural environment is essential to our lives.

In Webster's work the planting and growing of flowers is motivated by a political cause rather than the pursuit of an aesthetic effect. The same cannot be said of the use of flowers in a design by Bernard Lassus. The French landscape designer's "Les Buissons Optiques" (Optical Bushes), created in Niort in 1993, is a cross between a painting and a parterre garden. A colourful pattern of wavy, painted stripes is enhanced by the living colours of marigolds and petunias. The painted colours complement and match the colours of the flowers to create a dynamic, rainbow-like display. The effect is, of course, temporary and the flowers need to be replaced regularly.

The use of flowers to create art is not new. Seasonal bedding plants have been used to create decorative floral patterns since the eighteenth century. By the 1860s in England dwarf or creeping foliage plants were being used to create complex and maintainable

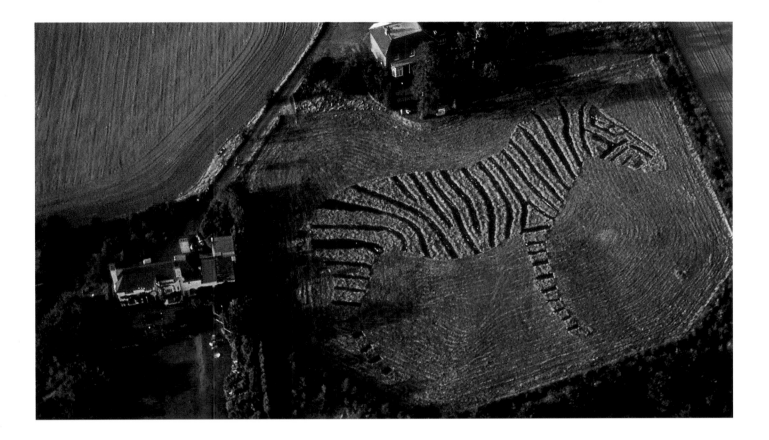

patterns. This technique, known as carpet bedding, soon spread into Europe, and by the end of the century geometric patterns were being supplanted by animal forms, emblematic shapes, and words. Floral art of this kind is still a common feature in public parks, where it is often used for commemorative purposes. Artists such as Bernard Lassus are simply translating the tradition of "bedding out" into the language of contemporary art.

Bedding plants have become a modern-day crop, grown in vast numbers in controlled environments to serve the demands of the gardening industry. Ornamental bulbous plants have been cultivated for centuries. Now they too are field-grown on a massive scale. The French artist Daniel Buren used 11,000 tulips for a work at Keukenhof, in The Netherlands, in 1987. He chose two different varieties, which he combined to form a long, red-and-white-striped band in a raised planting bed. Buren is interested in landscapes transformed and made orderly by human intervention, particularly evident in the ranks of flowers grown in plant nurseries in Europe and North America. The regimented rows of colourful tulips in the artist's work acknowledge this seasonal phenomenon.

Buren's enthusiasm for growing bulbs for art is shared by the American artist Gary Rieveschal, who, like Lassus, is attracted to tulips. He believes that "If art is about life,

ABOVE Seen here before its stripes were burned into the ground, Simon English's zebra continues a long tradition of making large pictorial symbols on and with the landscape. Many are still visible today. Unlike his ancient predecessors, English uses mowing and burning to create his landmarks. A further difference is that these modern works, unless maintained, soon disappear under new growth.

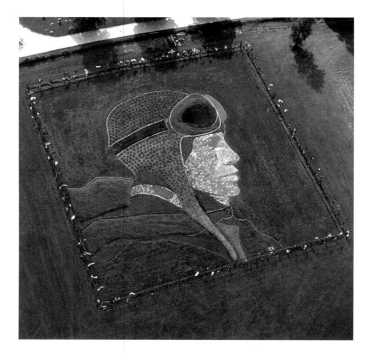

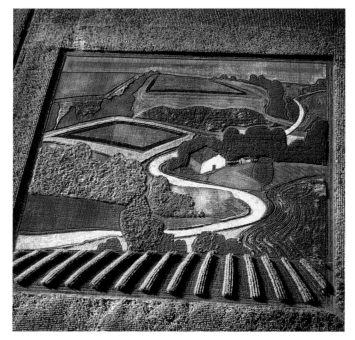

ABOVE This portrait of Amelia Earhart was Stan Herd's first permanent crop-art "painting." The image of the American aviator covers an area of 0.5 hectare (1 acre) on a hillside near the Atchinson International Forest of Friendship, in Kansas. Begun in the summer of 1996, it is composed of living plants, rock, and other natural materials.

ABOVE RIGHT Stan Herd's "Countryside" was made in Kansas from a mixture of crops, including fruits and vegetables. It presents a view of the agricultural terrain of the artist's home state as it looked in earlier times. Herd's non-commercial crop-art projects may be seen as a development of two traditional genres of painting: portraiture, as in the Earhart portrait, and landscape, as seen here.

then it is sensible to realize living ideas with living materials," and this is his personal justification for using seasonal flowers. Rieveschal also enjoys the fact that there is a sense of "letting go" that occurs when working with living vegetation. He is happy to accept "natural processes as working partners," and his willingness to surrender control over the living materials he uses and the ultimate destiny of a project offers an alternative to more conventional ways of making art.

He calls his landscape sculptures "lifeforms," and they are intended as reference points that connect nature with life in general. Planted in Berlin in 1980 as part of the series "Kreuzberger Lifeforms," his work "Heart Wave" was 180m (600ft) long and consisted of 12,000 red tulips. The zigzag line of tulips represented the waveform pattern seen in an electrocardiogram of a healthy heart and was planted as a "life sign" along the embankment in front of the city's Urban Hospital.

Rieveschal does not restrict the materials of his art to tulips. In the earlier work "Baum Ringe" (Tree Rings), made in 1976 as part of the series "Bremer Lifeforms" at Bremen, in north Germany, he planted 15,000 white crocuses, 5,000 blue scillas, and 2,500 yellow daffodils. The sculpture consisted of three sets of concentric circles, formed by plants, which were arranged around three trees. Each group of circles was formed from a different species of bulb, so that the plants would be in flower at different times. The circles were intended to symbolize the annual growth rings within the three trees.

Crop art often demands the use of complicated horticultural and agricultural processes, but sometimes the simplest methods are more effective. The mown-grass work "Repens" was made in 2000 by the British artist Anya Gallaccio at Compton Verney, near Stratford-upon-Avon, Warwickshire. The garden of this country house was designed by Lancelot "Capability" Brown, who, in the eighteenth century, pioneered a landscape style that emphasized the natural look in preference to the formal. It is easy to imagine that this landscaped park, with its scattering of trees and informal lakes, is an original natural landscape. But it was Brown's "constructed wild," as Gallaccio describes it, that inspired her to make a mown artwork on the lawns that sweep right up to the house. The eighteenth-century architect Robert Adam had also worked at the house, and it was a drawing by him for a ceiling rose that provided the decorative motif for the work.

Gallaccio achieved the complex pattern with the help of large, pastry-cutter-like templates. The grass of the lawns was allowed to grow longer than usual. It was then cut

BELOW Meg Webster's garden "Glen," with its informally planted and untended wild flowers, was more imaginative than practical and served as an antidote to the immaculate but sterile gardens of the American suburbs. The work was made at the Walker Art Center, in Minneapolis, Minnesota, in 1988–9.

OVERLEAF "Les Buissons Optiques" was created by Bernard Lassus in Niort, France, in 1993. The landscape designer combined brightly painted strips of wood with multicoloured varieties of seasonal bedding plants to make an abstract "living painting." The endless rows of colour bring to mind the large nurseries that grow such plants as a crop.

right up to the templates. Within these, however, it was allowed to continue growing, and by the end of the season it had reached a height of almost 1m (3ft). Left undisturbed, it was soon full of wild flowers.

Without a helicopter, the best view of the work is gained from the upper rooms of the house. In the context of a grand house, and in its style, it resembles a garden based on the parterre, the ultimate development in the evolution of the formal European garden. But in this work the formality is contradicted by the wildness of the grass that defines the patterns. It is what Gallaccio calls "the formal constructed by the wild," the man-made constructed with nature. This is also an apt definition of crop art.

Gallaccio's large artwork at Compton Verney reflects a recurring aspect of much crop art in that it is best seen from above and from a distance. The same is true of the works of

BELOW Gary Rieveschal made "Heart Wave" in Berlin for the Program for Art in City Spaces, and the American artist believes that public art should be about the people of the city and the spaces they inhabit. He chose to make his representation of a heart's rhythm in tulips because he feels that the best way to make art about life is to use a living medium.

Stan Herd, which are created on an agricultural scale. Other artists, including Pierre Vivant and Simon English, design their works so that they can be viewed from the ground. However, they have to compensate for the foreshortening of the image that occurs when it is viewed at an angle rather than directly from above. In order that the work can be seen properly, they elongate the image, as is done with traffic signs painted on roads. Naturally, if a work can only be "read" properly from above, the only way to see it is from the air or in an aerial photograph.

Although the artworks seen here are three-dimensional in that they are made from plants, they are essentially surface-based, and when they are seen from afar the resulting sense of "flatness" is reinforced. For this reason perhaps this type of crop art is not so much living sculpture as "living painting," in which cereal crops, grasses, and flowers take the place of colours on the artist's canvas.

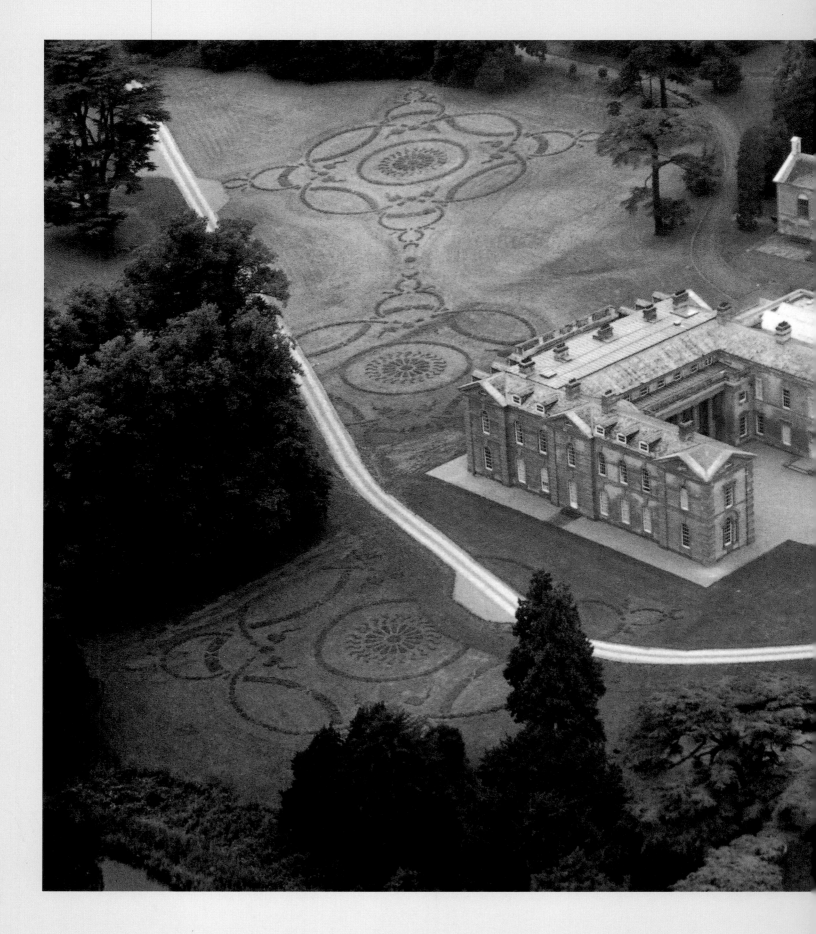

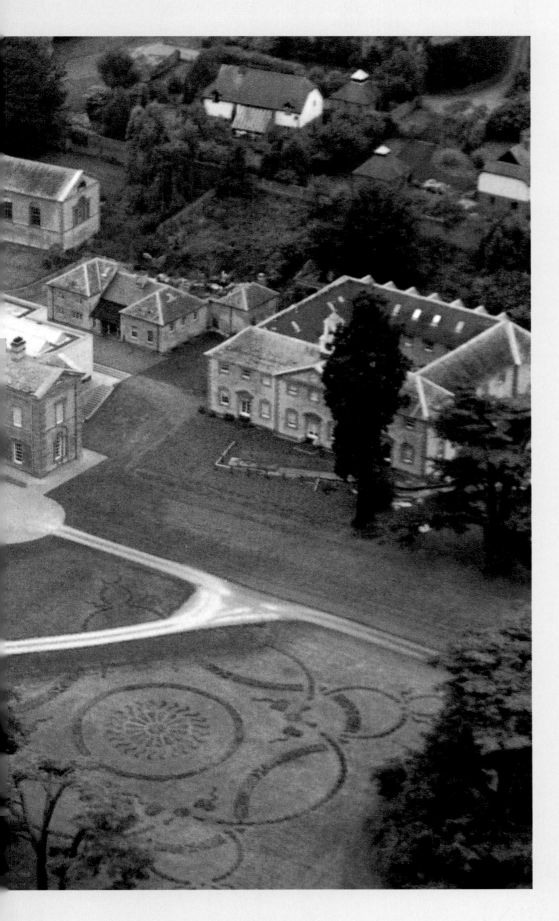

LEFT It is hard to believe that the elaborate patterns of Anya Gallaccio's large work "Repens," which spreads across the lawns at Compton Verney, near Stratford-upon-Avon, England, were created simply by cutting the grass. The dark-green patterns are areas of uncut grass that became overgrown with native wild plants often found in hay meadows, among them coarse grasses and flowers such as white clover and cowslip. A pattern associated with interior decoration, and normally seen fixed in paint or plasterwork, has been transferred into the garden through the use of a living medium.

GLOSSARY OF TECHNIQUES AND MATERIALS

Italics indicate a cross-reference to another entry in this glossary.

ARCHITECTURAL TOPIARY Geometric forms, such as spheres and obelisks, can be produced by growing a plant in a wire-mesh cage. The plant is allowed to grow until it protrudes just beyond the surface of the cage, and then is trimmed back to the mesh at regular intervals.

BEDDING A bedding plant is used to create temporary floral displays. It is "bedded out," or planted, in large numbers, usually after being grown elsewhere until it has almost reached the flowering stage. Carpet bedding is a specialized form of bedding in which very low-growing or ground-covering plants with colourful flowers or foliage are used for decorative purposes.

BENDING The technique of lowering shoots or branches into a more horizontal position by weighting or tying them. In horticulture it is often used to control vigorous growth and to stimulate the flowering of fruit trees and some ornamentals shrubs. In the making of living sculpture it creates forms and controls shapes.

CONTAINER GARDENING A term used to describe the growing of plants in pots or other

ABOVE An engraving published in France in the nineteenth century illustrates topiary techniques and some of the forms that can be produced.

containers. A plant that is grown in this way can be removed for planting with minimal disturbance to the roots. It should remain in its pot or container for at least three months of the growing season. Container-grown plants are used in *bedding* and in mosaiculture, which combines this style and carpet bedding.

COPPICING The cutting off at regular intervals of all growth that develops from the base of a tree. This produces a mass of smaller side shoots, which can be harvested as young flexible twigs or left to mature for use as fuel or in construction. Alternatively, new shoots can be left growing on the coppiced stump, or "stool," of the tree, to be bent and woven into architectural and sculptural forms.

CULTIVARS Distinct plant forms that do not warrant botanical recognition. Cultivars are selected from garden or wild plants and are maintained in cultivation by *propagation*.

FAMILY TREE A fruit tree consisting of two or more different *cultivars*, grafted onto a common *rootstock*. The technique is sometimes used where space is limited, as it makes it possible to grow several different forms of the same fruit, for example apples, on one tree.

FOLIAGE PLANT A plant grown for the colour, pattern, or texture of its leaves rather than for flowers. Smaller varieties are often used to add interest to carpet *bedding* displays.

GRAFTING A technique used to join two plants so that they will function as one. It was originally developed as a method of *propagation* or to repair a damaged specimen, but now it is also exploited by artists to grow trees with unusual shapes.

HYDROPONICS The cultivation of plants without soil. In one method plants are placed in mineral wool, through which water containing inorganic nutrient salts is pumped. In another method plants are cultivated in a liquid medium that provides the necessary nutrients.

INSTANT TOPIARY A recently introduced technique in which fast-growing climbing plants, such as ivy, are used to create large *topiary* specimens. Twining or creeping shoots are trained over elaborate and precisely constructed frames to form features that are hollow but, when established, bear a resemblance to traditional topiary.

LAYING A traditional method used to form livestock-proof hedges. The shoots or trunks of young trees are partially severed, bent over almost horizontally, and woven through vertical wooden stakes inserted into the centre of the hedge. In Britain the dialect word "fletching" is often used to describe the technique.

MOWING The cylinder mower, essential for maintaining a "bowling green" lawn, has been superseded by rotary mowers, hover mowers, and line trimmers. These newer machines permit a greater variety of depth of cut and can be used on less even ground.

PEAT A layer of partially decayed vegetation found at the surface of waterlogged soil. Harvested peat is used in gardening to improve soil structure. Peat blocks, cut directly from the bogs that hold natural deposits of the material, are sold in dry form and are used like bricks to build turf sculptures or to create organic retaining walls. Many sculptors use recycled peat from commercial suppliers to avoid depleting natural peat bogs.

PLEACHING A term traditionally used to describe the making of a hedge by *laying*. Nowadays it is more often used in horticulture to refer to the weaving together of branches of adjacent trees to create a narrow hedge or screen. Often only the upper part of the tree is pleached, creating a band of foliage, supported on pillar-like trunks.

POLLARDING The cutting off, back to the trunk, of all of a tree's branches. This is done either to keep it in shape and within space limits or to produce a strong crop of young shoots, for example of willow, to harvest.

PROPAGATION The increase and reproduction of plants. Most techniques used in horticulture to reproduce plants are adaptations of natural processes. Sexual propagation uses seeds, and asexual propagation works by reproducing an exact copy of the parent plant. The latter includes techniques such as using cuttings, layering, splitting, and grafting.

PRUNING The removal of overgrown or dead branches and stems from shrubs and trees. Usually done to improve and maintain a given shape, or used by gardeners to encourage better flowering or fruiting.

ROOT PRUNING The severing of a number of the roots of a tree to stunt its growth. The technique is used in the art of bonsai to cultivate miniature trees.

ROOTSTOCK The part of a grafted plant that supplies the roots. The term also refers to plants that are grown specifically to produce this root material.

SEEDING All earth-covered mounds created in "land art" need plants to retain the soil in dry weather and to prevent it from being washed away by rain. Grass is the most commonly used plant, and modern technology allows this to be sprayed in solution onto even complex forms, where it will seed evenly.

SOIL Soil is divided into two categories. Topsoil is the upper layer, which can vary considerably in depth. It contains nutrients and organic matter and supports growing plants.

Subsoil is the layers of soil beneath the topsoil, which usually have a low proportion of organic matter and poor structure and fertility.

SUB-BASE A term used in landscaping to refer to the foundation on which paths, paving, and other structures are laid. A commonly used sub-base is a mixture of gravel, rubble, and stone. In the making of earthworks a sub-base is used to build sculptured mounds and provide a firm support for the layers of soil and turf with which these are covered.

TOPIARY The art of clipping and training trees and shrubs, usually evergreen, into artificial shapes. The plants most often used are yew (*Taxus baccata)* and box (*Buxus sempervirens*). In traditional topiary one technique is the use of a wood-and-wire frame to train a plant into the desired shape. The plant is clipped annually to improve and maintain the shape. Alternatively, shapes are created by exploiting the plant's natural structure. New shoots are separated and tied into groups. Much modern topiary is made from mature privet or box plants or hedges. The shapes are created by regular and extensive clipping. Conifers, which are often used as hedges, can be clipped into topiary, but, unlike privet or yew, they will not recover or grow back if they are cut back beyond the green surface foliage.

TURF A piece of grass purpose-grown for making lawns and usually in the form of a rectangle of standard dimensions and depth of soil. Known as a sod in the United States. The term also describes a larger, established area of grass or meadow-forming plants.

WHIP A young tree, seedling or *grafted*, that is without lateral growth. The single flexible shoots, planted in groups, provide an ideal starting point for living woven features.

173

INDEX

175

ACKNOWLEDGMENTS

Acknowledgments in Page Order

Front cover Garden Exposures Photo Library/Andrea Jones; **back cover, top left** Andrew Lawson Photography/Lynn Kirkham; **back cover, top right** Jerry Harpur; **inside back cover;** Jo Cooper.

KEY TO ABBREVIATIONS

AL Andrew Lawson Photography; **GE** Garden Exposures Photo Library/Andrea Jones; **GPL** Garden Picture Library; **JH** Jerry Harpur; **KE** Kerstin Engstrand; **MP** Mick Petts

Endpapers GPL/Brigitte Thomas; **2** Richard Harris; **6** Bridgeman Art Library/Fitzwilliam Museum, University of Cambridge; **7** Corbis UK Ltd/Richard A. Cooke; **8** Corbis UK Ltd/Yann Arthus-Bertrand; **9** Jean-Loup Charmet/Biblioteque des Arts Decoratifs; **10** John Glover; **11 top left** Arborsmith Studios; **11 top right** Covello & Covello Photography; **13** GPL/Clive Nichols; **15** Clive Nichols Garden Pictures; **16** AL; **17** JH; **18–19** JH; **20** Collections/George Wright; **22–23** Patrick Taylor; **24–25** JH; **25 bottom** JH; **27** Pearl Fryar; **28–29** JH; **30** James Mason; **31 top left** Corbis UK Ltd//Michael S. Yamashita; **31 bottom right** Michael Yamashita, Inc.; **32 bottom left** GPL/Ron Sutherland; **32 bottom right** GPL/John Glover; **33** AL; **34–35** GPL/Jerry Pavia; **36** GPL/John Baker; **37** GPL/John Wright; **39** Marianne Majerus/Simon Gerhold; **41** AL/Lynn Kirkham; **42** MP; **43** Gardens Illustrated/Peter Anderson; **43 top right** AL; **44–45** Gardens Illustrated/Peter Anderson; **47** GPL/Mayer/Le Scanff; **48** John Glover; **49** Patrick Dougherty; **50** MP; **52–53** MP; **55** GPL/Howard Rice; **56** Papyrus/Judy & Dave Drew; **58–59** Sunniva Harte/Ivan Hicks; **60 left** Sunniva Harte/Ivan Hicks; **60–61** MP; **62 top left** MP; **62 bottom** MP; **63** MP; **65** GE; **66** MP/Sue and Pete Hill; **67** MP; **68** MP; **69 top** Edmund B. Thornton Foundation/Michael Heizer; **69 bottom** Edmund B. Thornton Foundation/Michael Heizer; **70** GE; **71** GE; **72** Ritsuko Taho; **73** Ritsuko Taho; **74** John Glover/Alex Champion; **75** JH/William H. Frederick; **76–77** John Glover/Alex Champion; **78** David Nash/DACS 2001; **79** David Nash/DACS 2001; **80** KE/Lena Lervik/DACS 2001; **82** John Glover; **83 left** KE/Liv Due/DACS 2001; **83 top right** Harry Smith Collection; **84** KE/Inga Hellman-Lindahl/DACS 2001; **85** Collections/George Wright; **86–87** AL/Ivan Hicks; **89** Ackroyd & Harvey; **90** Ackroyd & Harvey; **91** Ackroyd & Harvey; **92** KE/Ulla Viotti/DACS 2001; **93** Maya Lin Studio/Tim Thayer; **94** Colin Philp Photography/Gavin Jones Ltd.; **97** Catello di Rivoli Museo d'Arte Contemporanea; **98–99** Colorific/Michael Yamashita; **100** Birr Castle Demesne; **101 bottom left** Mise au Point/A. Descart; **101 bottom right** JH; **102 top** David Nash/DACS2001; **102 centre** David Nash/DACS 2001; **103** Vladimir Sitta; **104 top left** David Nash/DACS 2001; **104–105** David Nash/DACS 2001; **106 left** David Nash/DACS 2001; **106–107** David Nash/DACS 2001; **107 right** David Nash/DACS 2001; **108** MP; **109** GE; **110** AL; **111 top left** AL/Ackroyd & Harvey; **111 top right** GPL/Sunniva Harte; **112** Papyrus/Bruno Coutier; **113** GPL/Christi Carter; **114–115** JH; **116** Covello & Covello Photography/Axel Erlandson; **117** Arborsmith Studios/Axel Erlandson; **118** Enver Hirsch/Joseph Beuys/DACS 2001; **119** Enver Hirsch/Joseph Beuys/DACS 2001; **121** Laura Stein; **123** Axiom Photographic Agency/Mikihiko Ohta; **124** AL/Lawhead Croft, Lanarkshire; **125** JH; **126–127** Swarovski Kristallwelten/D. Swarovski & Co./Spiluttini Margherita; **127 top right** Swarovski Kristallwelten/D. Swarovski & Co./Mario Katzmayr; **128** Axiom Photographic Agency/Ian Cumming; **129 top right** Axiom Photographic Agency/Alberto Arzoz; **129 bottom left** KE/Ms Bitte Jonasson-Akerlund; **130 top left** Derek St Romaine; **130–131 bottom** Derek St Romaine; **133** GPL/John Glover; **134–135** Samm Kunce; **136** KE/Ms Annika Oskarsson and Mr T Nordstrom/DACS 2001; **137** Clay Perry; **138** Barbara Gladstone Gallery/Vito Acconci; **139** GPL/Erika Craddock; **140 top left** The Interior Archive/Helen Fickling/Art Cars; **140 top right** Paul Cooper; **141** Meg Webster; **142–143** Sally Matthews; **144** Dr Ian Hamilton Finlay; **145** Dr Ian Hamilton Finlay; **146** GPL/Erika Craddock; **148–149** GE; **151** Skyscan Photolibrary/Bob Croxford; **152** M&Y Portsmouth; **153** AL/Kathy Swift; **155** AL; **156** Patrick Taylor; **157** Dennis Oppenheim; **158–159** Pierre Vivant; **160–161** Pierre Vivant; **162** Simon English; **163** Simon English; **164 top left** Jon Blumb/Stan Herd; **164 top right** Jon Blumb/Stan Herd; **165** Walker Art Centre/Lannan Foundation/Meg Webster; **166–167** Bernard Lassus; **168–169 bottom** Gary Rieveschl; **170–171** Locus+ Archive; **172** Jean-Loup Charmet.